THE WHO, THE WHAT, AND THE WHEN

THE WHO
THE WHAT
AND THE WHEN

65 ARTISTS ILLUSTRATE THE SECRET SIDEKICKS *of* HISTORY

FOREWORD BY
KURT ANDERSEN

BY
**JENNY VOLVOVSKI,
JULIA ROTHMAN,**
and **MATT LAMOTHE**

CHRONICLE BOOKS
SAN FRANCISCO

Library of Congress Cataloging-in-
Publication Data available.

ISBN 978-1-4521-2827-6

Manufactured in China

MIX
Paper from
responsible sources
FSC® C008047
www.fsc.org

Design by ALSO

The text face is Mercury Text,
designed by Hoefler & Frere-Jones.
The titling face is Verne Jules,
designed by Isaac Tobin.

10 9 8 7 6 5 4 3 2

Chronicle Books LLC
680 Second Street
San Francisco, CA 94107
www.chroniclebooks.com

"Thunder is good, thunder is impressive; but it is lightning that does the work."

— MARK TWAIN

CONTENTS

FOREWORD

WRITTEN BY **KURT ANDERSEN**
novelist and public radio host

ILLUSTRATED BY **WENDY MACNAUGHTON**
illustrator and graphic journalist

I jumped at the chance to be part of this book because I've been fascinated for a long time by one of history's most extraordinary and improbable secret accomplices, a promising young man who signed on as second fiddle to an unpromising young man who became one of the nineteenth century's most famous and consequential men of all.

At the dawn of industrial capitalism, Friedrich Engels was a tall, handsome capitalist working in his father's cotton-milling business, helping to manage a factory in Manchester, England. But he had simultaneously turned himself into an *anti*capitalist, writing articles for radical papers and a book-length exposé of the wretched lives of Manchester's mill workers and their families, *The Condition of the Working Class in England*. (Imagine a modern equivalent: Jamie Dimon's kid, say, running a JPMorgan Chase derivatives trading desk while also publishing screeds in *The Nation* and organizing Occupy Wall Street.)

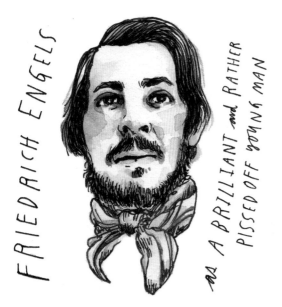

FRIEDRICH ENGELS

as a brilliant and rather pissed off young man

At twenty-three, Engels befriended a cranky, excitable, scrounging twenty-five-year-old journalist and rabble-rouser—Marx—and became his lifelong collaborator (*The Communist Manifesto*, *Capital*) and patron. And in order to fund his bourgeoisie-loathing BFF's bourgeois lifestyle, Engels kept his lucrative capitalist-tool day job for the next quarter century. I'm a fan of Fitzgerald's line about living with contradictions—"The test of a first-rate intelligence is the ability to hold two opposed ideas in the mind at the same time, and still retain the ability to function"—but Engels's life is a gobsmacker.

A plurality of the accomplices here are (like Engels with Marx) men who helped other men, and nearly as many are women (wives, mothers, assistants) who helped men. There are only a handful each of men who helped women and women who helped women. As an academic might say, such is the genderedness of historiography. What an academic might say about a possible lesbian having an *animal* accomplice—Emily Dickinson and her dog Carlo—Lord only knows.

These accomplices are variously mentors, partners, spouses, muses. In my own career, I've had three unequivocally indispensable enablers. I met them all in my twenties, during my first five years in New York City.

The crucial mentor was Gene Shalit, then the *Today* show's full-time movie critic and cultural correspondent, who hired me out of college to be his writer (mainly of the daily essays he broadcast on the NBC Radio Network). He created and offered the job, he admitted later, because at our

first meeting I'd used the word "anthropomorphic." As a boss he was perfection: unfailingly cheerful, encouraging and grateful, generous in every possible way. A year or so into my tenure, he signed a contract to produce a book of humorous essays called *The Real Thing,* and asked me to write it for him. Around Christmas, after I'd finished maybe a half dozen of the essays, he called me into his office to announce that he'd changed his mind. Instead of being his ghost (and by the way, his company's official name was Scrooge & Marley), the book would have my name and my name alone on the cover. And thus, at age twenty-six, I became a published author.

I left Scrooge & Marley to become a staff writer at *Time,* and a few weeks into that job one of my colleagues popped his head in my office door to introduce himself—"Hi, I'm Graydon Carter"—and tell me he'd loved *The Real Thing.* We promptly became friends, then close friends, and, finally, partners. At weekly lunches we'd gossip about the juicy stories our journalist pals had heard but couldn't or wouldn't publish. We'd rhapsodize about the magazines we read in the 1960s and '70s—*MAD,* *New York, Rolling Stone, Esquire, National Lampoon*—that had inspired us to work in magazines. And we'd lament that now, in the 1980s, we had no magazine we truly *loved,* the way we had as kids. Which led to conversations about what form such a hypothetical publication might take: smart but also fun . . . funny but journalistic . . . insider-y but fearless. In 1986, we gave birth to *Spy,* which turned out to be almost as wonderful as we'd hoped, and much more successful. Our temperaments and editorial skills were perfectly complementary, and together we ran the magazine for five of its twelve years, each of us understanding implicitly that the other was essential to its existence and occasional greatness. For me—for both of us—it was the thing that got the world to pay attention and permit my next adventure, and next and next.

Another person instrumenal in *Spy*'s success was Anne Kreamer, whom I'd married five years before we started the magazine. First, she'd introduced Graydon and me to a college classmate of hers with an MBA, who became our business partner and pushed us to turn our larkish notion into an actual magazine. And when we launched, Anne quit her corporate job to come aboard as our underpaid advertising sales director, allowing the magazine to survive infancy and then to thrive. After she and I moved on from *Spy,* she was my de facto patron for a few years, her fancy new corporate job helping to subsidize my professional lane change from magazine editor to fiction writer. Again and again she has served as my muse. The first big magazine piece I published, "Why Men Marry," was an ode to her, and in my first novel many strands of the main female character's DNA were transplanted directly. It was Anne who fortunately talked me out of switching career lanes again a few years ago, from writer back to weekly magazine editor; she who's the first reader of everything I write; she who has more faith in my talent than anyone else in our household.

And it's she with whom I finally reciprocated, becoming her mentor, patron, and enabler a dozen years ago when she decided to reinvent herself as an author of intelligent, thoughtful, candid memoirs and guides to life.

So maybe the moral of this story—of this book—is that the most fortunate among us are all each other's secret accomplices, and that the secrets should be revealed.

SOLID MENTOR

UNCOMPROMISING COLLEAGUE

GENEROUS, WHIP-SMART HUSBAND/WIFE

DUMB LUCK

*GREATNESS

INTRODUCTION

Would we still have the classic novel *Lolita* had Véra Nabokov not pulled it from the flames? Would Muhammad Ali have boxed his way to greatness had he not met a police officer when he was twelve? Would George Washington have been able to orate his way to the presidency were it not for his dentist?

Behind every great person there is someone who enabled his or her ascension. These friends, relatives, partners, muses, colleagues, coaches, assistants, lovers, teachers, and caretakers deserve some credit. This book is about celebrating them.

When you consider your own life, there are dozens of people who have guided you along your path—whether a teacher from fifth grade who finally got you to raise your hand in class, a family friend who gave you your first camera, or that whiskey-sipping neighbor who'd tell you stories of his childhood. These relationships shape our lives, some lightly and others with more impact.

The three of us have worked together for more than eight years. Each would name the other two as truly significant influences. Every day we offer each other constructive criticism for our designs and ideas. Matt helps Jenny figure out every technical challenge. Jenny guides Julia's fledgling typography skills. Julia reins in Matt's wild schemes. We are each fill-ins for the others' shortcomings. Without one another's influence, our work wouldn't be the same. Would this book exist if one of us weren't involved?

We've asked more than sixty writers to help us with the task of highlighting some of history's "unknowns" along with their famed counterparts. The writers chose subjects based on their interests, but researching these hidden accomplices often proved difficult. There was often very little source material that outlined the relationship between the famous person and the unknown one. Sometimes, their presence even escaped the Internet altogether (yes, it can still happen). A few of these secret helpers are alive and well and were able to be interviewed for the book. In the final essay, a writer explains firsthand how he helped bring an unknown photographer into the public eye.

We then matched artists, illustrators, and designers with a story we thought paired well with their individual styles. The artists had the task of creating a portrait of the accomplice and the relationship that person shared with the famous counterpart.

While it was intriguing to learn about these obscure characters, the relationships also brought to light new details about the famous figures. Ultimately, these are stories of humanity: of love, competition, obsession, hardship, and true passion. People who may have been icons in our minds—the fashion queen Coco Chanel, the animation visionary Walt Disney, the fearless revolutionary Lenin—suddenly became real people. They had relationships that we could relate to: an unrequited love, an inspiring business friendship, a brotherly honor to defend. With decades, even centuries, of time between us, we are all still feeling the same connections to people, needing the same encouragement, and having the same kinships.

We hope this book will not only introduce you to new figures and bring dimension to these historical personalities, but also help you recognize and honor the same relationships in your own life.

WRITTEN BY / **JENNY VOLVOVSKI**,
JULIA ROTHMAN,
and **MATT LAMOTHE**

1916 JOE MARTIN 1996

MUHAMMAD ALI'S COACH

ARLY IN HIS CAREER, REFLECTING ON HIS development as a fighter, Muhammad Ali said, "Man, all the time somebody is telling me, 'Cassius, you know I'm the one who made you.' I know some guys in Louisville who used to give me a lift to the gym in their car when my motor scooter was broke down. Now they're trying to tell me they made me, and how not to forget them when I get rich. . . . But you listen here. When you want to talk about who made me, you talk to me. Who made me is me."

Those who knew Muhammad Ali as a young man sometimes describe the inevitability to the fighter's becoming—in his own mind and that of many others—the greatest boxer of all time.

To see Ali as something less destined, to see who, if anyone, really did "make him," we'd have to go back in time a bit, before Cassius Clay became Muhammad Ali, before the force of nature was entirely unleashed, before Ali was the most recognized face on the planet and the self-proclaimed "Greatest," to when Ali was the twelve-year-old Cassius Clay, who went to the Louisville Service Club convention to hang out with his friends, getting there on his new bike, a $60 red Schwinn that he received for Christmas.

After enjoying free popcorn and hot dogs, the boys were ready to leave the convention and ride back home. But Cassius's bike was gone.

Clay was beyond himself with anger. The tearful boy was directed to the basement of the auditorium, which functioned as the Columbia Gym, a boxing training center owned and run by Joe Martin, a policeman with a boxing hobby who, in addition to coaching young Golden Gloves boxers, also produced a local television amateur boxing program called *Tomorrow's Champions*. The thirty-eight-year-old Martin was an easygoing man who lived comfortably, drove a Cadillac, and was called Sergeant as a joke by friends because, despite almost twenty years on the force, he had never bothered to take the promotional sergeant's exam.

Martin, in his role as police officer, took down the information about the boy's bike and patiently listened to the insatiable Cassius's seemingly endless vows of physical revenge

upon the culprit. Finally, he asked, "Well, do you know how to fight?"

"No," Cassius said, "but I'll fight anyway."

"Why don't you learn something about fighting before you go making any hasty challenges?" Martin said.

Martin arranged for Cassius to visit the gym and learn the rudiments of boxing. When he started, "He didn't know a left hook from a kick in the ass," Martin recalled. But Cassius soon revealed himself to be a natural: The reflexes and speed that made him perhaps the fastest to ever fight were already pronounced. He fought his first bout after six weeks of training. The three-round match resulted in a split decision, but Cassius let out a shout that he would "soon be the greatest of all time."

Martin helped guide Cassius through his amateur boxing career, and Martin's wife would drive the young boy cross-country to tournaments, stopping to buy takeout sandwiches for them at the roadside diners that typically refused to serve African Americans. Before the Olympics in Rome, Martin spent hours sitting with Cassius, convincing him that it was safe to fly to Rome for the Olympics. Cassius, terrified of flying, insisted that there must be a train of some kind to make the journey. Martin explained the necessity of flying to Rome, the necessity of winning the medal if Cassius wanted to become champion of the world. Cassius ultimately assented to the flight, albeit with a self-purchased parachute strapped to his back.

On the return flight he wore his Olympic jacket and gold medal.

After that, it was time for the eighteen-year-old Clay to leave the amateur circuit and to get a professional trainer, although Martin and his former fighter would remain in contact for life.

Martin trained a total of eleven Golden Gloves winners and became an auctioneer after his retirement from the police force. In 1980, Muhammad Ali appeared in a boxing exhibition held as a fund-raiser for Martin's unsuccessful run for sheriff of Jefferson County, Kentucky. Martin passed away in 1996, nationally remembered for his role in Ali's life story, and loved by many others far less famous.

WRITTEN BY DANIEL KUGLER
Torevealourbackstreets.tumblr.com

ILLUSTRATED BY RUBBER HOUSE
www.rubberhousestudio.com

JOHN GREENWOOD

GEORGE WASHINGTON'S DENTIST

AS HE MADE HIS INAUGURAL ADDRESS ON APRIL 30, 1789, at Federal Hall in New York City, George Washington faced a young nation with abundant potential. But, as he smiled at the crowd that day, he did so with only one real tooth. Thankfully, his grin was made complete with the help of a trusted confidant: John Greenwood, his favorite dentist.

Those who write about Washington have had much to say about his intellect, work ethic, and physical stature. When it comes to the first president's teeth, however, one historian described them as his "feeblest physical characteristic." While poor dental health was common at the time, Washington's accelerated tooth decay can be attributed to the treatments he received for several diseases. By the age of twenty-six, he had survived smallpox, malaria, pleurisy, and dysentery. Bloodletting and ingesting mercurous chloride were among the prevailing treatments of the day, and the latter leads to significant tooth decay. Washington sought the help of dentist after dentist but didn't regard their work highly. John Greenwood was finally the dentist who changed this.

Greenwood was born in Boston in 1760 and grew up around dentistry. His father, Isaac Greenwood, was the first American-born dentist, and his three brothers followed suit. Silversmith Paul Revere was a childhood neighbor; though better known for his midnight ride, he was also a noted amateur dentist.

At the age of fifteen, Greenwood joined the Revolutionary War as a fife player. In addition to the Battle of Bunker Hill, Greenwood participated in Washington's famed Christmas-night crossing of the Delaware River in 1776 that preceded the decisive American victory at the Battle of Trenton. He remained a soldier until the end of the war in 1783 and settled in New York.

Once in New York, Greenwood opened a machine shop making nautical and mathematical equipment. His technical skill so greatly impressed a physician friend that he asked him to extract a tooth for one of his patients. Though he came from a family of dentists, this is how he first entered the field—with no formal training. In fact, the first American dental school wouldn't open for nearly fifty years. This first extraction was a success, and by 1786 records show that he was running newspaper ads for his own dental practice.

Though he had a nontraditional start to his career, within three years Greenwood would become known as the most prominent dentist in New York, and he soon caught the attention of the president-elect. While his practice did promote preventive dentistry and cleaning, Greenwood's skill and ingenuity as an instrument maker had helped make him the preeminent denture maker of the time.

From 1789 to Washington's death in 1799, Greenwood made four sets of dentures for the president. When compared to modern dentures, they may look barbaric, but these contraptions of lead, gold, hippopotamus tusk, and real teeth (horse, cow, and even human) were pioneering for the time. Contrary to popular myth, Washington's dentures were never made of wood.

Once the US capital moved to Philadelphia, most of Greenwood and Washington's communications regarding new dentures or repairs happened via mail. These letters exhibited cloak-and-dagger secrecy; most used vague language that rarely made specific mention of teeth. Washington was very embarrassed by his condition, and he both demanded and appreciated that Greenwood could practice absolute discretion.

In one of these vaguely worded letters, Washington wrote, "I shall always prefer your services to those of any other in the line of your present profession." When Washington finally lost his last tooth, he gave it to Greenwood. For the dentist, it would forever be a cherished item, protected in a special case.

When Washington died in 1799, he was buried along with a set of his Greenwood dentures. His favorite dentist would continue to practice and innovate for another twenty years.

WRITTEN BY **JOHN LIBRÉ** / ILLUSTRATED BY **PATRICK THEAKER**
www.patricktheaker.com

VLADIMIR NABOKOV'S WIFE

THEIR FIRST MEETING IN 1923 WAS THE STUFF of legend: She wore a black satin mask on a bridge in Berlin and recited his own poetry to him. From that moment, the young writer Vladimir Nabokov felt that Véra Slonim was destined to share his life. In one of the passionate letters of their courtship, he wrote, "It's as if in your soul there is a preprepared spot for every one of my thoughts." For the next fifty-four years, he was nearly inseparable from the brilliant, elegant, and self-effacing woman who became Mrs. Nabokov.

Born in prerevolutionary St. Petersburg to upper-class Jewish parents, the teenaged Véra and her family fled to Germany in 1921. There, she learned to shoot an automatic weapon and was allegedly involved in an assassination plot against a Soviet leader. Fearless and intelligent as she was, she bypassed an intended degree in architectural engineering, instead teaching herself to type and working as a writer and translator—and eventually finding her life's true purpose in her husband.

She believed adamantly in Vladimir's genius and felt it an honor to devote her life to nurturing his art and securing his reputation as the literary giant of his time. With her sharp mind, aesthetic sensitivity, staggering memory, and multilingualism, she was perfectly suited for the role. She and Vladimir shared the unusual neurological condition synesthesia, which enabled both of them to perceive letters and words as colored. People who knew them described the uncommon intimacy of their marriage; some remarked on the nearly psychic connection they seemed to share.

Among her many roles, Véra was amanuensis, translator, chief correspondent, teaching assistant, literary agent, chauffeur, Scrabble partner, and butterfly-catching companion. She was the first reader of all her husband's works, as well as critic, editor, and inspiration. Many suspected she had a hand in the writing itself; some believed Véra was the true author. As he worked, she typed and retyped his manuscripts and organized the thousands of index cards on which he famously took notes. By managing such practicalities, she freed her husband to exercise his creativity unencumbered.

As lifelong designated driver, Véra piloted the couple's many excursions across the United States in pursuit of Vladimir's butterfly specimens. During one such expedition in Arizona, she was so shaken by an encounter with a rattlesnake that she subsequently acquired a pistol—adding the role of bodyguard to her repertoire. It was rumored that she carried the gun in her purse to social gatherings and the lecture hall to protect her husband against assassination. She guarded his writing no less fervently, against bad contracts, poor translators, and sometimes the author himself. She saved the novel *Lolita* from destruction more than once, literally pulling pages from the flames when he tried to set the draft afire.

When, near the end of his life, her husband began to fall, Véra attempted to catch him, injuring her spine in the process—so that she grew humpbacked and, eventually, completely bent. As the great author's obituary proclaimed, "Their dedication to each other was total." Appropriately, the dedication page of every Nabokov novel reads, "To Véra."

WRITTEN BY LAUREN ACAMPORA / ILLUSTRATED BY THOMAS DOYLE
www.thomasdoyle.net

1775 JOHN ORDWAY 1817

LEWIS AND CLARK'S COLLEAGUE

"**I** AM WELL THANK GOD AND IN HIGH SPIRITS," wrote Sergeant John Ordway to his parents on April 8, 1804. As spring approached, Lewis and Clark's Corps of Discovery were preparing to depart their winter camp in southwest Illinois. "We are to ascend the Missouri River with a boat as far as is it is navigable, and then go by land to the western ocean if nothing prevents," Ordway continued, stating that should they succeed, "Great Rewards more than we are promised" would be due. The twenty-nine-year-old Ordway knew that in the pursuit of such rewards, he might lose his life. "For fear of exidants, I wish to inform you that I left 200 Dollars in cash, at Harkensteins . . . and if I should not live to return, my heirs can git that and all the pay due me from the U.S. by applying to the seat of government."

Sudden death in the early nineteenth century was of course a continual, permanent hiccup lurking in the back of any perceived outcome for the future. Put your foot down on the wrong rusty nail, catch a tough strain of the flu, roll the dice poorly with that mild infection, and you'd soon join the rest of your family in the graveyard. It is then astounding to consider that in the two years and eight thousand miles the Corps traveled, they lost only one man, to what was probably a ruptured appendix.

What was to account for this happy result—luck? Preparedness? Good soldiering? A little of all three, and in no small measure, the assistance of a man like Sergeant Ordway. From rooting out sleeping or drunken watchmen (dips into the whiskey barrel were a common problem) to presiding over the court-martial of a soldier who had uttered "expressions of a highly mutinous nature," Ordway was essential in maintaining the discipline of the expedition—which in turn led to their safety from potentially hostile Indians, seemingly invincible grizzly bears, and all the sloppy deaths that can easily occur from accident and poor judgment.

Later, on their return home from the Pacific coast, the captains further showcased their trust in Ordway by choosing him as the sole leader for an expedition through what is now Idaho and Montana. Ordway was to lead ten men down the Missouri, through uncharted, dangerous territory, in what historian Stephen E. Ambrose called "a highly ambitious plan, exceedingly complex," that "showed how confident the captains were about their men."

Ordway the man was integral to the expedition's safety and spirit, but it is in Ordway the writer that his true value to the legacy of Lewis and Clark resides. Ordway had been deputed to "keep the orderly book," providing a daily log of events for the entire journey. And while the captains have been called the "writingest explorers of their time" they felt it necessary to purchase Ordway's journal (for three hundred dollars) after their return to the East. It provided the duo with, as one early scholar noted, the only "complete daily record of the expedition from start to finish written by one man."

Ordway's vision of his day-to-day experiences were folded into the captains' journals, which were edited for publication by Nicholas Biddle in 1814. The sergeant's journal filled in blanks, corroborated timelines, and otherwise enriched a document that has helped enshrine the expedition into a key feature of American mythology.

Ordway's original journal was lost by Biddle and never returned to the sergeant, and Ordway himself also soon vanished into history. After he started a prosperous farm near New Madrid, Missouri, the record goes cold. But there is some speculation on the fate of the sergeant. In 1811, a series of earthquakes ripped through the Missouri River Valley— for a time reversing the course of the river itself—causing widespread destruction. Historians assume that Ordway lost everything. Nature, which had largely spared the Corps of Discovery from anguish, had finally caught up to Sergeant Ordway. Missouri state records from 1818 list him as deceased with no further information known.

And then, a century later, among forgotten stacks of correspondence, the grandchildren of the late Nicholas Biddle discovered a "considerable manuscript contained within loose covers which proved to be the long-lost journal of Serg. John Ordway." The sergeant's account was published in 1916. The man who had done so much to help create a legend was finally able to become part of that legend himself.

WRITTEN BY **JAY SACHER** / ILLUSTRATED BY **JON LAU**
www.jaysacher.com / www.jonlaustudio.com

JULIA WARHOLA

ANDY WARHOL'S MOTHER

ANDY WARHOL, THE MOST RECOGNIZABLE ART star of the twentieth century, had been a sickly child, suffering from scarlet fever and St. Vitus Dance, and his mother kept him home from school at the slightest complaint. His two brothers said he often exploited the specter of his poor health to stay home with her, and she was grateful for the company. Julia placed his bed at the edge of the kitchen so Andy would always be at her side. This sickroom, looking in on his mother's kitchen workshop, became Andy Warhol's first art studio.

Julia Warhola (née Zavacky) was born in Mikova, Czechoslovakia, on November 17, 1892. She married Ondrej Warhola in 1909 and immigrated to the United States in 1921. With no TV or radio, Julia and Andy used nearly constant art-making to cope with the poverty, isolation, and loneliness they experienced as outsiders in urban Pittsburgh.

"I drew pictures, so Andy made pictures when he was a little boy. He liked to do that, sure, he made very nice pictures." Julia said. She exposed Andy to pop-culture imagery and encouraged him to transform it. "I buy him comic books. Cut, cut, cut, nice. Cut out pictures. Oh, he liked pictures from comic books."

Andy greatly respected his mother's creative abilities, frequently citing her direct influence on his work. "The tin flowers she made out of those fruit tins, that's the reason why I did my first tin-can paintings. My mother always had lots of cans around, including the soup cans. She was a wonderful woman and a real good and correct artist."

In his early twenties, Andy moved to New York City to try to make it as a commercial illustrator. He had trouble finding work, so Julia prayed for him every day and, when she could, sent letters with a one- or five-dollar bill enclosed. In the spring of 1952, Julia learned that Andy was nearly destitute. She left her home in Pittsburgh to live with her son in his squalid apartment on East Seventy-fifth Street. They had to share a bedroom, sleeping on mattresses on the floor, but with Julia there to take care of him and the household, Andy was able to spend long hours making art at the kitchen table.

Commercial drawing work picked up for Andy, and mother and son became official collaborators in what seemed to them a natural arrangement. In 1954, amid their growing menagerie of house cats, they created two books together, *25 Cats Name Sam and One Blue Pussy* and *Holy Cats by Andy Warhol's Mother*. Andy loved his mother's calligraphy and asked her to write the titles and even sign his name on many of his pieces. As Andy adopted his talismanic silvery wigs and fey clothing, friends began to comment on how Andy and Julia were growing increasingly similar in appearance.

In a nostalgic nod to coming home for lunch in grammar school (when Julia gave Andy a bowl of Campbell's soup every day), Andy sent Julia to the store to buy cans of Campbell's soup, one of each of the thirty-two varieties, that would become his hallmark imagery. Andy's obsessive representation of American visual icons and celebrity can be read as a desperate attempt to shed the mantle of the foreigner and social outsider that he and his mother shared.

The more the art world took notice of Andy, the more the strain on the codependent mother-son relationship grew. Andy spent more time away and was often embarrassed by his babushka-wearing mother who spoke little English. Fed up with Andy's profligate spending and her increasing loneliness, Julia moved back to Pittsburgh. Andy demanded she return to New York and, upon her arrival, Julia expressed frustration at her lack of recognition by yelling, "*I* am Andy Warhol!"

Despite mounting tensions, Julia continued to influence Andy's work and was featured in some of his films, including a starring role as an aging, bleach-blonde playgirl. Once, when a visiting friend asked Julia if she'd had a good night's sleep, she said, "Oh, no! I stayed up all night watching Andy sleep." This loving gaze is mirrored in Andy's 1963 film *Sleep*, a five-hour, twenty-minute-long shot of his sleeping boyfriend.

Because her health was failing, Andy sent his mother back to Pittsburgh in 1971. Julia Warhola died on November 22, 1972. Her last words to her son Paul were, "Promise me you'll take care of Andy." Andy Warhol, unable to make sense of the loss, did not attend his mother's funeral and did not tell his closest colleagues of her death.

WRITTEN BY **JOHN NIEKRASZ**
JohnNiekrasz.wordpress.com

ILLUSTRATED BY **LESLIE HERMAN**
www.leslieherman.com

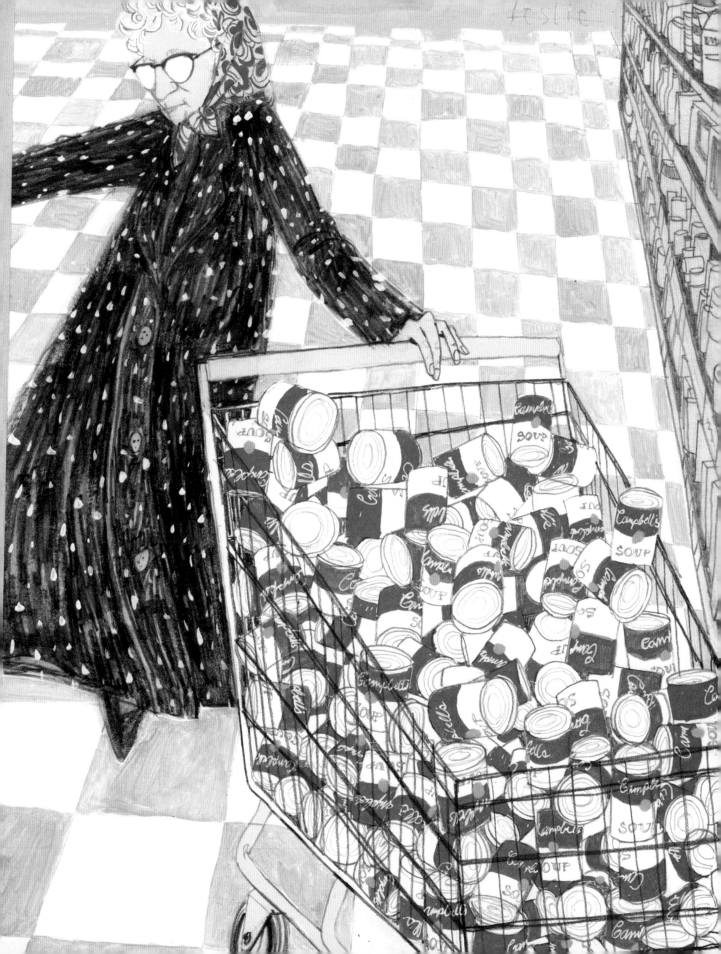

1768 QUEEN KAʻAHUMANU 1832

KAMEHAMEHA I'S WIFE

Of Kamehameha's two possessions, his wife and his kingdom, she was the more beautiful. —S. Kamakau

KAʻAHUMANU WAS BORN IN A CAVE ON THE remote Hana coastline of Maui. Her father, a Hawaiian chief, had hidden his wife to protect their unborn child from his political rival. Following tradition, they named the baby to reflect the circumstances surrounding her birth: *Kaʻahumanu* means "the bird-feather cloak," which was the signature attire of Hawaiian *aliʻi*, or royals—and the symbol of her father's foe. Fifty years later, upon the death of her husband, King Kamehameha, Kaʻahumanu would don his feathered cape and declare herself queen regent, *kuhina nui*, the first ruling woman in Hawaii.

Before her husband unified the kingdom by force in 1810, the islands were sovereign nations ruled by warring *aliʻi*. Political rivalries were fierce, intermarriage was common, and ancestral ties formed powerful allegiances between tribes. Kaʻahumanu's father was an adviser and friend to Kamehameha. He bequeathed his daughter to the future king when she was ten years old. Kamehameha was smitten by her strong character and beauty; they were married when she was thirteen. Later, he would say of his favorite wife, "She is all things; she is undefeatable. Strong in times of crisis, she can also ride the waves like a bird. And she is as lovely as a lauhala blossom." She served as Kamehameha's adviser, encouraging his war to conquer the islands, and she used her royal family connections to help him forge alliances and unite the kingdom. In gratitude, he granted her *puʻuhonua*, the divine power to pardon criminals; her lands became places of refuge, sanctuary from danger. The Hawaiian historian Samuel Kamakau wrote of the couple, "He dealt out death, she saved from death."

Despite her esteemed position, as a woman, Kaʻahumanu was subject to the sacred laws and strict taboos of the Hawaiian religion. The *kapu* system forbade women from eating meals together with men and prohibited them from consuming certain foods such as banana, pork, and coconut. While the king had seventeen wives, adultery by chiefesses was forbidden, and Kamehameha had two of Kaʻahumanu's lovers killed when he discovered the affairs. The queen resented the restrictions placed on her, and she set in motion a repeal of the ancient customs that would transform Hawaii forever.

When King Kamehameha the Great died in 1819, Kaʻahumanu tattooed the date onto her arm in English. Her adopted son, Prince Liholiho, was heir to the throne, and when he arrived at the coronation she greeted him wearing Kamehameha's royal cloak. "We two shall rule the land," she announced in front of the gathered crowd. She persuaded the young king to sit at her table and share a feast, and no gods struck them down. The sacred *kapu* was broken. One year later, the missionaries arrived. Kaʻahumanu embraced Christianity, and with the support of Liholiho, crowned Kamehameha II and ordered the destruction of the temples to the Hawaiian gods. Kaʻahumanu established Hawaii's first civil laws based on the biblical Ten Commandments and negotiated the first treaty with the United States in 1826. By opening the door to Christian rule, the most powerful woman in Hawaii led the way to the ultimate downfall of the kingdom she helped create.

WRITTEN BY **GUINEVERE DE LA MARE** / ILLUSTRATED BY **ELEANOR TAYLOR**
www.guineveredelamare.com / www.eleanortaylor.co.uk

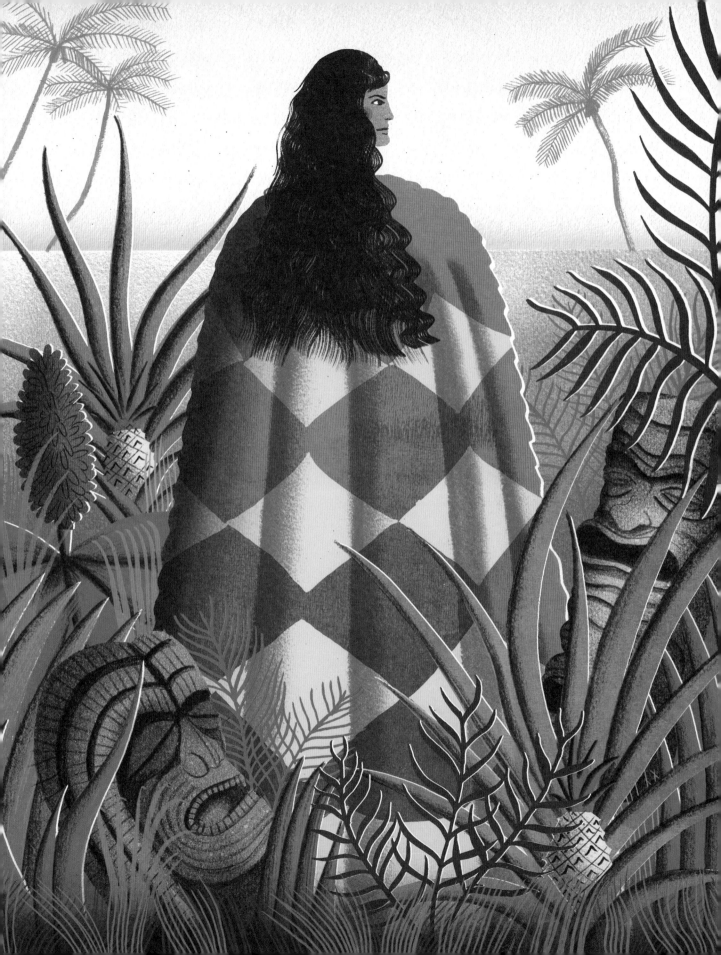

ROLLING STONES' SIXTH MEMBER

"HE LOOKS LIKE A COAL MINER," SAID ANDREW Loog Oldham, the Rolling Stones' newly appointed, image-conscious manager, insisting that the extremely talented pianist Ian Stewart be kicked out of the group.

Stewart, as a founding member, helped shape the group's lineup. The only one with access to a phone, he booked the band's early shows from his shipping-clerk desk at Imperial Chemical Industries, drove the band to gigs in a VW van he bought for that purpose, secured the first recording date, and, as one of the best rhythm-and-blues players in England, provided the backbone to the group's emerging sound.

The other Stones, hungry for fame and a record contract, went along with Oldham's decision to sack their friend, who was several years older, heavyset, paid little attention to his clothing, and had an extended lower chin as the result of a childhood illness.

Keith Richards, recalling Stewart's reaction to going from full-fledged group member to road manager, observed, "I'd probably have said, 'Well, fuck you,' but he said, 'OK, I'll just drive you around.' That takes a big heart."

Initially barred from playing with the band onstage for his lack of a fashionable bad-boy look, Stewart appeared on all but two Rolling Stones albums made during his lifetime, contributing to some of the band's best-known songs. But he would refuse to play on any song, like "Wild Horses," that had minor chords—or, as he called them, "Chinese chords."

Mick Jagger said, "Stu was the one guy we tried to please. We wanted his approval when we were writing or rehearsing a song. We'd want him to like it."

By the late '60s, he would be seen at concerts tuning a guitar one minute, adjusting a speaker the next, and then ambling over to the piano when a song had the type of boogie-woogie beat that he relished.

After taking down the stage after each show, he'd move the piano last, playing it before an empty auditorium with the same abandon he would before a crowd of screaming thousands.

Stewart remained a confidant of the group while disliking their drug use and socialite habits, preferring to visit obscure jazz and blues clubs while touring. He continually vexed the band by booking far-off hotels due to their access to championship golf courses, which he, a Scotsman, would avidly play as the frustrated band found itself too far from the city to locate groupies.

Stewart maintained old friendships and never moved from the neighborhood he lived in before the band was formed. "I don't like rock 'n' roll as a way of life," he said. "I think it's awful. Most of the people who are living on rock 'n' roll are living in a dream world."

"I think Stu looked on us as overpaid and overindulged, and I suppose he was right," said Charlie Watts.

While recording *Dirty Work* with the Stones in 1985, Stewart died of a massive heart attack in a doctor's office waiting room.

"I always thought he'd be the one to shovel the dirt on us all," Richards said.

"He'd have to load the van, pick us up, drive us home at six in the morning. That was his life for years, and I think it took its toll on him. I believe that devotion to the Rolling Stones was the reason for his death," said Bill Wyman.

When inducted to the Rock and Roll Hall of Fame, the Stones requested that Stewart be listed a member.

"To me," said Richards later, "the Rolling Stones is his band. It was his vision."

WRITTEN BY **DANIEL KUGLER**
Torevealourbackstreets.tumblr.com

ILLUSTRATED BY **MATT ROTA**
www.mattrotasart.com

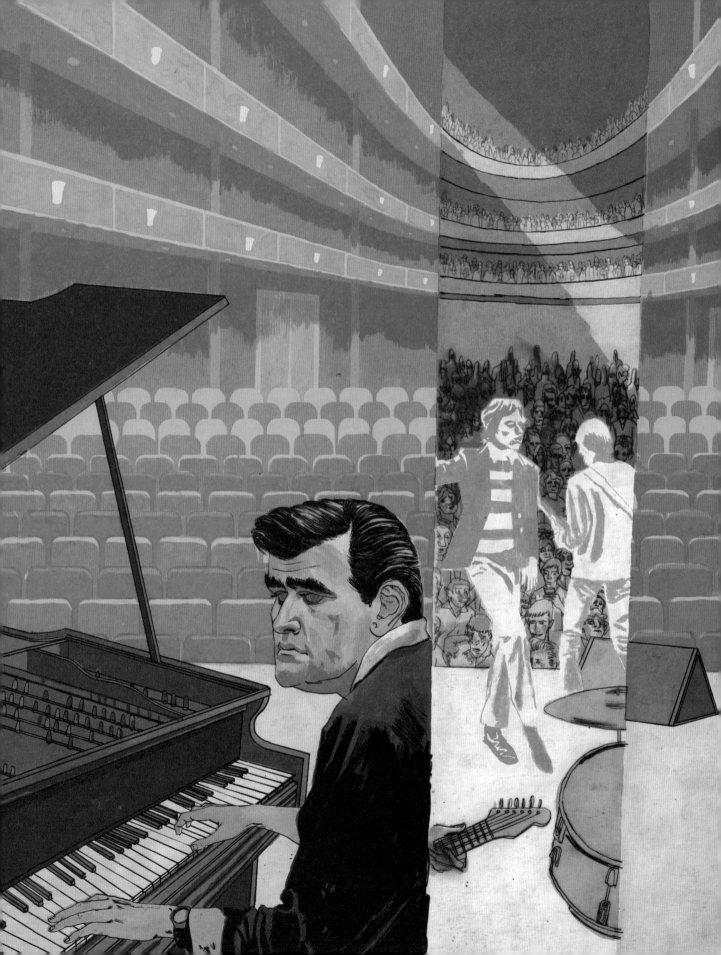

1854 THOMAS A. WATSON 1934

ALEXANDER GRAHAM BELL'S ASSISTANT

MOST OF US KNOW THAT ALEXANDER GRAHAM Bell invented the telephone, but few have heard of Thomas Watson, the assistant who built it. At age sixteen, Watson worked at a machine shop that made keys, relays, sounders, registers, switchboards, galvanometers, and telegraph instruments. His reputation as a diligent, quick worker recommended him to Bell, who first came to the shop looking for someone to make him a harmonic telegraph machine. Although that vision failed, Bell soon shared another idea with Watson: a machine where one could talk by telegraph via a sound-shaped electrical current.

After two years of collaborating in secret, Bell and Watson finally arrived at a satisfactory prototype. The first words uttered over a telephone were "Mr. Watson, come here, I want you." Bell had accidentally spilled some acid on his pants, and only realized Watson had heard him over the line when his assistant burst through the door.

Watson made every part of the first telephone by hand. One of the many rejected models Bell and Watson tested was a telephone made from the internal bones and drum of a human ear. He also invented the call bell, which remained mostly unchanged for the next fifty years (other failed options: the Watson Thumper and the Watson Buzzer, which "caused a howl loud enough to raise the house").

To raise money, Bell often gave lectures and demonstrations of the telephone, with Watson on the other end of the line, shouting, "Good evening!" "How do you do?" "What do you think of the telephone?" Then he would sing songs and play the coronet. "My singing was a hit," wrote Watson. "The telephone covered its defects and gave it a mystical touch." He loved hearing the applause and "was usually encored to the limit of my repertory."

The telephone business quickly expanded, and Watson soon found himself in a managerial position. Bored and dissatisfied with office work, he quit at age twenty-seven. With the money he had earned, he bought his parents a house. For himself he purchased a piano and an ill-tempered horse, who, Watson wrote, "took every opportunity to show his contempt for me."

For the rest of his life he was a vocational peripatetic. He traveled and learned languages. He bought a farm but hated hoeing and haying. He opened a steam engine shop, the Fore River Engine Company, that the navy eventually contracted to build two four-hundred-ton destroyers. Constructing warships for the US government, Watson employed so many men he brought prosperity to Eastern Massachusetts and reestablished it as a major shipping center. At one point his shipyard was the largest in the United States.

Ever the polymath, he went to college at age forty and studied geology and elocution, two lifelong passions (one of the reasons he admired Bell was his superior diction; Bell's father had written several books on elocution and phonetics). A new genus of fossil gastropod was named after him. In what he called his third period of life, Watson devoted himself to cultural studies. At age fifty-six he joined an acting troupe in England, eventually adapting Dickens novels for the stage.

When he returned to America, Watson gave public readings and lectured on the telephone. In 1915, the first transatlantic phone line was installed; President Woodrow Wilson attended the inaugural ceremony. Bell, in New York, made the first transatlantic call to Watson, in San Francisco, ceremoniously repeating his famous line: "Watson, come here, I need you."

Watson replied, "I should be very glad to, Dr. Bell, but we are now so far apart it would take me a week to come instead of a minute."

WRITTEN BY **JESSICA LAMB-SHAPIRO** / ILLUSTRATED BY **YINA KIM**
www.jessicalambshapiro.com / www.yinakim.com

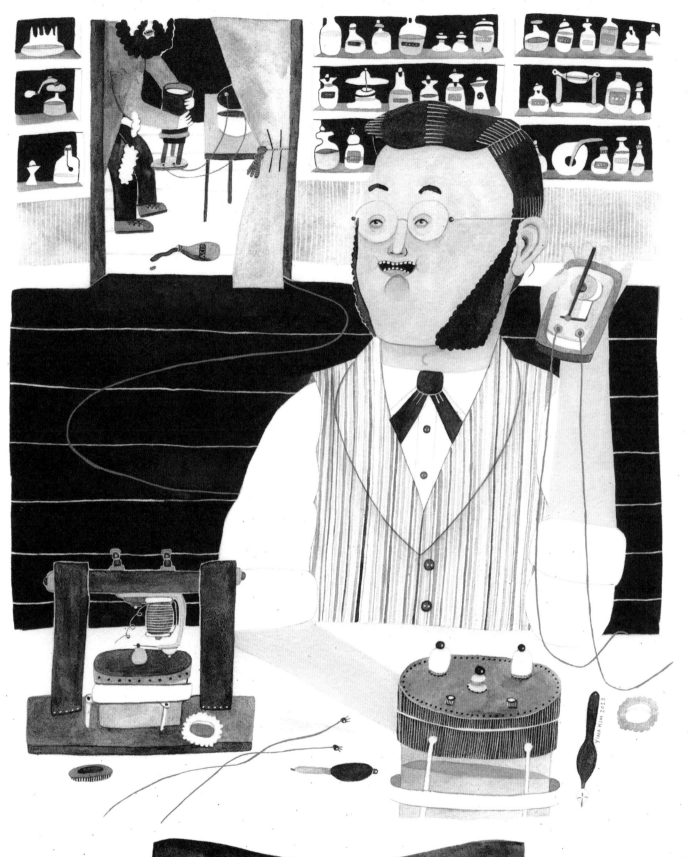

THOMAS A. WATSON
1854-1934

ROALD DAHL'S MOTHER

AN OLD, WRINKLED GRANDMOTHER FILLS OUT every inch of an armchair, chewing with relish on a foul-smelling black cigar, in *The Witches*, one of the many popular children's stories written by Roald Dahl. Smoke encircles her large body as she tells the young main character the "gospel truth" about how to identify witches.

"She was a wonderful story-teller and I was enthralled by everything she told me," the character narrates.

The description purposefully echoes how Roald thought of his own mother, Sofie. He based the grandmother's character on her in a tribute to "undoubtedly the absolute primary influence on my own life," Roald says in *More About Boy*, an expanded version of his memoir of his earlier years.

The Norwegian Sofie married Roald's father, Harald, in 1911, and she moved to Wales to be with him and his two children from a previous marriage. She had three children of her own, two girls and Roald, before her seven-year-old daughter, Astri, died from appendicitis in 1920. Only three weeks later, Harald also passed away from pneumonia, leaving a pregnant Sofie alone to raise her soon-to-be five children.

Rather than return to Norway to live with her parents, she respected her late husband's wishes that she stay in Wales and have her children educated in British schools. And despite her children's mischievous activities while growing up, she was "a rock, a real rock, always on your side whatever you'd done," Roald noted. "It gave me the most tremendous feeling of security." Roald was her favorite child, and although the family called him "Boy," she also called him "Apple."

To entertain the children, Sofie told tales, pulling creative inspiration from folklore from her home country. "When we were young, she told us stories about Norwegian trolls and all the other mythical Norwegian creatures that lived in the dark pine forests, for she was a great teller of tales," Roald wrote in *More About Boy*. "Her memory was prodigious and nothing that ever happened to her in her life was forgotten."

Roald reciprocated this creative storytelling when Sofie enrolled him into boarding school when he was nine years old. He started writing letters to Sofie, telling stories about his life that meant to entertain and amuse.

In one letter in 1929, after Sofie gave him a pair of roller skates for his birthday, Roald tells his mother about skating in his school's yard. "At one time I had eight chaps pulling me with a long rope, at a terrific lick, and I sat down in the middle of it," Roald wrote. "My bottom is all blue now!"

From those very first letters until Sofie died thirty-two years later in 1967, he wrote her at least once a week whenever he was not home, including his time in school, when he worked with the Shell Oil Company in Africa, and when he flew with the Royal Air Force in the Mediterranean during World War II.

Sofie secretly collected every single letter, amounting to more than six hundred from 1925 until 1945, into neat bundles with green tape, according to Roald. Only one term's worth of letters are missing: the fall of 1928, which were damaged in a bombing in 1940. At the bottom of each letter, he signed his love with his given name—all except his first semester at boarding school, when he simply wrote "love from Boy."

WRITTEN BY **JACKIE LEAVITT** / ILLUSTRATED BY **JENSINE ECKWALL**
www.jackie-leavitt.com / www.jensineeckwall.com

1881 CAPTAIN ARTHUR EDWARD "BOY" CAPEL 1919

COCO CHANEL'S LOVER

H E WAS ALWAYS KNOWN AS "BOY," BUT HE MET Coco Chanel when he was coming into his own as a man. It was not yet the second decade of the twentieth century, and Capel was not yet thirty years old, and he was already quite wealthy. He was the son of a shipping merchant and had made his own fortune, taking up polo along the way; he was a tycoon in the making, a proper Englishman running with the upper echelon of Parisian society, including fellow polo player and dear friend Étienne Balsan, the wealthy French textile heir and socialite.

Though perhaps two years younger than Boy, Chanel was a street-smart woman, a feisty and wise person who had been playing the role of Balsan's *coquette* (hence her nickname, *Coco*) since he'd plucked her out of the cabaret circuit in the French city of Moulins. She lived with Balsan in his château in the woods, a sweeping estate engraved with equestrian paths and hunting grounds—luxuries from which she was kept at arm's length. She was, after all, a kept woman, meant to simply wait for whenever Balsan wanted her.

And then Capel met his friend's dark-haired mistress, and he wanted her, too. As Chanel recalled later in life of those years before the Great War: "Two gentlemen were outbidding each other for my hot little body." Instead of choosing, she had them both: Capel as her lover, Balsan as her benefactor.

Chanel was close in age to Boy; she was a Leo, he a Sagittarius—a perfect match. It was infatuation, obsession; he was her muse. She saw things in Capel that drew her to him both physically and quixotically—his look, his style, his flair—and she began adopting some of his sartorial sense as her own. She borrowed his shirts, his blazers, his polo trousers. At the time, she had begun designing hats for some of the ladies running in Balsan's circle, and it was Capel who put her up in a Paris apartment so that she might be better positioned to meet the demands of her growing clientele. Eventually, he helped her open her first hat shop.

It's rumored that Capel proposed to Chanel at some point and she declined, insistent on gaining her own financial independence. And so they carried on as lovers for a decade, with Balsan floating in and out of Chanel's life, and other women in and out of Capel's. Capel eventually married a wealthy English aristocrat in 1918, though Chanel remained a constant in his life. At Christmas the following year, 1919, Capel was riding in the back of his chauffeured Rolls-Royce en route from Paris to Cannes to see Chanel for the holiday, when a tire burst suddenly. The chauffeur was seriously injured; Boy was killed.

Chanel mourned. Years later she confided to a friend, "In losing Capel, I lost everything." She ordered black sheets for her bed. She began wearing black on a daily basis—dresses, little and dark as night—declaring that she would put the whole world in mourning for him. And the world mourned, and the little black dress was born.

The mourning, the black, followed the path of Chanel's increasingly successful career. She couldn't shake the memory. The bottle of Chanel's first perfume—for which she commissioned master perfumer Ernest Beaux—took inspiration for its beveled, rectangular design from Capel's toiletry bottles, which he carried along during their travels together. Or perhaps it was inspired by Capel's whiskey decanter, which she admired for its exquisite glass. When it came time to select the fragrance to go in the bottle, one which Chanel referred to as "a woman's perfume, with the scent of a woman," of all of Beaux's prototypes, she chose No. 5—her favorite number, for good luck. One must imagine that every time she looked at that exquisitely designed bottle thereafter, perhaps dabbing perfume on wrists exposed below the sleeves of her little black dress, she was reminded, once again, of the Boy.

WRITTEN BY **LAUREN VIERA** / ILLUSTRATED BY **SAMANTHA HAHN**
www.laurenviera.com www.samanthahahn.com/blog

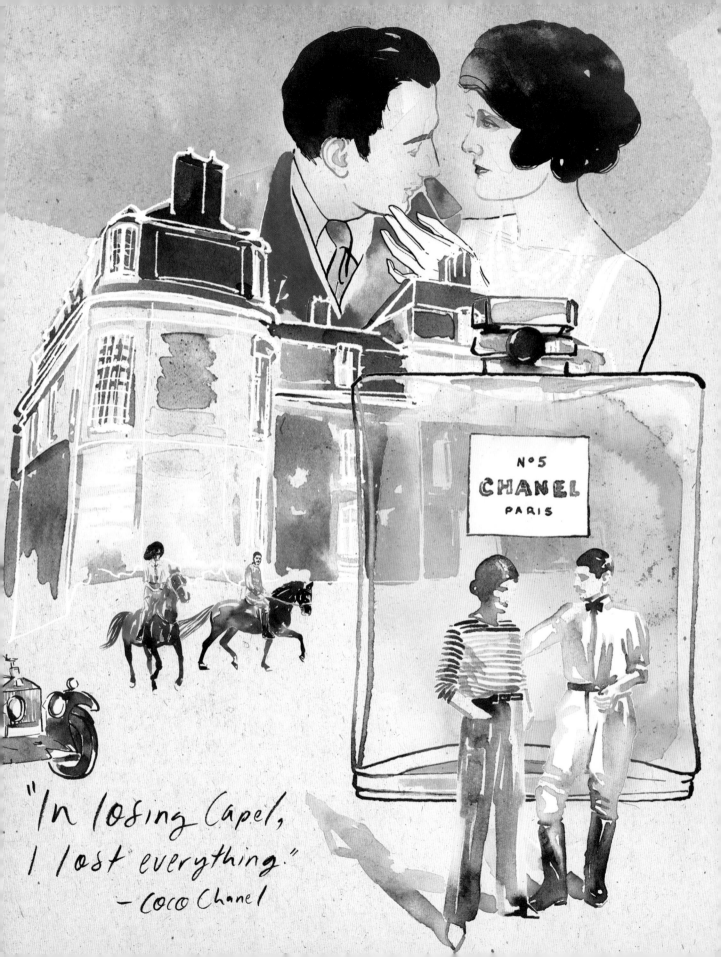

"In losing Capel,
I lost everything."
— Coco Chanel

ALAN TURING'S FRIEND

IN 1930, AN ENGLISH TEENAGER NAMED CHRISTOPHER Morcom died of bovine tuberculosis (from drinking tainted milk years earlier). His death remains memorable because he was the first love of another boy at his school: Alan Turing. Later, Turing would lay the foundation for the computer, lead the British code-breaking team in World War II, and establish the idea of artificial intelligence—any one of which accomplishments would have earned him a place in history.

But when Chris Morcom died, Alan Turing was just a schoolboy with a teenage crush.

Chris was a year older but small and slight, with fair hair. Alan was socially awkward; Chris was at ease. Alan was a terrible conversationalist—before Chris, he'd had no friends at all—but he and Chris shared the language of mathematics and began setting problems for each other and comparing solutions. We don't have Chris's account of the friendship, but Alan wrote that Chris made everyone else seem ordinary. He made a point of sitting with Chris in classes, and though he had no interest in music, he joined the gramophone society, a music appreciation group of which Chris—a piano player—was a member, so they could have more time together.

Alan never spoke of his romantic feelings, but they talked passionately about science and mathematics, and Chris brought a discipline to Turing's work that had never been there before.

Chris's sudden death devastated Alan but made him fixate on a new subject: the relationship between the mind and the brain. He struggled to make sense of the fact that Chris's brilliant mind was gone simply because his physical brain had died. He read anything that would help him understand human consciousness: biology, philosophy, logic.

This line of thinking, about intangible thoughts housed in tangible brains, would run through each of Turing's accomplishments.

In his landmark paper published in 1936, Turing laid the foundation for the "universal machine." Computing devices had been built before, but they were created for specific tasks—their design defined what they could do. Turing conceived of a machine that could calculate anything that was calculable. What it did wouldn't depend on how it was built, but on the program you fed into it. The machine was, in effect, a brain, while the software was the mind, and separating these two things allowed Turing to make a critical breakthrough. The theoretical device became the template for every computer afterward, doing more for the computer age than Steve Jobs or Bill Gates.

During World War II, the Nazis changed their code every day. Each new code took a long time to unravel—no one could decipher the messages fast enough to extract information while it was still useful. But Alan understood that if you took the human thought process and installed it in a faster artificial "brain," you could do the job quickly enough. Again the issue of how thoughts relate to the physical mechanism that processes them was a key to his work. Although his role was largely unknown because of wartime secrecy, Winston Churchill said Turing made the single biggest contribution of any person in the world to Allied victory.

In 1950, Turing published another paper, establishing a new science: artificial intelligence. He was the first scientist to seriously ask, "Can machines think?" and he created a procedure for determining when an artificial system should be considered intelligent. The discipline of artificial intelligence is based entirely on the idea that if thoughts can be embodied in a human brain, then it should be possible to encode thought-like processes in an artificial brain.

The train of thought about human consciousness that began with Turing's love for Chris Morcom, and his grief over Chris's death, contributed to each of these world-changing achievements.

WRITTEN BY **NAS HEDRON** / ILLUSTRATED BY **KEITH NEGLEY**
www.nassauhedron.com / www.keithnegley.com

HARPER LEE'S PATRONS

HARPER LEE MET HER FUTURE PATRON, THE Broadway writer Michael Brown, through their mutual friend Truman Capote. Lee and Capote were neighbors, schoolmates, and close childhood friends in Monroeville, Alabama. When Lee left law school (because she "loathed" it) and moved to New York to focus on writing, Capote asked Brown to look after his shy, twenty-three-year-old friend. From their first meeting in 1949, Lee and Brown got along famously; they had much in common as hyper-literate Southerners trying to make it in the creative arts in New York City.

Brown came from a small town in Texas and served abroad in World War II. He moved to New York and worked odd jobs as he tried to establish himself as a composer and lyricist. His smart, satirical songs about real-life figures and events, such as the disappearance of Judge Crater and the ax murderer Lizzie Borden, drew savvy audiences and he began to find success. Brown fell for the stunning Joy Williams, a ballerina from Balanchine's School of American Ballet, and the two eventually married.

Lee became a welcome fixture in the Browns' home in Manhattan. Their friendship grew warm and strong and she became like a member of the family. "Common interests as well as love drew me to them," Lee said, "and an endless flow of reading material circulated amongst us; we took pleasure in the same theater, films, music, and we laughed at the same things."

And the Browns believed in Lee's talents as a writer. Michael found her work "unusually perceptive." He said, "She was a writer to the depths of her soul . . . she just amazed us."

But the writing life was proving fickle for Lee. To make ends meet, she had to take a job as an airline reservationist. She found great comfort in her friendship with the Browns but longed for more time to write.

By the autumn of 1956, Michael had made good money writing a show for an *Esquire* magazine production. "Here we have this bit of money," Joy Brown said, "so why don't we see if Harper could take some time off?"

On Christmas day, Lee received a note from the Browns that contained a year's wages and read, "You have one year off from your job to write whatever you please. Merry Christmas." The Browns never imagined that their gift would help change the course of American letters and inform the dialogue of the civil rights movement.

Lee made great use of the Browns' generous gift. She quit her job and spent the year diligently writing the first draft of *To Kill a Mockingbird*. Lee's first and only novel bravely challenged racial inequality in America and was met with critical and popular acclaim. *To Kill a Mockingbird* was awarded the Pulitzer Prize in 1961 and went on to sell more than thirty million copies—making it one of the most read and most socially important classics of American literature.

WRITTEN BY **JOHN NIEKRASZ**
JohnNiekrasz.wordpress.com

ILLUSTRATED BY **PIETER VAN EENOGE**
www.pietervaneenoge.be

ALMA REVILLE

ALFRED HITCHCOCK'S WIFE

ALMA REVILLE, WHO BECAME ALFRED HITCHcock's wife and lifelong creative sounding board, was already well established in the world of London film production by the time they met in 1921. She was a film editor, a job she'd learned as a teenager, and he was the lowly designer of "dialogue cards" for silent films. When Hitchcock became assistant director on a 1923 picture, *Woman to Woman,* he hired Reville as editor—it had taken him two years of professional striving to feel comfortable calling her.

Reville worked as assistant director on Hitchcock's directorial debut, *The Pleasure Garden,* wrote the screenplays of *Suspicion* and *Shadow of a Doubt,* and played various roles in classics such as *The 39 Steps* and *The Lady Vanishes.* In *The Lodger,* Hitchcock's take on Jack the Ripper, Reville plays an uncredited role as "Woman Listening to Wireless." Stills reveal her working on the sets of Hitchcock productions across the decades in a long and multifaceted career that included casting advice, script rewrites and polishing, editing suggestions, and even location scouting.

But it is her behind-the-scenes influence on the great director that has intrigued later biographers. Hitchcock lore emphasizes that Reville noticed Janet Leigh swallowing when she was supposed to be dead in the shower scene of *Psycho,* leading to an invaluable fix in the editing room. Lesser known was Reville's role in the negotiations to add the now-famous soundtrack to the shower scene. Hitchcock's initial decision was to leave the shower scene devoid of any soundtrack.

Reville was a literal and metaphorical master of continuity in Hitchcock's productions and in their marriage, which lasted more than fifty years, until Hitchcock's death in 1980. By all accounts, their closeness as creative partners was not matched by physical intimacy—Hitchcock joked that they had slept together only once, to conceive their daughter, Patricia. Persistent rumors of an affair between Reville and writer Whitfield Cook—exaggerated for effect in the biopic *Hitchcock*—tantalize but do not illuminate the deeper creative bonds between husband and wife.

Hitchcock was not secretive about his wife's major role in his moviemaking. On the occasion of his lifetime achievement award from the American Film Institute in 1979, he said:

> I beg to mention by name only four people who have given me the most affection, appreciation, and encouragement . . . and constant collaboration. The first of the four is a film editor; the second is a scriptwriter; the third is the mother of my daughter, Pat; and the fourth is as fine a cook as ever performed miracles in a domestic kitchen. And their names are Alma Reville. Had the beautiful Miss Reville not accepted a lifetime contract—without options—as Mrs. Alfred Hitchcock some fifty-three years ago, Mr. Alfred Hitchcock might be in the this room tonight, not at this table but as one of the slower waiters on the floor. I share this award, as I have my life, with her.

Reville sometimes sounds almost more like a producer than an eternal assistant, but Hitchcock's own use of the phrase "constant collaboration" acknowledges her coauthorship on some of the most memorable passages in film history.

WRITTEN BY **J. M. TYREE** / ILLUSTRATED BY **CUN SHI**
www.nereview.com/j-m-tyree/ / www.cunshiart.com

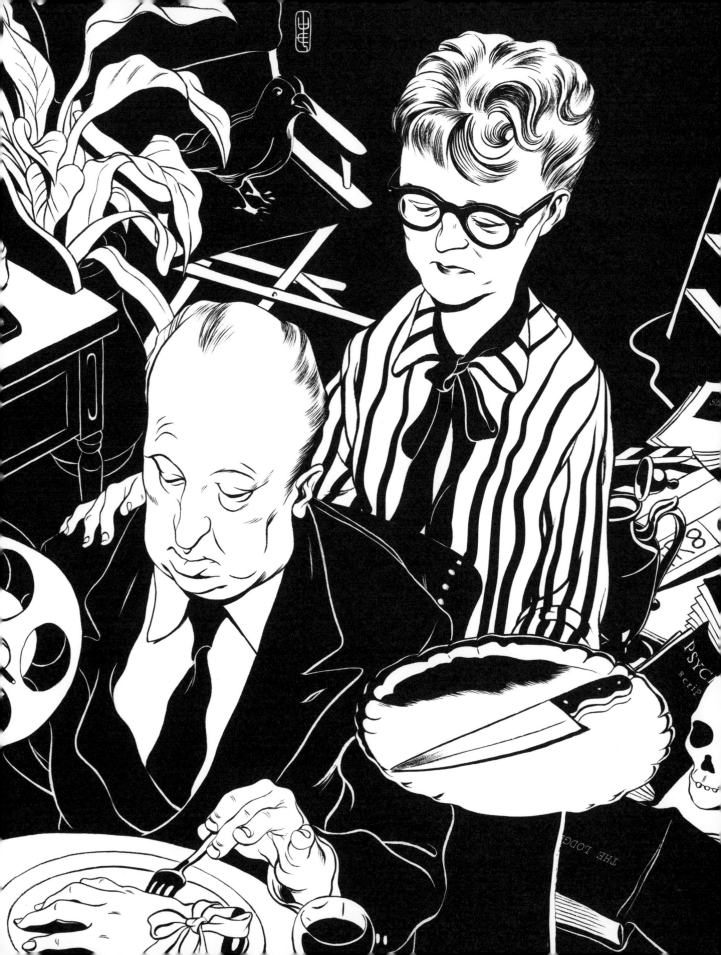

BROWNIE WISE

EARL TUPPER'S PARTNER

EARL TUPPER WAS AN IDEA MAN. HE HAD AN idea for a no-drip ice cream cone, an automatic tie-knotter, and a fish-powered boat. When none of these took off, he became a tree surgeon. When that failed, he took a job at Dow Chemical working with plastics. That's when he had another idea: He got a block of raw polyethylene, bought a molding machine, and—inspired by paint cans—came up with his Wonder Bowl. It had a lid that could be sealed entirely shut, airtight, watertight.

Brownie Wise was a consummate saleswoman, and she found her niche in the mid-1940s working for Stanley Home Products, selling brushes, vacuums, and kitchenware in the homes of housewives. When Wise noticed Tupperware at a department store, she started her own business selling it with the home-party model.

This was 1949. During World War II, many American women had both run their homes and worked outside the home. But with the war's end, a new ethos looked to put them in their place—back at home—and subordinate to their husbands. Wise's insight was to work both sides of this cultural clash. She emphasized women's ability to determine their future—both as salesladies who could earn their own money and as beneficiaries of a sophisticated product that saved time and money. All the while, she helped sell the image of the industrious housewife entrenched in the kitchen.

Earl Tupper had created a great product that he did not know how to sell. Brownie Wise created a way to sell that product that was itself an invention: the Tupperware party. Their partnership was the essence of complementarity: Both were wildly driven and ambitious; one knew how to make new things that were ahead of their time, while the other knew how to use the spirit of the times to sell things. One was the classic dreamer; the other was the classic doer.

They each had a different story about how they met. Wise said she called headquarters and insisted on talking to Tupper directly about insufficient inventory. Tupper said he noticed strong sales in the Detroit area and asked who was responsible.

When they came together—she persuaded him to pull his products from stores and sell them exclusively through home parties—they cocreated Tupperware as a national brand and a cultural phenomenon.

And then the adventure began. Wise went to Florida, where, on the swamps from which Disney World would rise, she built a theme park of her own, a fantasyland for her annual "Jubilees," that was a combination of a sales conference and pep rally. She buried prizes in the fields. She baptized a machine-dug pond with polyethylene beads. She built a wishing well for ladies to drop in their hopes and dreams sealed inside two-inch Tupperware bowls.

In the early 1950s, Tupperware's PR men suggested they make Brownie Wise the face of the company—here was a powerful female executive who could represent a product to women buyers. Tupper resisted, then acceded, and it led to a boom: Wise was the first woman on the cover of *BusinessWeek*. "Brownie Wise became Tupperware and Tupperware became Brownie Wise," Charles McBurney, the company's PR director, said. "They were almost synonymous."

This led to two kinds of trouble. First, Tupper resented her high profile; all the attention to her charisma and her methods undersold, he thought, the real drama of the company: his magic products. Second, Wise herself began, as one associate said, to believe her press releases. She started tussling with Tupper more, taking more prerogatives.

In 1958, Tupper fired her. Though she had built Tupperware and was the face of the company, she was also just a salaried employee. She didn't even have a contract, let alone an equity claim. Tupper at first refused her a severance. He finally conceded to the entreaties of her former colleagues to give her a year's salary.

Brownie Wise tried a number of second acts, with no real success, and lived the rest of her life in Kissimmee, Florida.

Months after he fired the woman who made his company, Tupper sold it for $16 million—about $125 million in today's dollars. He got divorced and bought a private, fourteen-thousand-acre island, and that's where he went to live.

WRITTEN BY **JOSHUA WOLF SHENK** / ILLUSTRATED BY **MARC ASPINALL**
www.shenk.net / www.thetreehousepress.co.uk

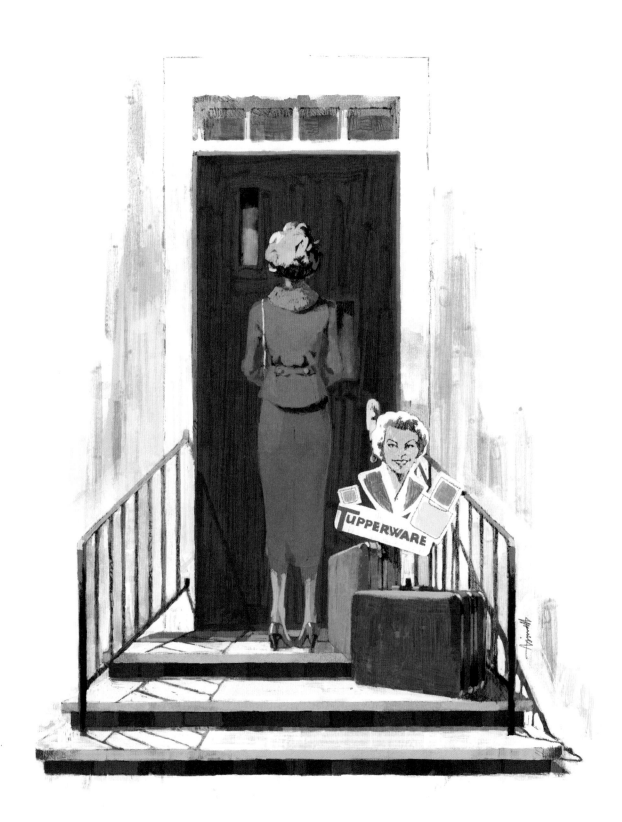

WALT DISNEY'S EMPLOYEE

WARD KIMBALL WORE A BLUE-AND-WHITE-striped train engineer's cap, patterned red neckerchief, and overalls. He yelled, "All aboard!" one last time, and then gave a stern warning to his passengers: "No shooting of buffalo, prairie dogs, children, or other wild game from the chair car windows while the train is in motion." His train—the twenty-two-ton narrow gauge *Emma Nevada*—rolled out of the Grizzly Flats station under full steam.

Journeys on the *Emma Nevada* passed by a windmill, a water tower, and a yellow Victorian train station. From start to finish, it took sixty seconds because Ward's railroad ran on just 650 feet of track from the train shed in his backyard to his front lawn. Ward had the distinction of operating America's first privately owned, full-size backyard railroad. He had purchased the train in 1938 on a whim and then spent the next five years restoring it back to working order. After each run, the train crew would back the train up to its starting position, and repeat, often a dozen times during a steam-up session.

The novelty of a backyard railroad attracted visitors far and wide. One of the repeat visitors to the Grizzly Flats was Ward's boss, Walt Disney. Disney employed Ward as an animator, and Ward was one of the Disney studio's best. Born from Ward's pencil were such memorable characters as the pint-size Jiminy Cricket, the feel-good quintet of crows from *Dumbo,* the villainous feline Lucifer from *Cinderella,* and the Cheshire Cat and Mad Hatter from *Alice in Wonderland.*

Ward was a character himself. When he wasn't donning engineer's gear, he dressed in nauseating colors and clashing patterns of plaid stripes and polka dots. He could be a troublemaker at the studio, like the time he spent an afternoon frightening coworkers by running around the Disney halls in a gorilla costume. Walt accepted this because Ward was Ward, and there was no one else like him. He was, Walt said, "the one man who works for me I call a genius," the first and only time he ever publicly paid such a compliment to one of his artists.

Disney was a workaholic, and he appreciated Ward, who both worked hard and played hard. It was inevitable, then, that Ward's love of railroadiana would rub off on his boss. First, Walt started collecting toy trains. Then, he built a live steam scale-model railroad in his backyard. Ward would visit Walt's place on weekends to help him run the setup for celebrity visitors such as Salvador Dalí.

In 1948, Disney became serious about the idea of building a theme park. His initial concept of "Disneyville" was a modest family amusement center built next door to his Burbank film studio. He wanted to feature trains prominently in his park.

During the development of the park, Ward became Disney's unofficial adviser on all things train. Together, the two men took a one-week vacation to the Chicago Railroad Fair in 1948. Of course, they rode the Santa Fe *Super Chief* from Los Angeles to Chicago.

When Disneyland opened in 1955, a narrow-gauge railroad circled the park. Ward had consulted with Walt and his Imagineers on every aspect of the railroad—from the type of train to the design of the stations to the messages that would be announced by the conductors. The Disneyland train unified the various themed lands sprung from Walt's imagination with the ultimate symbol of escape and freedom. The initial spark of locomotive inspiration came from Disney's "genius" employee who had constructed his personal fantasyland in a backyard.

WRITTEN BY **AMID AMIDI** / ILLUSTRATED BY **ELLEN SURREY**
www.amidamidi.com / www.ellensurrey.com

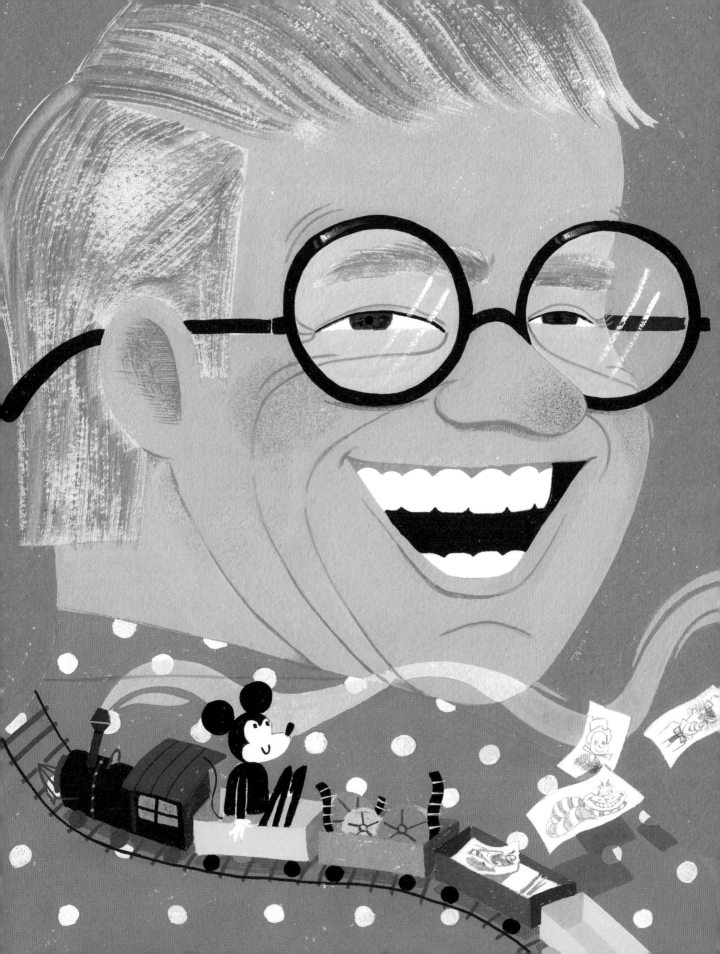

HARRY PIERPONT

JOHN DILLINGER'S MENTOR

JOHN DILLINGER'S LIFE OF CRIME DIDN'T GET off to an auspicious start. By 1924, he was a hard-partying high school dropout who'd deserted the navy, so he drunkenly took part in a botched $50 robbery of a Mooresville, Indiana, grocer. Thinking leniency was in the offing, Dillinger pleaded guilty, only to be handed a ten- to twenty-year sentence. Inside the prison walls, Dillinger made friends with similar interests, the most important of whom would mentor the malleable young crook in the fine art of bank robbery.

Dillinger would go from petty crook to master criminal, learning from the seasoned veteran "Handsome" Harry Pierpont, a quiet leader who brought together Indiana State Prison's finest, a Depression-era "Legion of Doom," bound together through a shared love of stealing money. Pierpont was a disciple of the "father of modern bank robbery," Herman Lamm. The German bank robber preached the importance of precision, of meticulously casing the bank beforehand, understanding its layout, knowing who had access to the vaults, and mapping out multiple escape routes. And, as in all great productions, everything was rehearsed until the ensemble was rock-solid ready. Lamm's system provided the blueprint for the Dillinger gang's epic spree. (Ironic that all of the sophisticated criminal minds met behind bars.)

First, though, they had to bust out. Pierpont was a prisoner's prisoner, respected for his ability to withstand a beating and his dedication to jailbreaks. When Dillinger was paroled in May 1933, one of the great big house escapes in American history was already underway. Pierpont (and the rest of his gang) gave Dillinger a list of the easiest banks and stores to rob and provided him reliable accomplices to aid in their cause: freedom. Dillinger spent that summer raising funds to get his boys out of the hoosegow. He and his new pals on the outside looted tens of thousands of dollars for briberies, a safe house, and guns and ammunition, which were snuck into the prison's shirt factory in a barrel of thread. The guns that Dillinger bought were used by Pierpont and crew to escape on September 26, 1933. Hostages, taken from the factory, slowly walked them across the yard, telling guards at the gates that the prisoners had guns and would shoot to kill. One guard resisted and took a severe beating, but for the most part, the plan came together.

The only rub was that in the days before the prisoners flew the coop, Dillinger had gotten locked up again in Lima, Ohio, so Pierpont simply returned the favor on October 12. In the act of busting Dillinger out, Pierpont and criminal cohort Fat Charley Makley killed Sheriff Jess Sarber. That murder kicked off one of America's wildest crime sprees, a rolling fury of tommy guns and the eight-cylinder Essex Terraplane for speedy getaways, enabling the Dillinger gang to knock off banks, much to the public's delight. A quiet type, Pierpont wasn't a publicity seeker; he let Dillinger become the face of the gang, a.k.a. Public Enemy No. 1.

The gang armed itself by emptying a police arsenal in Peru, Indiana. (Local cops showed two of the gang members, posing as tourists, where the stockpile of weapons was.) Famously, while hitting their first bank in late October, Dillinger refused to take a farmer's cash. The gang's Robin Hood ethos made them folk heroes, and the $75,000 they walked out with made them rich. Pierpont would later say, "I stole from the bankers who stole from the people," a sentiment that went over well in the poverty-stricken times and wouldn't sound out of place at a Tea Party rally or an Occupy Wall Street conclave today. Everyone hates "the man."

After a few successful bank jobs, the crew went to Tucson, Arizona, to hide out. Like a lot of criminals flush with cash, they got careless and were arrested, one by one, in January 1934.

Dillinger had one more escape in him—he successfully brandished a fake wooden gun—but on July 22 he'd be violently rubbed out by the FBI after taking in the film *Manhattan Melodrama* at Chicago's Biograph Theater.

Pierpont and Makley tried a similar trick, using phony pistols carved out of soap and painted black with shoe polish, but they failed. Guards killed Makley; Pierpont survived, barely. He'd already been sentenced to death for Sheriff Sarber's murder, so his paralyzed body had to be carried to the electric chair. No word on whether Pierpont shed a tear for his apprentice. He uttered no last words on October 17 as two thousand volts from "Old Sparky" spread through his body.

WRITTEN BY **PATRICK SAUER** / ILLUSTRATED BY **WESLEY ALLSBROOK**
www.patricksauer.com / www.wesleyallsbrook.com

JOYCE MCLENNAN –

P. D. JAMES'S PERSONAL ASSISTANT

WHEN JOYCE MCLENNAN TAKES A LONDON bus to work, the slender woman with patrician features arrives at the Holland Park home of multi-award-winning English writer P. D. James, the queen of British mystery, creator of detective and poet Adam Dalgliesh. She is also known as Baroness James of Holland Park, OBE, FRSA, FRSL, recipient of seven honorary doctorates and four honorary fellowships, and a life peer in the House of Lords; but, after thirty-seven years of working together, to McLennan the esteemed author is simply "Phyllis." McLennan was hired after the publication of James's seventh novel.

McLennan's intelligence and organization complement her natural kindness. James notes in her autobiography, *Time to Be in Earnest*, that McLennan is "unfailingly good-tempered," a quality James could count on as her popularity rose and, with it, the demands on her time: "She is high among the small group of friends on whom I can rely to keep me sane." Their process evolved from McLennan's original job as part-time typist, working from home and raising two young children. Then, James would dictate a tape from her handwritten notes. McLennan or her husband, Mike, who worked for James's publisher, Faber & Faber, would often pick up the tape, sometimes hidden at James's side gate in a large china pig. Today, McLennan transcribes into a computer and prints pages for James to edit, leaving the famed mystery author to concentrate on research, plotting, and writing.

The increasing time needed to attend to the business side of being a successful author found James and McLennan tackling the mail together, which soon spread to modern e-mails and includes requests for photos, autographs, signed books for charity auctions, interviews, and advice. When James traveled, McLennan would deal with incoming mail and day-to-day matters in her absence, leading James to say: "What would I ever do without her?" In recent years she has taken to accompanying James on longer trips.

Working alongside a popular figure serving on various committees, McLennan's support sees the baroness through all of these activities, from chairing the Booker Prize panel of judges to a sixteen-year tenancy as president of the Society of Authors. After James's appointment to the Church of England's Liturgical Commission, McLennan's humor showed in her response to its bulging paperwork. She created a file labeled "God."

McLennan has remained an unobtrusive ally to James, someone UK journalist Kate Kellaway terms "secretary, friend and all-round prop." James hints at the closeness of their relationship in her author's note from 2001's *Death in Holy Orders*: "I am particularly grateful to my secretary, Mrs. Joyce McLennan, whose help with this novel went far beyond her skill with a computer."

Both genteel women appear a most unlikely duo to be so steeped in murder and betrayal. Yet the work ethic to produce complex mysteries persists, and when James recuperated from cardiac issues in a private Oxford hospital, McLennan traveled from London twice a week to help finish work on the most recent Dalgliesh novel, *The Private Patient*. James is known for her sense of setting and the psychological depths she brings to her mysteries, as well as her strong descriptions, as in this excerpt from that same novel: "There was only the crack of the smashed bottle, like a pistol shot, the stink of whisky, a moment of searing pain which passed almost as soon as she felt it and the warm blood flowing from her cheek, dripping onto the seat of the chair, her mother's anguished cry."

McLennan's calm, steadfast backing has allowed the author to continue writing into her nineties, yet she is rarely photographed or interviewed. A native of Pinner in the Middlesex area, McLennan is now a widow, and with her boys grown and out on their own, she shares her home in the west London suburb of Ealing with two cats, Tyler and Rafferty.

After decades of Joyce McLennan's service as James's trusted aide, it should come as no surprise that when James combined her two lifelong enthusiasms—writing detective fiction and the novels of Jane Austen—to create her sequel to Austen's *Pride and Prejudice*, she chose this fitting dedication for 2011's *Death Comes to Pemberley*:

> To Joyce McLennan
> Friend and personal assistant who has typed
> my novels for thirty-five years
> With affection and gratitude

WRITTEN BY **MARNI GRAFF** / ILLUSTRATED BY **JULIA ROTHMAN**
www.auntiemwrites.com / www.juliarothman.com

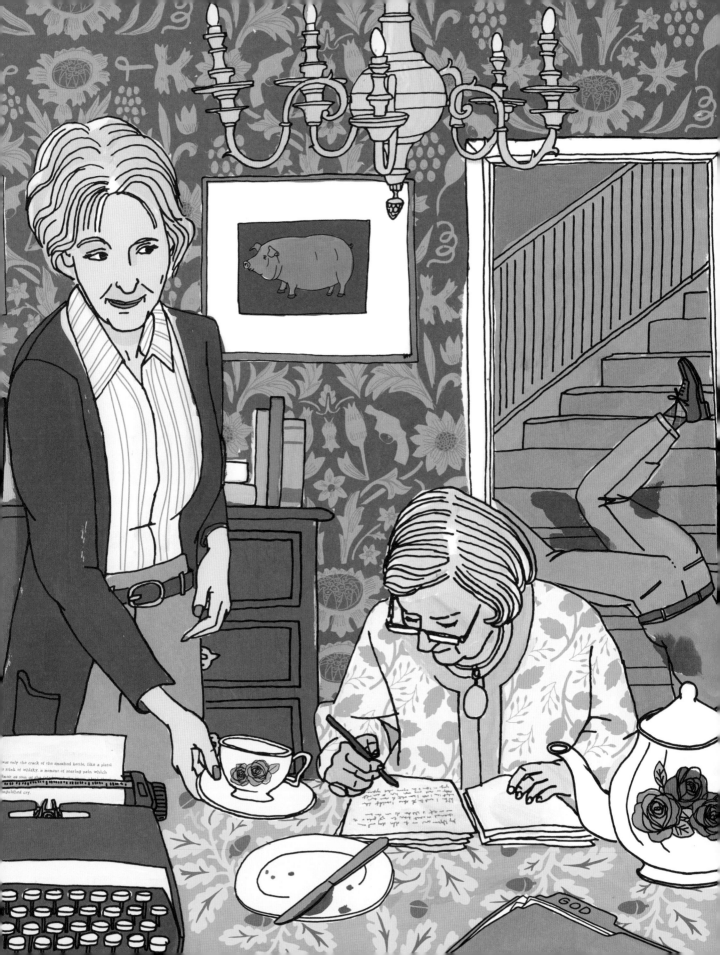

GIUSEPPE VERDI'S WIFE AND MUSE

THE HEROINE OF GIUSEPPE VERDI'S MOST beloved opera, *La traviata* ("The Fallen Woman"), is a courtesan named Violetta. She eventually dies of tuberculosis, though not before finding true love. Speculators have long wondered if Violetta, whose most famous aria, "Sempre libera," celebrates the freedom of living outside the mores of society, was created as a tribute of sorts to Verdi's wife, the retired soprano Giuseppina Strepponi. In fact, Verdi had based his libretto on a play by Alexandre Dumas, *fils*, which he and Strepponi saw in Paris.

But, wow, Strepponi's life would make a terrific contemporary opera! I'd focus act I (were I hired to write the libretto) on her early years: the daughter of a composer who enters the conservatory in Milano at fifteen and becomes one of the finest singers of her generation, performing works by Bellini and Donizetti at a time when Italian opera houses, according to Verdi biographer John Rosselli, hungered for new content as voraciously as Hollywood studios do today. All of this allowed Strepponi, after the death of her father, to become a rare woman for her day—which is to say, a wholly independent one. She supported her mother and siblings at the cost of her own health, maintaining a truly brutal work schedule of up to six performances per week, such that she'd destroyed her voice by age thirty. (We'd have to figure out a way, in our opera, for our Strepponi's vocal chords to sound ravaged from this point forward without entirely repelling the audience.) Oh, and also: She's quite often secretly pregnant. Performers at the time (again, Rosselli) found themselves placed on the social spectrum somewhere between middle-class respectability and high-class prostitution. They remained *sempre libera*, but when Strepponi's romances with the impresario Camillo Cirelli and (most likely) a fellow singer resulted in three live births (and one suspected stillbirth), well, luckily, her mother country had yet to invent the *paparazzo*. The children all went to foster homes and orphanages, rarely seen again by their mother.

Who, nonetheless, seemed tortured by the fact that she would never have children with Verdi, her true love—act II!—in whose career she played so crucial an early role, when she agreed to be *prima donna* of the struggling young composer's opera about Hebrew slaves, *Nabucco*. Verdi's previous opera, his second, had flopped, and then his first wife had died (tragically young), and he'd subsequently vowed never to write again. But then he did, and Strepponi's star power persuaded Bartolomeo Merelli, who ran La Scala, to greenlight the production, effectively launching Verdi's career. The romance between Verdi and Strepponi didn't start until years later (creating a nice tension for the purposes of our opera), in Paris, Strepponi by that point retired and teaching.

They "drink from the joyful cup" (to quote another *La traviata* number, "*Libiamo ne' lieti calici*"): Strepponi is positively worshipful of Verdi, her "dear *Mage*." She sings (and critiques) his melodies as he works—a handwritten love duet from Verdi's *Jérusalem* features alternating lines in his hand and hers—and leaves behind a paper trail of wonderful letters that could be mined for lyrics in our production. (One small example, before a trip to St. Petersburg: "It will require perfect tagliatelle and maccheroni to keep him [Verdi] in good humor amid the ice and furs.")

Act III, alas, given the conventions of the genre, requires a tragic turn: nostalgic Giuseppe's insistence on moving back to his family estate in Busseto, a small town in Parma which Giuseppina hated, and where she found herself shunned by the villagers—she and Verdi had not yet married—but she's stuck there, while the old man, increasingly famous and in demand, travels the globe, eventually striking up an affair with a much younger German soprano, Teresa Stolz, who plays *Aida*. This one isn't kept out of the tabloids. Still, Strepponi remains by her husband's side—the trio occasionally traveling together!—until her death at age eighty-two. Verdi hung on for another four years.

On second thought, maybe in my opera, the performer who plays Strepponi will retain a perfect voice until the very end.

WRITTEN BY **MARK BINELLI** / ILLUSTRATED BY **JULEE YOO**
www.markbinelli.com / www.ju-leeyoo.com

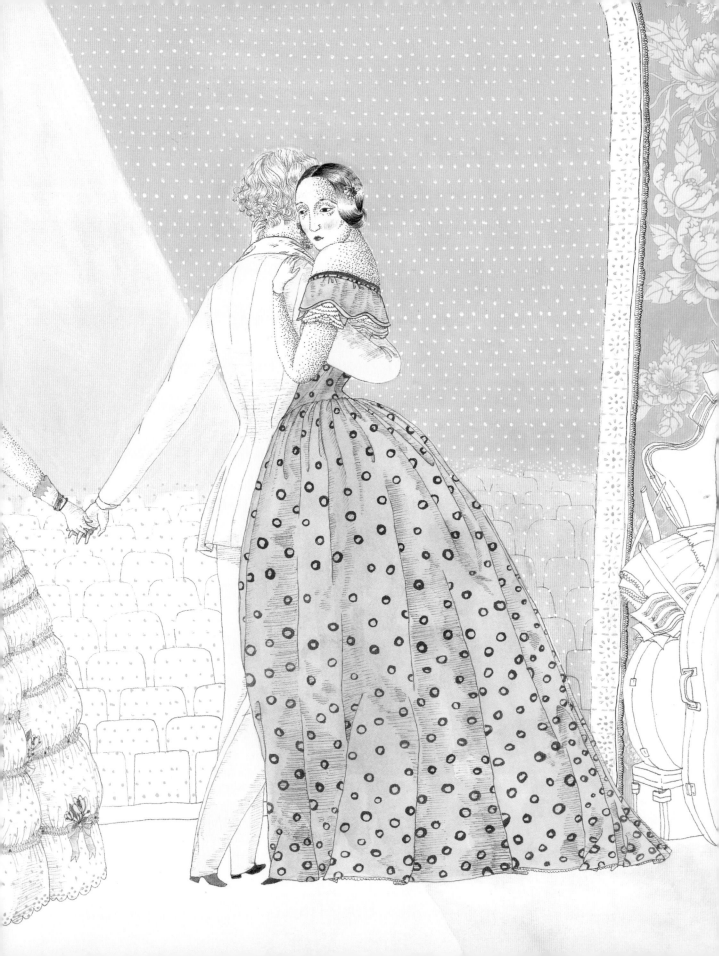

HIROSHI ARAKAWA –

SADAHARU OH'S COACH

HIROSHI ARAKAWA, FORMER PROFESSIONAL baseball player and hitting coach for the renowned Tokyo Giants, must have slouched smaller than his five-foot, four-inch frame on the night he sent his first baseman, Sadaharu Oh, off to make his way home in the rain. The teacher had failed to unlock the potential in the student, and the student had failed to learn from the teacher. Oh was three years into a professional career that fell short of expectations he had set as a high school hero. In 1962, in his fourth year, home runs came rarely and his batting average was mediocre. Fans around the league called him *Sanshin Oh*, "King of Strikeouts" (*Oh* being Japanese for "king").

Despite thousands of hours of practice and study with Arakawa, Oh could not hit with consistency. Earlier that night he had struck out and was immediately benched. The teacher and the student parted ways after a silent car ride to Arakawa's house, and the young man who would become the Japanese Babe Ruth stood alone in the rain, soaked and unable to persuade a cab to give him a ride.

Arakawa and Oh first met when the former, already a pro, paused while walking his dog to watch Oh and his friends play pickup ball. "You look left-handed," he told the fourteen-year-old, who hit righty out of a sense of propriety. Oh turned around to his natural side and rang a double. He would see Arakawa only sporadically for years before they were reunited as professional and coach.

Arakawa was no power hitter himself, with just sixteen homers from 1953 to 1961. What he lacked in ability he made up for with insatiable curiosity, applying knowledge from all around him to hitting. Throughout his apprenticeship, Oh eagerly absorbed each teaching that Arakawa presented him, from Zen Buddhism, Japanese Noh theater, and Kabuki theater to the martial art of aikido.

On Arakawa's first visit to the dojo of aikido master and founder Ueshiba Morihei Sensei, someone mentioned that he was a ballplayer. The wispy-whiskered old master asked,

"Why don't you just cut through the ball with a sword?" Then he flung Arakawa around the dojo. Arakawa became a dedicated student.

While Oh was denied the opportunity to practice aikido due to injury risk, Arakawa agreed to be his surrogate, teaching what he learned of the coordination of mind, body, and skill. Oh would sit along the edge of the mat while his teacher was beaten and manhandled. "Even as I watched him get battered," Oh wrote, "my sense of belief and trust in Arakawa-san grew." Arakawa taught while they drove from dojo to stadium. They discussed every element of hitting, day and night.

The year had progressed, and Oh still could not coordinate the elements of his swing. Now more than three years into his career, he was a collection of machine parts working against themselves.

"You are beyond baseball," Arakawa told Oh. Waiting in the rain, Oh imagined a life beyond the sport, working in his parents' noodle restaurant. He collapsed in bed that night, relieved that a rainout would likely free him from the next day's inevitable failure.

"The sun on the sidewalk was like the first sun of the world." So began the day after the rain for Sadaharu Oh, the day of the flamingo batting stance. Exhausted, out of ideas, Arakawa made a proclamation: Oh would stand on one leg. It was a technique they had flirted with earlier in their studies. Oh would balance on one leg while he waited for the pitch. "I order you to do it," said the teacher, graciously relieving his troubled student of a choice in the matter.

"I approached the plate, stepped up into the batter's box, and then assumed my pose," wrote Oh. "I flicked out my bat and hit a clean single into center field." Two innings later, he raised his leg again and hit a home run. From that point forward, Arakawa and Oh worked together to deepen their understanding of "what it is to hit on one foot."

"Arakawa-san will always be my teacher," wrote the King of Strikeouts near the end of a career that featured nine MVP awards, many championships, and 868 home runs.

WRITTEN BY **TED WALKER**
www.tedwalker.net

ILLUSTRATED BY **PAUL WINDLE**
www.paulwindle.com

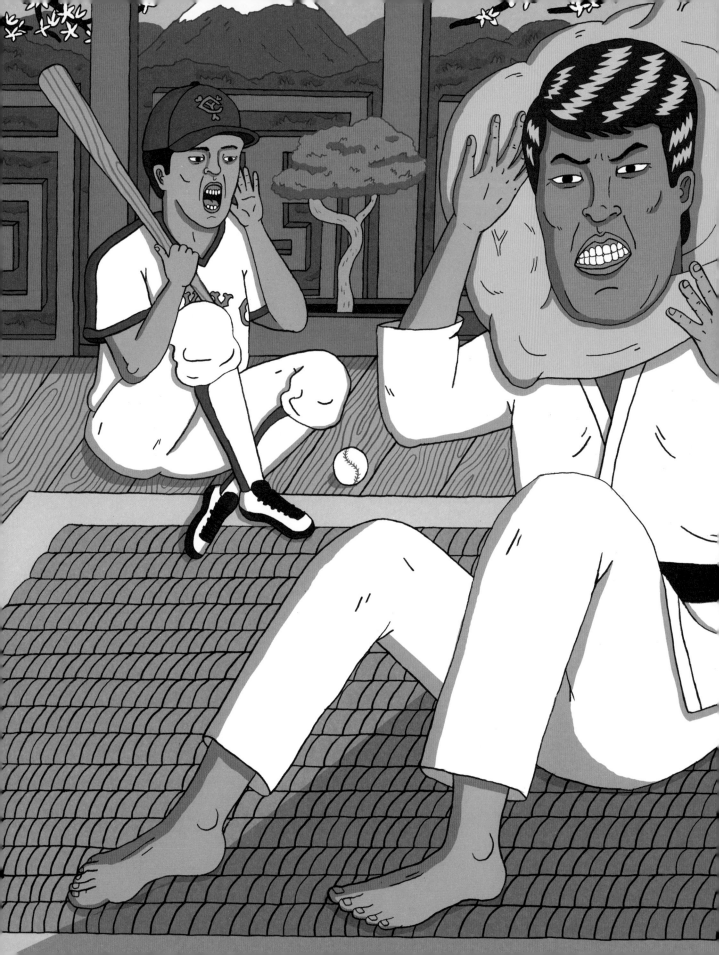

JERRY SIEGEL'S FATHER

MICHEL SIEGEL WAS NEVER QUITE SURE what to make of Jerome.

While Michel's other five children were either making career plans or finding husbands, each according to their gender, it seemed Jerry, his youngest, always had his head in the clouds.

And 1932 was a time for practical men, not for dreamers. Michel sold secondhand suits from his shop on the East Side of Cleveland, in a building he owned. He was proud of his accomplishments. He only wished seventeen-year-old Jerry would exhibit enough interest to someday inherit the business.

Jerry's elder siblings had helped their father in the store, but despite his energy, Jerry wasn't industrious, at least not in a way Michel could understand. He preferred to stay at home reading in the bedroom he shared with his brother, or to haunt nearby movie theaters or the office of his high school newspaper.

On the other hand, the Siegel family was American now; Jerome and three of his siblings even had been born here. So perhaps young Jerry could be pardoned for doing as Americans did, for spending his time in the single-minded pursuit of the trivial. Jerry wrote poetry and humor for the school paper. He submitted manuscripts and fan letters—endlessly, it seemed—to science fiction pulp magazines. He even painstakingly produced copies of his own amateur publication packed with tales of life in the future, running alongside meticulous illustrations courtesy of his school friend Joe.

So perhaps, in a way, producing a child who had the luxury of indulging his imagination was the reward for a life of hardship.

And it had been hard. The son of a tailor, Michel was born in 1872 in a small city in a mostly Jewish portion of Lithuania. He served for a time as a conscript in the Russian army before emigrating to the United States, to Ohio. Here he continued his Old World trade, that of sign painter (an artistic vocation that gave him some sympathy for Jerome's dreamy demeanor), before transitioning into the garment business. Michel Siegel had been a good sign painter, and he was a good tailor, a good businessman. He was a good father.

In service to immigration, pronunciation, and simplicity, the man had, in his time, answered to Mikhel, Michael, Mitchell, and Michel. His family had been Segaliovich and Sigel and Siegel, a common story in this city where ethnicities and races met, where immigrants lived alongside natural-born Americans.

These were the sorts of thoughts that filled Michel Siegel's mind until the evening of June 2, 1932, the day a man entered the store with two companions, handled a suit as if to consider purchasing it, and fled with the suit without paying.

In response, Michel became "excited," according to a police report filed later. Five minutes after the theft, Michel Siegel had a heart attack. He fell. He died, there in his shop. The funeral was three days later. The thieves were never caught.

Boys idolize their fathers. Boys think their dads are constant. Michel Siegel was an immigrant, a man who went by several names and, in the act of losing a suit, shattered his son's world and proved his own mortality.

Soon after his death, Michel's son Jerry enlisted his artist friend Joe, and the two of them created Superman, an immigrant on a cosmic scale, a man who goes by several names, hails from a world that is quite literally shattered, and uses a suit to disguise the fact that he is invulnerable.

Yes, the boy spent much of his time with his head in the clouds. And inspired by heartbreak, Jerry Siegel invented a man who could live there.

WRITTEN BY **AARON RAGAN-FORE** / ILLUSTRATED BY **CLAY RODERY**
www.clayrodery.com

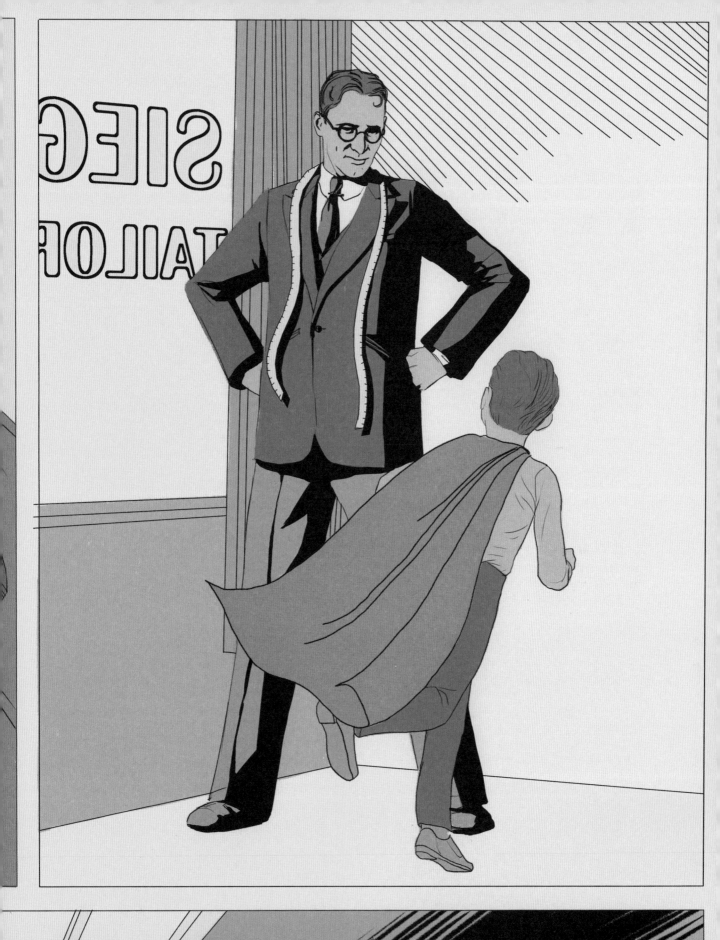

1912 SAM SHAW 1999

MARILYN MONROE'S PHOTOGRAPHER

IN 1951, SAM SHAW WAS HIRED TO PHOTOGRAPH THE film *Viva Zapata!* Since Shaw never had a driver's license, the film's director Elia Kazan asked a little-known actress named Marilyn Monroe to drive the photographer to and from the set each day. It was the beginning of a lifelong friendship and professional collaboration between the actress and photographer, which culminated in some of the most iconic photographs of the twentieth century.

By the time Shaw met Monroe, he had already transitioned from his start as a courtroom artist into an art director for picture magazines, then a photojournalist for those same magazines, and finally settled into photographing films often featured in weekly publications. By the early 1950s, Shaw had built a reputation as a talented movie photographer specializing in promoting films through the still photograph. His shots of Marlon Brando in a ripped T-shirt became the symbol of the film adaptation of Tennessee Williams's *A Streetcar Named Desire.*

In 1954, the by-then-famous Marilyn Monroe was cast in what became one of her most memorable film roles as the Girl in *The Seven Year Itch.* As the film's photographer, Shaw photographed his friend Monroe throughout the making of the movie, both behind the scenes and on set. Reading the script, Shaw was especially attracted to the photogenic potential of one scene, where the Girl character and her costar, Tom Ewell, are exiting a movie theater on a hot summer night. When a draft from the subway passes beneath them, the Girl says, "Oh, do you feel the breeze from the subway. Isn't it delicious?"

The scene reminded Shaw of a photo series he created in 1941 for a story in the left-leaning magazine *Friday.* The article featured images of navy men enjoying their day off at the Coney Island boardwalk. Usually the magazine's covers illustrated working-class issues of the period, but Shaw encouraged the editors to use a playful photograph of a sailor and a young woman inside a rotating tunnel, the wind from the spiraling tunnel slightly lifting her skirt. As soon as the publication went to press, all copies sold out.

Thirteen years later, Shaw wanted to retest the success of the "tunnel" image with Monroe in *The Seven Year Itch.* A publicity event was staged on Lexington Avenue. A large crowd of fans and press gathered to glimpse Monroe and Ewell perform the scene. Bystanders cheered for Monroe in her white billowing dress, take after take. The crowd was so loud that director Billy Wilder was unable to use the footage, and Shaw had to reshoot the scene on a closed soundstage in Los Angeles.

The noise in New York didn't keep Shaw from getting his shot. Standing over a breeze from the subway grate below, Monroe turned to her friend, calling out her nickname for him, based on Humphrey Bogart's character in *The Maltese Falcon.* "Hi, Sam Spade" she said, and Shaw captured Monroe's image. The photo was front-page news the next day in New York, Berlin, London, Paris, Rome, and Tokyo. In a reference to the famous Ralph Waldo Emerson line (the "shot heard 'round the world") that came to represent several historical events, Shaw's "flying-skirt" photograph was quickly dubbed "the shot seen 'round the world."

Shaw's iconic photographs solidified Monroe's legendary status worldwide. Nearly sixty years later, a new generation of fans and scholars alike are equally entranced with Marilyn as a symbol of postwar hope and sexual freedom, all captured in her powerfully playful flying-skirt pose. As Shaw later reflected, "The major reason for her myth becoming larger and larger every day, for the legend growing on such a gigantic scale, is not the tragedy of her life. It's the joy of the girl. She presented the joyous moment of a vibrant woman. More important, she represents the freedom, which kids have today. Only she was fifteen or twenty years ahead of the times, so she paid the price for her freedom." Ironically, the skirt-blowing photographs were the only staged shots Shaw ever took of Monroe. The rest of his more intimate portraits of her were an attempt "to show this fascinating woman, with her guard down, at work, at ease offstage, during joyous moments in her life, and as she often was—alone."

WRITTEN BY **MELISSA STEVENS**
www.shawfamilyarchives.com

ILLUSTRATED BY **JULIANNA BRION**
www.juliannabrion.com

1877 GODFREY HAROLD (G. H.) HARDY 1947

SRINIVASA RAMANUJAN'S DISCOVERER AND COLLABORATOR

IN HIS SEMINAL WORK, *A Mathematician's Apology* (1940), G. H. Hardy writes, "No mathematician should ever allow himself to forget that mathematics, more than any other art or science, is a young man's game." Hardy lived to the age of seventy-seven and published his apology at the age of seventy. He had left behind not only his youth, but also what he considered to be his greatest contribution to the field of mathematics nearly thirty years before.

From 1909, when he received his MA in mathematics, until 1913, Hardy was a relatively well-known mathematician lecturing at Cambridge and championing "pure mathematics"—that is, mathematics without practical application. (In spite of his desire for pure mathematics, his work has, in fact, been applied widely in physics, nuclear physics, and genetics, among other scientific fields.)

Then, in 1913, Hardy received nine pages of notes on mathematics from an Indian clerk, Srinivasa Ramanujan. Reading through these, he assumed the manuscripts were a fraud. It is unclear whether he thought the mathematics were a fraud, or the mathematician. Quite possibly both, as both were foreign to him.

True, some of the theorems Ramanujan included in his manuscripts had already been proved by other English mathematicians, and slightly more elegantly than Ramanujan, but reading through Ramanujan's theorems on continued fractions, contained in the last pages of his manuscript, Hardy felt undone by the ingenuity of the foreigner's work and decided that these could not be a fraud; they must be true because "if they were not true, no one would have the imagination to invent them."

Hardy then worked to bring Ramanujan to Cambridge to conduct research and continue his study. He was amazed by the mathematician's intuitive mathematical genius, as well as the unlikelihood of its existence. Ramanujan, born to poverty and lacking a university education, derived much of his foundation in mathematical analysis, infinite series, continued fractions, and number theories by the serious study of a book he borrowed from a friend, who had it on loan from the library: *A Synopsis of Elementary Results in Pure and Applied Mathematics* (George Carr), little more than a collection of more than five thousand theorems intended as an aid to students preparing for college exit exams.

Ramanujan, after some wrangling, came to England, gave lectures, demonstrated his mathematics, guided along by Hardy, and astounded the English society of mathematicians. Together, in 1918, Hardy and Ramanujan developed their best-known work, the Hardy-Ramanujan asymptotic formula, dealing with integer partitions, which was then used by Niels Bohr to find quantum partition functions of atomic nuclei, advancing the field of nuclear physics. Then, two years later, at age thirty-two, Ramanujan died—possibly due to a parasitic infection of the liver. Though their partnership lasted only seven years, Hardy was, afterward, known first and foremost less as a brilliant mathematician than as the man who had discovered a brilliant mathematician.

WRITTEN BY **MANUEL GONZALES** / ILLUSTRATED BY **AVITAL MANOR**
www.avitalmanor.com

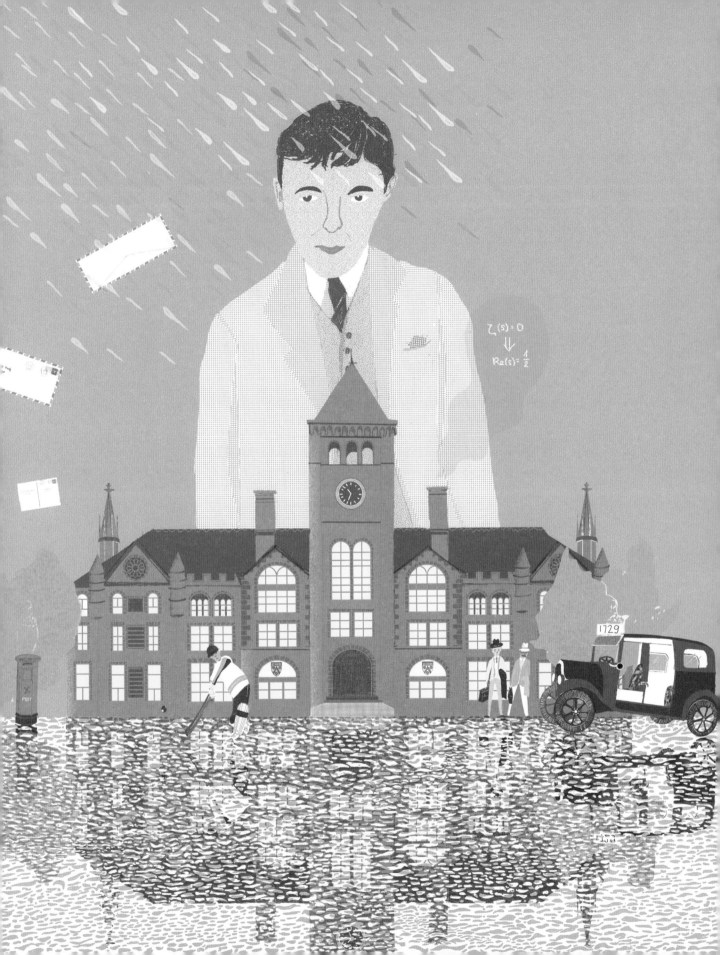

$$\zeta(s) = 0$$
$$\Downarrow$$
$$\mathrm{Re}(s) = \tfrac{1}{2}$$

1729

1872 EDITH BOLLING WILSON 1961

WOODROW WILSON'S WIFE

ON OCTOBER 2, 1919, PRESIDENT WOODROW Wilson suffered a massive stroke. It wasn't the first time, but it was the worst. He was found on the bathroom floor, bloody and unconscious. Wilson lived, but his entire left side was paralyzed and he was severely incapacitated. Somebody had to take charge, so a "secret president" stepped up and seized the White House reins.

After her husband's stroke, Edith Bolling Wilson decided she would be the sole conduit to the president of the United States. She limited face-to-face availability to herself, White House doctor Cary T. Grayson, and the president's personal secretary, Joseph Tumulty. Edith received everything sent to the president, deciding what warranted his attention (a little), and what could be kicked to the governmental curb (a lot). In *My Memoir,* Edith claimed she made no important decisions regarding public affairs, but she also said, "The only decision that was mine was what was important and what was not, and the very important decision of when to present matters to my husband."

Edith may have believed that her stewardship was benign, but she who controls the information . . . For seventeen months—let that sink in for a moment—the only contact a sick, isolated Wilson had with the burgeoning world power he was ostensibly running was through his wife, and vice versa. She kept things on lockdown, so much so that to this day, the full extent of her involvement in the nation's affairs remains a mystery.

Edith, a widow when she married Woodrow Wilson, never seemed to care much about societal conventions. For example, she said nuts to automobile etiquette by being the first woman to own, and drive, an electric car. To her job: operations manager at her deceased first husband's jewelry store. Edith was a wealthy, modern woman, who caught the eye of the studious Wilson after his first wife, Ellen, died during his first term, just as World War I broke out. Woodrow was devastated; but, a few months later, he fell hard for Edith after a chance White House meeting. She "enthralled" Woodrow (his word) and they were married less than a year and a half after Ellen's death.

From then on, they were rarely apart. It might have been in the country's best interest for Edith to cede authority to vice president Thomas Marshall, but the Twenty-fifth Amendment to the Constitution had yet to be passed, and she was concerned the veep would not stick to her spouse's agenda. So, she ignored US company man no. 2, in easily the most sweetly romantic/confoundingly dangerous power move in presidential history.

It was love, not Lady Macbeth leanings, that was Edith's driving force. She wanted what was best for Woodrow, and, in some cases, her instincts were dead-on. She refused him surgery for an inflamed bladder; it healed naturally. Unfortunately, circling the wagons so the world didn't know how weak the president was kept Wilson from the daily temperature taking and politicking needed to rally congressional and public support for the Treaty of Versailles, which included membership in his beloved peacekeeping League of Nations.

It's a crapshoot as to whether Wilson would have cobbled together a coalition to ratify the Versailles treaty, but the stroke effectively ended his presidency, making that a moot point. What isn't in doubt is that the First Lady stood by her man long enough to finish out his term at the White House. They went on to spend his three remaining years together in a warm, comfortable DC home. She remained there long enough to ride in John F. Kennedy's inaugural motorcade.

Edith's actions were questionable (and somewhat unethical), but she was a valued adviser who wanted to protect the president, her spouse. There was no official transfer of power. Someday soon, a woman is going to become the first official president of the United States. Edith Bolling Wilson may be "The First Woman President" in nickname only, but by nature of deciding what was best for the country, she got there first.

WRITTEN BY **PATRICK SAUER** / ILLUSTRATED BY **JACOB STEAD**
www.patricksauer.com / www.jacobstead.com

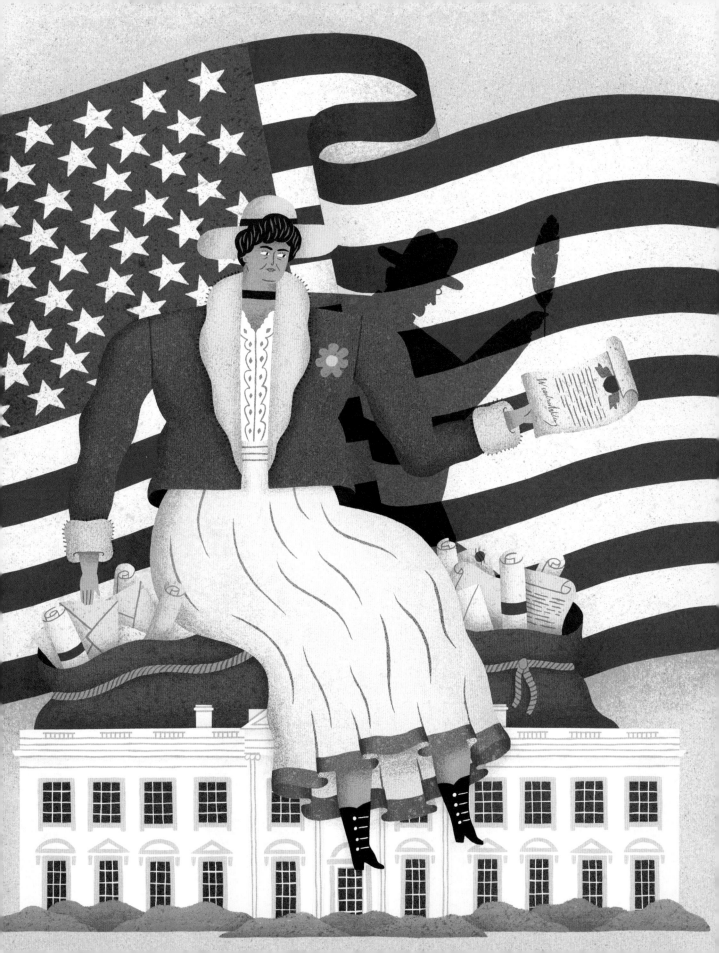

1887 G. P. PUTNAM 1950

AMELIA EARHART'S HUSBAND

IN HER TWENTIES, AMELIA EARHART—HISTORY'S most famous female pilot—referred to marriage as "living the life of a domestic robot." She turned down at least one proposal and counseled friends against it. It was an obstacle to having a career as a woman, something she thought crucial even if she didn't know what hers would be. Earhart loved flying, but her family's fortunes were always shaky, and she eventually became a social worker, teaching immigrants English on weekdays and demonstrating airplanes on weekends.

Then, at the age of thirty, she met G. P. Putnam—publisher, author, and adventurer—whose dedication to her career (first professionally and then as her husband) would enable Earhart to become a full-time aviatrix, or female aviator.

From a well-off family in Rye, New York, Putnam was the grandson of the founder of the publishing house G. P. Putnam's Sons. Ten years older than Earhart, he'd published the newspaper of Bend, Oregon, been the city's mayor, and served in World War I, before returning east to lead expeditions through Greenland to the Arctic and to Canada's Baffin Island for the National Geographic Society. Working for his family's business, he commissioned Charles Lindbergh's wildly successful account of his groundbreaking solo flight across the Atlantic in 1927, *We*.

When Putnam met Earhart he was looking for the "right sort of girl," on behalf of a wealthy sponsor, to be the first woman to cross the Atlantic by plane. (Fourteen people had perished in similar attempts since Lindbergh's trip the year before.) Slim, pretty, and well-mannered, Earhart had earned her pilot's license four years earlier and could also write dispatches for *The New York Times*. Putnam offered her no money to be captain of the crew, but a way to make her name. Earhart described herself as "just baggage" on that first transatlantic flight, but in Putnam's hands, her celebrity was instant. She ascended from Halifax a "Boston girl" and returned to a ticker-tape parade up Broadway with the nickname "Lady Lindy" and a plane bought on Putnam's credit.

Over the next nine years, through the Great Depression, Putnam used his tenacious gifts as a publicist to make Earhart's career possible. She wrote books, gave lectures, made publicity tours, signed autographs, and accepted endorsements under his guidance, so that she could buy planes and afford to fly them, and so she could promote the cause of women pilots and women working in general.

The intensity of Putnam and Earhart's early professional relationship led to a romance, but he had to propose six times before she would agree to enter into the "attractive cage" she had so long mistrusted. Even on their wedding day, Earhart delivered a letter to Putnam asking for an open marriage, that they "not interfere with the others' work or play," and that "you will let me go in a year if we find no happiness together." While it's not clear that the romance lasted, the respect did, and Earhart once described her marriage as "a reasonable partnership . . . conducted under a satisfactory system of dual control."

Putnam kept Earhart in the spotlight and, in 1932, helped her make her solo transatlantic flight, the first by a woman. The couple counted Franklin and Eleanor Roosevelt among their friends, as well as Hollywood stars. Putnam once introduced himself at a celebrity charity event as "Mister Earhart."

When, in 1937, at the age of thirty-nine, Earhart wanted to make her round-the-world flight, as close to the equator as possible, in addition to helping raise thousands of dollars, Putnam bartered Earhart's name for fuel service, sunglasses, flight-plan assistance, and luggage. Three difficult weeks into it, Earhart called Putnam from Calcutta and said she was having "personnel trouble." Her navigator was an alcoholic. Putnam advised her to stop the flight, but she insisted she could manage it. If possible, then, he wanted her home by July 4 for two important radio interviews. Earhart disappeared on July 2 over the Pacific. With Putnam, she lived and died in the air, having once said, "When I go, I would like to go in my plane. Quickly."

WRITTEN BY **DAPHNE BEAL**
www.daphnebeal.com

ILLUSTRATED BY **BJORN RUNE LIE**
www.bjornlie.com

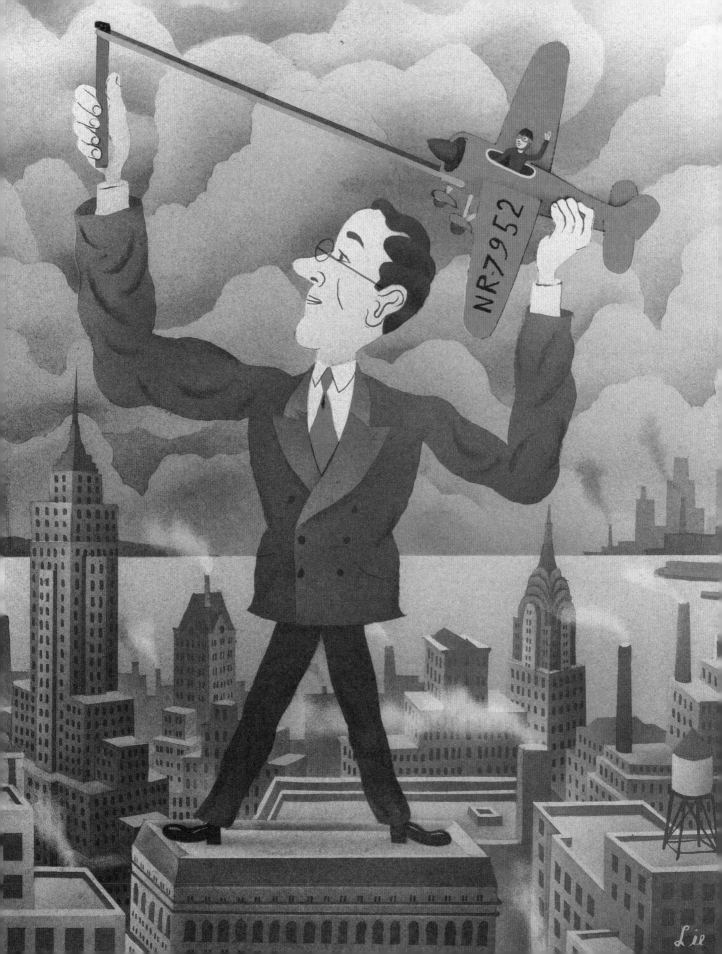

1905 LESLEY RIDDLE 1980

THE CARTER FAMILY'S FRIEND AND TEACHER

IN 1927, A. P. CARTER HAD TROUBLE PERSUADING HIS wife, Sara, and her cousin Maybelle to take an arduous twenty-five-mile drive so the three of them, all nonprofessional musicians, could audition to record as the Carter Family.

But persuade them he did, and—with A. P. arranging and singing, Sara singing and playing autoharp, and Maybelle singing and playing guitar—the trio became the definitive group of the newly discovered "hillbilly" market.

Later, while searching for new material for the group's next session, A. P. met African American guitarist Lesley Riddle in Kingsport, Tennessee. In the words of Riddle, "I played him a couple of pieces, and Mr. Carter wanted me to go home with him right then and there."

Despite their racial differences and the twenty years between Riddle and the elder A. P., the two were natural compatriots. A. P. was born with a tremor that caused his hands to shake so badly he was continually laughed at as a child until he was withdrawn from school. Riddle, too, knew suffering. As a teenager, his right foot was ripped off in a cement plant accident, and then, shortly afterward, the middle and ring fingers of his right hand were blown off by a shotgun. The tremor colored A. P.'s singing, and Riddle developed his playing style around his deformed hand.

Soon, Riddle began spending weeks at a time staying at A. P. and Sara's home, playing music. Maybelle credited him with helping develop her unique guitar sound, which would become a hallmark of the emerging country music.

In addition, Riddle would be the driver when A. P. and he set off on three-week-long trips in A. P.'s car, knocking on doors, seeking old songs. A. P. would write down the words and Riddle would play the melodies to the group upon returning. Many of these songs, as recorded by the trio, have become part of the American songbook.

There were, however, societal restrictions. Although A. P. would seek places to house both a black and a white man overnight, often the two were forced to sleep in separate dwellings; at mealtimes A. P. would eat in the dining room, Riddle in the kitchen.

On one road trip, while the two men were headed toward Florida, they stopped at a diner in Georgia, farther south than they had previously been. As they would have done at home in the Appalachians, A. P. went in the front entrance and Riddle went into the kitchen. However, once there, Riddle found out that the diner was not only segregated but in fact would not serve African Americans at all. Riddle came around to the front and told this to A. P., who canceled his meal, saying, "If they don't serve you here, they can't serve me." The two men walked back to A. P.'s car, which Riddle promptly turned around and drove home without saying a word. Years later, Riddle recalled warmly that A. P. never once asked him, "How come you turn around and come back?"

These at times difficult, but remarkably rewarding, trips did not last forever. In 1933, Sara, frustrated with A. P.'s obsessive musical ambitions and trips, left him and their children. A. P.'s new responsibilities at home effectively put an end to his and Riddle's song hunting.

Despite the separation, A. P. persuaded Sara to continue with the group. The Carters moved to Texas for a radio contract. Riddle married and moved to Rochester, New York. He and the Carters lost touch. Selling his guitar, Riddle worked as a crossing guard and a shoe shiner, playing music only at church. The Carter Family dissolved in 1944, having helped create the genre of country music. A. P. died in 1960, proprietor of a general store, still heartbroken over losing Sara and about the group's demise.

In the mid-1960s, folklorist and musician Mike Seeger performed a concert with Maybelle Carter, who was playing the group's old repertoire with her children to renewed national fame. He asked her how she had learned her classic song, "Wabash Cannonball." Maybelle told him about Riddle, whom Seeger then tracked down, recorded, and persuaded to play a handful of concerts and festivals. Riddle reconnected with the Carters, playing the Carter Family Fold in the mid-1970s, receiving visits from the family at the nursing home where he lived until his death in 1980. In 1993, the US Postal Service released a stamp of the Carter Family; that same year recordings of Riddle singing his songs were finally released commercially.

60

WRITTEN BY **DANIEL KUGLER**
Torevealourbackstreets.tumblr.com

ILLUSTRATED BY **MARIO ZUCCA**
www.mariozucca.com

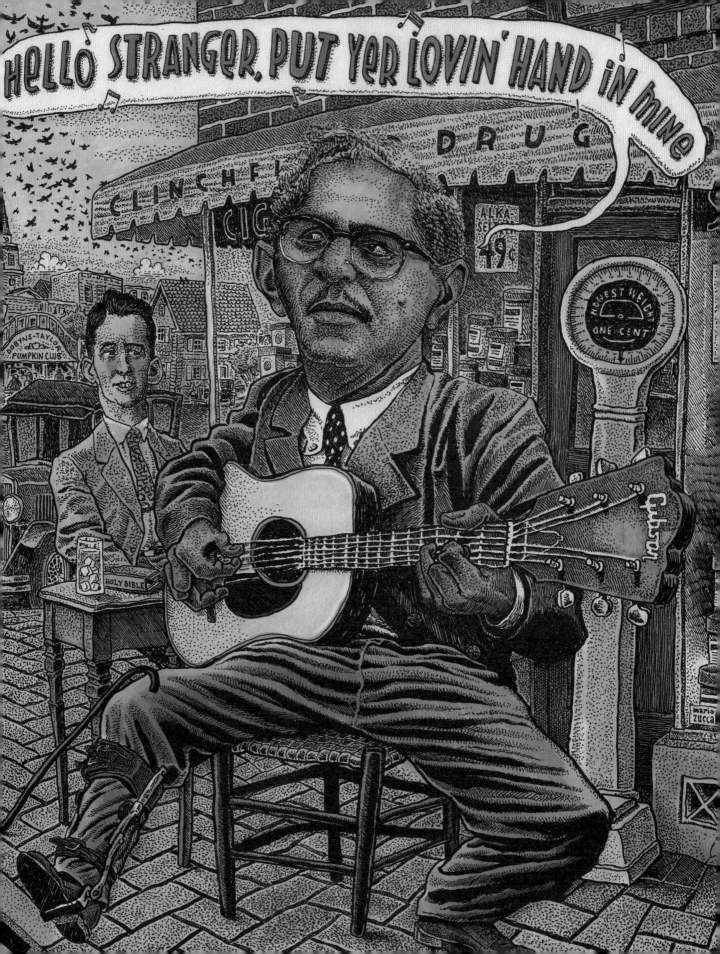

LE CORBUSIER'S COLLEAGUE

IN A FAMOUS PHOTOGRAPH TAKEN IN 1938, THE father of modern architecture stands naked save his signature black frames, stirring a cup of paint. He is turning to look at the voyeur; his nude form marked only by a ghastly scar snaking around his right thigh. The man is Le Corbusier, the highly influential Swiss-French architect, and he is working on one of eight murals, *Graffite à Cap-Martin,* as he would later call them, on a site one hundred feet above the Mediterranean Sea. His admiration for E.1027, the modern house that occupies this secluded, rocky outcropping, was at that moment blossoming into a dark obsession.

E.1027 was designed and built by Eileen Gray in southeastern France between 1926 and 1929 as a summer villa for herself and Jean Badovici, a Romanian architecture critic and her lover at the time. Notoriously private, Gray named the house with a coded puzzle using the initials of its occupants: *E* for Eileen, *10* for Jean (J being the tenth letter of the alphabet), *2* for B, and *7* for G.

Born in Ireland in 1878, Gray moved to Paris in 1902, where she established herself as a pioneering designer of modern furniture and interiors; her masterful use of lacquer, tubular steel, aluminum, and glass set her apart. Independent and introspective, a woman in a male métier, Gray found solace among Paris's lesbian set, though she entertained partners of both sexes. E.1027, acknowledged now as an extraordinary example of twentieth-century design, was her first architectural project and one of only three houses completed during her lifetime. Scouting the isolated plateau on foot, Gray rigorously studied the land before a single stone was set.

Le Corbusier was immediately taken with the dwelling. After a visit with Badovici in 1938, he expressed his approval, writing to Gray, "I am so happy to tell you how much those few days spent in your house have made me appreciate the rare spirit which dictates all the organization inside and outside."

Gray had in fact adopted many of Le Corbusier's tenets into her plan: raising the house up on *pilotis,* or stilts; using horizontal windows, a flat roof, and an open interior with a mix of freestanding and fixed walls (much like Le Corbusier's iconic Villa Savoye outside of Paris). But she did not blindly agree with his standardized, sometimes sterile approach to design, nor with his famous statement that a house is a "machine for living in." Where he believed in a pure architectural aesthetic, Gray preferred a more emotional approach, allowing the evocative site and the individual needs and desires of E.1027's inhabitants to drive her careful design.

"It is not a matter of simply constructing beautiful ensembles of line, but above all, dwellings for people," Gray said.

Her subtle critique had captivated Le Corbusier. He returned to E.1027 later that year, coloring the villa's quiet walls with eight garish, sexually explicit murals. Though Badovici had granted permission, Gray was horrified by the act, an affront to her work and her sexuality; she never came back. For Le Corbusier, however, the fixation deepened. He visited the house frequently to socialize with Badovici, and later to repair the murals after they were damaged during World War II. He was finally expelled sometime around 1948. Undeterred, he built a rustic mountain hut nearby, with a window facing E.1027.

For the next eighteen years, Le Corbusier summered on the spot; here he designed the expressive, sculptural chapel of Notre Dame du Haut in Ronchamp, and the craft-like Maisons Jaoul, a pair of rustic homes realized in rich brick and stone. Both projects were later viewed as radical departures from the purely functional forms that defined his earlier work. Le Corbusier never explained this traitorous change of style nor its sensuousness, though the influence of Gray and of E.1027 should not be underestimated. By the time of his death in 1965, he had in some way or another occupied nearly all the land around the Maison Bord de Mer and, in fact, was often credited for its design. Swimming in the blue waters below the villa on a late August morning, Le Corbusier suffered a heart attack and died. His obsession with E.1027 had finally come to an end; his body washed in later that day with the tide.

Eileen Gray continued working in relative obscurity for most of her life and died peacefully in her Paris apartment in 1976, at the age of ninety-eight. The fate of E.1027 remains unfinished. Abandoned for many years, the site is now a historic monument; restoration is underway.

WRITTEN BY **BRYN SMITH** / ILLUSTRATED BY **JOSEPHIN RITSCHEL**
www.brynsmith.com / www.mevameva.de

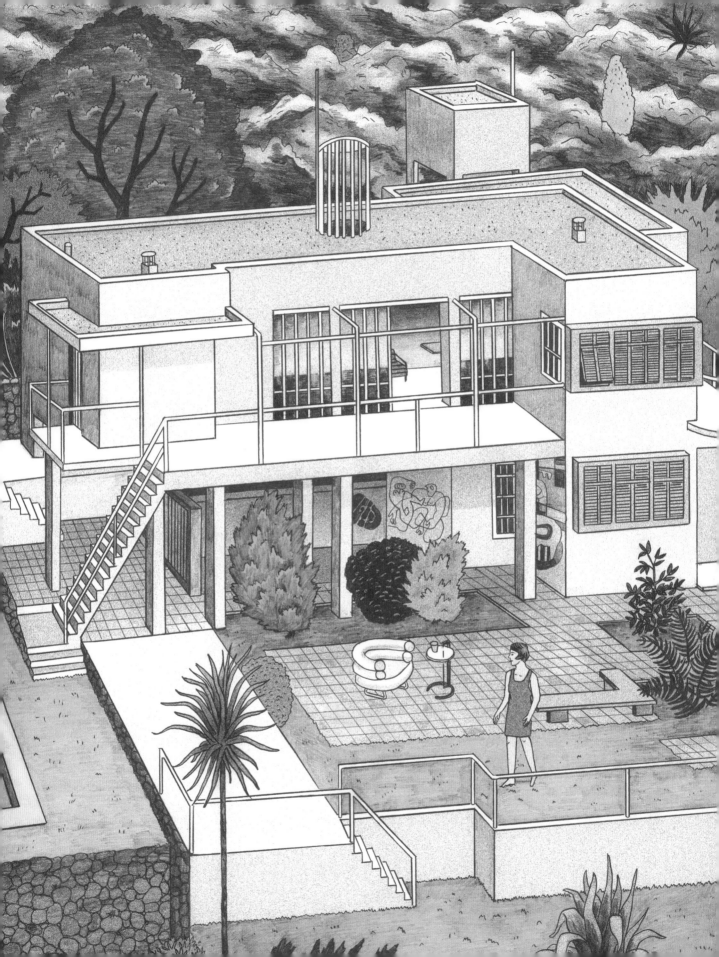

JOHN MARTIN –

CHARLES BUKOWSKI'S EDITOR

JOHN MARTIN WAS AN AVID READER WHO BEGAN collecting hardcover books as a boy in 1940s Los Angeles, just before the paperback revolution put pocket-size softcovers in the hands of the masses. Almost two decades later, he came across a piece by a relative unknown named Charles Bukowski in a mimeographed mag at a local haunt. "It was like turning on a light in a dark room," he says. Martin found the poet in the phone book, got in touch, and the two struck up a rapport, forming a bond that changed the course of both of their lives.

Martin was determined to find a way to share Bukowski's distinctive talent with the world. In 1966, he sold his extensive collection of first edition novels to the University of California–Santa Barbara, which provided him a windfall large enough to follow his dream. That year, he founded Black Sparrow Press, primarily as a means to publish Bukowski's prose. "I wasn't even positive what a publisher was when I started," he says. "But I knew what I liked."

Believing so fully in Bukowski's genius, Martin promised the forty-six-year-old post office worker a steady, incredibly generous $100 a month for life if he quit that gig to write full-time. Within a few weeks, Bukowski delivered the manuscript for *Post Office,* his first novel and the introduction to alter-ego antihero Henry Chinaski, whose hard living belied the tough vulnerability and tenderness personified by the writer himself.

For almost five years Martin kept his own day job managing the printing department of an office supply company, while spending nights and weekends editing texts, shipping copies, and taking care of his fledgling independent empire. His wife, Barbara, was similarly inspired; with no previous experience, she began designing all of Black Sparrow's cover art and title pages, using a spare but striking combination of straightforward type, simple graphic elements, and rich colors printed on a range of thick matte stock. Each edition remains—to this day—a tangible, accessible work of art.

Meanwhile, it was a fertile time for new literary heroes borne from LA's thriving underground scene, and Martin organically amassed an impressive roster of fresh talent through word of mouth and recommendations from friends of friends. Bukowski's ever-growing apocryphal reputation only increased his work's appeal and prolific success; his boozy tales of bedding women, betting at the track, and being beaten down by the drudgery of work struck a chord with a generation enamored with Beats and outsiders. "People read his books and think he was just a wild alcoholic. He could drink—he could get out of control—but I never saw it," Martin says. "He was a wonderful man. He and I had a completely solid relationship."

In 2002, after introducing hundreds of titles and establishing Black Sparrow as a true monument to the written word, Martin sold the rights to his inventory. "I took care of all my authors, and I loved all my authors," Martin says, reflecting on his time as an editor. "But let's face it. Bukowski was always number one."

WRITTEN BY **JORDAN KUSHINS** / ILLUSTRATED BY **RYAN HAYWOOD**
www.jordankushins.com / www.ryanhaywood.com

ELEANOR CALLAHAN

HARRY CALLAHAN'S WIFE AND MODEL

IT DIDN'T MATTER IF SHE WAS WASHING DISHES OR dozing off. When photographer Harry Callahan told his wife, Eleanor, that the light was right, she dropped what she was doing to pose for him. "He knew I never, ever said no," she recalled in 2008. "If he said: 'Come quick, Eleanor—there's a good light,' I was there."

The two met in Detroit in 1933, when Eleanor was seventeen. Eleanor—then Eleanor Knapp—saw a photograph of Callahan, who had roughed up her cousin's boyfriend while playing hockey on the grass. "Oh, I'd like to meet him," she told the boyfriend, who arranged for the two to go out. They married in 1936; Callahan began taking photographs two years later.

Over the next nearly six decades, until his death in 1999, Callahan photographed his wife hundreds of times. The photographs, which have appeared in numerous monographs and in retrospectives at the National Gallery of Art and Atlanta's High Museum, to name a few, range from the straightforward to the experimental. Some show Eleanor reduced to a simple form, like the series that shows her standing nude, back to the camera, grasping a radiator, or photographs in which she lies on her side on a bed, her young daughter draped over her body. There is an almost elegiac shot showing Eleanor up to her shoulders in Lake Michigan, her long dark hair disappearing into the water, and experimental photographs in which other images—a window, a field, a building edifice—are superimposed over her body. And then there are the photos of a fully clothed Eleanor around Chicago, some of which read as snapshots, others as more formal, composed portraits, in which Eleanor stands alongside a pipe, within a copse, or in a shaft of light.

Despite the time and patience these photos required— "He did not do these things quickly," Barbara, the couple's daughter, remembered—Eleanor was quick to brush off credit for her roles as model and muse. "I never initiated any of the poses myself," she said. "Everything, photographically, was purely from Harry." Others, however, grant her far more recognition. The Los Angeles–based photography dealer Stephen White likened Eleanor to "an additional f-stop"— aperture—"on [Harry's] lens. Through her, he saw form and structure more clearly, both in nature and in the world. She was present in his photographs even when she wasn't in them. Eleanor was Harry Callahan's collaborator, for she rested inside his psyche."

In addition to serving as model and muse, Eleanor also supported the family as an executive secretarial assistant, for several decades earning more than her husband did making and teaching art. "I liked working," she told *The New York Times*. "It's a good thing I was industrious. A lot of my money would go into photography. That suited me fine."

WRITTEN BY **RACHEL SOMERSTEIN** / ILLUSTRATED BY **LEAH REENA GOREN**
www.rachelsomerstein.com / www.leahgoren.com

JUAN DE MARCHI

1866 1943

SALVADOR ALLENDE'S MENTOR

ALVADOR ALLENDE BELIEVED IN A DEMOCRATIC Chilean government that valued meeting the needs of its citizens above the accumulation of capital. Allende's policies of providing widespread social services and nationalizing certain means of production (large farms, banks, copper mines) are radical by capitalist standards, but his socialist approach resonated with the Chilean electorate, and in 1970 he was elected president.

Allende was raised to be a progressive thinker; his grandfather was a physician and social activist, and his parents worked for liberal causes. But Allende cited a source outside his family for inspiring much of his socialist belief. As a teenager, on his way home from high school each day, he would stop by the workshop of an Italian immigrant shoemaker and carpenter named Juan De Marchi. Though Allende was nearly fifty years younger than De Marchi, a unique friendship grew between them. "We exchanged opinions about foreign and national matters. He willingly spoke to me about the events of his life; he even lent me his books and taught me to play chess," Allende said.

De Marchi was a committed anarchist who believed that the best interactions are those based on nonhierarchical relationships. He championed the rights of the individual worker over the coffers of the elite. De Marchi introduced the young Allende to the writings of prominent radical thinkers and engaged him in great political discussions.

Allende said his time with De Marchi was instrumental to the development of his political ideologies. "His influence was important to me because I didn't yet have the calling to read such profound books, and he introduced me to the straightforward generosity of the average worker."

By several accounts, De Marchi wasn't just an average worker. Even in his sixties, he took provocative actions as a rebel and insurrectionist. He reportedly traveled to Argentina to help plot a famous attempted coup known as "The Red Plane." De Marchi wanted to forcibly topple the Ibañez dictatorship by smuggling weapons into rebel hands via the railroad. The plan was betrayed by regime loyalists, and when De Marchi tried to cross back into Chile illegally, he was arrested and exiled to an island off the coast of Chile.

Meanwhile, De Marchi's protégé Salvador Allende was graduating from medical school and publishing the important social wellness works *The Social and Medical Reality of Chile* and *Crime and Mental Health*. Allende was active in politics for years and eventually sought and won the chair of the Chilean Senate. He introduced legislation that guaranteed universal health care in Chile, the first of its kind in the Americas.

During his climb to power, Allende was the target of US and USSR Cold War maneuverings. The CIA spent millions trying to keep him from office but the KGB eventually succeeded in supporting his rise. On his fourth attempt at the office, Allende secured the presidency of Chile. Armed with radical egalitarian ideas from an immigrant shoemaker, President Allende wasted little time in making sweeping changes to further equalize Chilean society.

The military and other branches of his own government accused Allende of going too far, and the well-connected elite class in Chile bristled under his socialist policies. On September 11, 1973, Allende's presidency was cut short by a military coup, ending forty-seven years of democratic rule in Chile. The details of his death are disputed, but when the army seized the presidential palace, Allende was found dead, shot in the head with his own AK-47 that had been a gift from Fidel Castro. Salvador Allende's last public words were, "Long live Chile! Long live the people! Long live the workers!" Augusto Pinochet's military junta would rule Chile for the next seventeen years.

WRITTEN BY **JOHN NIEKRASZ**
JohnNiekrasz.wordpress.com

ILLUSTRATED BY **HEATHER MACKENZIE**
www.heather-mackenzie.com

1846 ANNA DOSTOYEVSKAYA 1918

FYODOR DOSTOYEVSKY'S WIFE

FYODOR DOSTOYEVSKY DIDN'T LIKE INDEPEN-dent women. He loved them.

Anna Snitkina (Anna Grigoryevna Dostoyevskaya) wasn't independent or modern, and she didn't try to be. But he loved her, too.

Anna was Dostoyevsky's second wife. She was a nineteen-year-old stenography student when she came to work for the already-famous forty-five-year-old writer.

Anna admired him from the start, but a romantic relationship didn't cross her mind. She wrote, "Nothing can convey the pitiful appearance of Fyodor Mikhailovich when I met him for the first time. He seemed confused, anxious, helpless, lonely, irritable, and almost ill."

Stenographers were very different from the typists who came half a century later. Stenography was a high-tech radical innovation and the stenographers Dostoyevsky was used to were a special sort of women. In Russian they were called *nihilistki*—"women who believed in nothing." They smoked a lot (like Dostoyevsky himself) and had spectacles. She did not. He liked that she happened to not be a *nihilistka*.

With Anna's help he wrote *The Gambler* in less than a month. He was happy. She was happy, too, because he proposed to her a week after completing the novel.

Dostoyevsky had vast experience dealing with *nihilistki* women and their type—well educated, independent, and obsessed with the idea of freedom. His lover Apollinaria Suslova was a real femme fatale and an inspiration for characters in *The Idiot* and his other novels. Suslova's sister is known in Russia for being the first female doctor. Fyodor considered marrying Anna Korvin-Krukovskaya, but she declined, wanting to "live an independent life." Krukovskaya's sister, Sofia Kovalevskaya, was the first Russian female scientist.

Anna Snitkina didn't have sisters in the "league of first women." She happened to be a "first" herself, although she confessed in her memoirs to "not being beautiful, talented, or well educated." She is now named "first" in two fields. One of those is "first Russian philatelist"; that's for another time, though.

Dostoyevsky had a well-known passion for gambling, but it was not the main source of his financial burdens. He took on huge debt from his brother's publishing house. This indebtedness frustrated both spouses. Dostoyevsky's brilliant idea was to make money using his foolproof "system" for playing roulette. Anna had a more sober approach—the publishing business. No Russian author had tried self-publishing before. It was a revolutionary idea. Anna analyzed the book market, found the best supply chain, and negotiated with art directors as well as with book distributors. The couple had some commercial success with Dostoyevsky's novel *Demons*. (Later, Sofia Andreevna Tolstaya came to Anna asking to learn her secrets; she was interested in self-publishing a book by her husband, Leo Tolstoy.)

Their next project was an example of DIY in the mid-nineteenth century. Dostoyevsky started self-publishing *A Writer's Diary*—a periodical with his stories and political essays, a sort of blog in hard-copy form.

The Dostoyevskys expanded the book trade, with orders from cities outside their hometown of St. Petersburg. Anna sent thousands of invitations, using the subscribers to *Writer's Diary* as their client database. But Anna knew the business would have no chance of survival unless the enterprise had the "Dostoyevsky" brand name. In fact, his name was the only investment Fyodor could give the family business. Once, after many years of living together, he, the cofounder, asked Anna to write down her birth surname. He couldn't recall it while trying to fill in some official forms.

The business grew, and the family debts were paid off, but after Dostoyevsky's death, Anna gave up self-publishing. The business had just been her way to make life easier for her husband so he could write his masterpieces in comfort. Without hesitation, she gave up the book trade, devoting herself to putting together a full collection of Dostoyevsky's works.

This is why some modern Russian editors consider Anna Dostoyevskaya the first Russian female publisher, while others refer to her as the first Russian businesswoman. A considerable achievement, even when compared to those of some of Dostoyevsky's other women.

WRITTEN BY **IGOR LEVSHIN** / ILLUSTRATED BY **LAURA CALLAGHAN**
Igor.levshin.com / www.lauracallaghanillustration.com

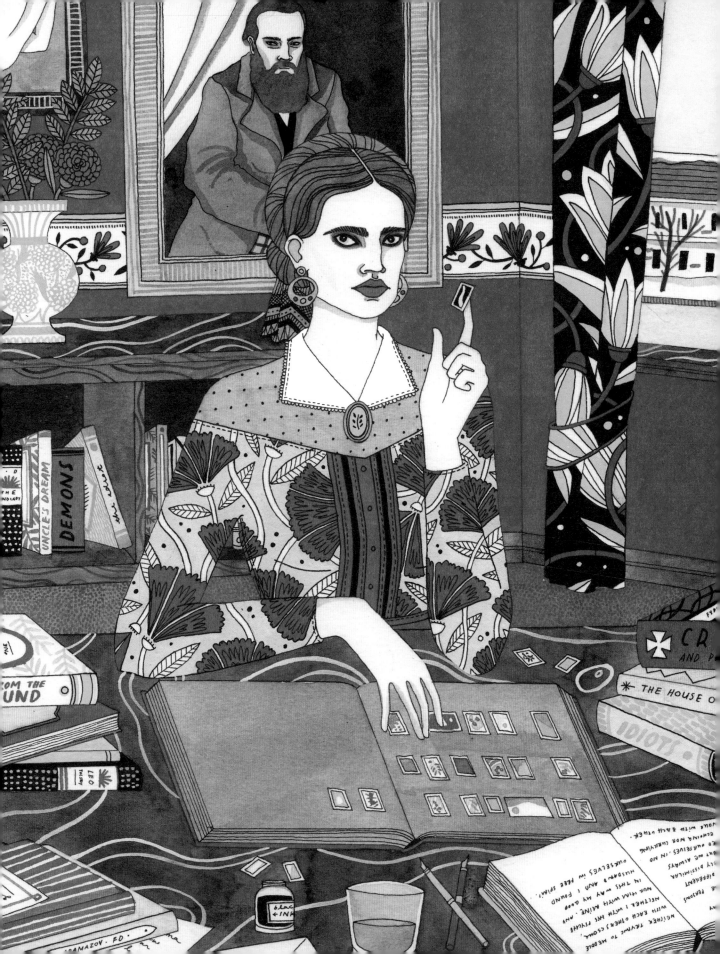

GERTRUDE EDERLE'S COACH

IN 1926, GERTRUDE EDERLE BECAME THE FIRST woman to swim across the English Channel. The frigid, forbidding strait, twenty-one miles wide at its narrowest point and often chopped by waves and wind, separates England from France; a swim crossing during the era was considered the most epic of physical feats. Ederle demolished the existing men's record by more than two hours, using the recently developed American crawl stroke. This faster and smoother speed-kick variation of the Australian crawl was developed at the Women's Swimming Association, or WSA, under the directorship of its founder, Charlotte "Eppie" Epstein.

In a time when women didn't compete in sports, Epstein was a pioneer. A court stenographer when she founded the WSA in 1917 at a tiny pool on the Lower East Side of Manhattan, she and other fellow secretaries and working girls decided that swimming would be a good way to get exercise.

Though she wasn't herself an excellent swimmer, Epstein loved to swim and worked tirelessly to establish American women as a force in worldwide competition. The goal dovetailed with her work as a champion of women's rights. In one of her signature achievements as the "mother of women's swimming in America," Epstein got the Amateur Athletic Union to endorse women's swimming—the only sport it recognized for female competition in 1917—though the swimming costumes were literally a drag: neck-to-toe black wool (which had to be covered with robes when swimmers weren't in the pool). Later, she persuaded the governing body to let female swimmers compete in a one-piece racing suit without stockings (considered "nudity" at the time).

Mindful of the example that was made of "Eppie's Girls," Epstein shepherded her swimmers to success both in and out of the water, making sure that they behaved as ladies, had impeccable manners, and dressed well, sometimes staging photographs with the swimmers helping their mothers with housework.

When Ederle joined the WSA as a thirteen-year-old girl in 1919, the organization was well on its way to training and sending swimmers to the Olympic Games the following year. Epstein had acquired the volunteer coaching services of Louis Handley, an Italian-born Olympian who used the WSA as a lab to develop and refine the American crawl; together, the two changed the world of swimming forever. Ederle was Epstein's ultimate success story: Between 1921 and 1925, Ederle held a whopping twenty-nine national and world amateur swimming records and became one of the era's most beloved sports heroes. During the 1924 Summer Olympics in Paris, she won three medals; the following year, Epstein selected Ederle for the Channel swim, and the two traveled to England for Ederle's first attempt (she was disqualified when their British guide touched her halfway through the swim). Ederle came back the following year and beat the men's record, proving that women could rival men in athletic competition.

She returned home as a national heroine, with more than two million New Yorkers celebrating her feat with a ticker-tape parade.

Epstein eventually coached her swimmers to more than fifty world records. In 1930, *The New York Times* declared that so many "really brilliant and speedy mermaids" had been turned out by the club that it "doesn't cause much wonderment when some new miss is brought forth and declared to be a coming Ederle."

WRITTEN BY **BONNIE TSUI**
www.bonnietsui.com

ILLUSTRATED BY **ROMAN MURADOV**
www.bluebed.net

JOHN WAYNE'S STUNTMAN

THE STORY OF JOHN WAYNE BEGAN IN IOWA with the eldest son of a pharmacist's assistant, a boy who went by the name of Duke. Hard times drove the family to California, and after dropping out of college on account of a lost football scholarship, Duke found work hauling props on movie sets.

Duke Morrison didn't know much about movies, and he knew even less about cowboys. What he had going for him was this: He was handsome, he worked very hard, and he was friends with Yakima Canutt.

Yak was born out West, the son of a rancher. Broke his first wild horse at eleven and followed the rodeo to California. He figured he would teach the movie folks a thing or two about horses. He showed the early studios what a real cowboy was, showed them how to walk like a solemn fact, stare down a gun, and speak calmer than an oak tree.

Duke had worked his way in front of the camera through a series of minor roles, first in football-themed movies and then in low-budget Westerns. Yak was working the same circuit staging action scenes and devising more and more ambitious stunts. When Yak met Duke in 1932, he found an actor who was as tough as a stuntman.

Yak taught him how to ride a horse like a cowboy and fall off it like a rodeo star. Neither was a man to pull a punch, and the two developed rougher, more realistic fight scenes than moviegoers had ever seen.

In Yakima Canutt, Duke found the purest form of the American cowboy. He studied Yak's walk, his diction, his mannerisms, and built them into the iconic hero of the Western genre, John Wayne. Duke appeared under that stage name in more than 170 films over the course of half a century, and the movies had never seen a character like him—John Wayne was as much a stage creation as the cowboy heroes he played.

John Wayne was a man of the earth with a taste for plain talk and whiskey. He believed in justice and honor, but if you came at him with a chair, he'd come back at you with a table. He showed America the promise of the West, the pure freedom of a lone man on a horse. He went by Duke, but his swagger was Yak.

WRITTEN BY **JOSEPH RINGENBERG**
www.jringenberg.com

ILLUSTRATED BY **PEDRO LOURENÇO**
www.tigerbastard.com

EMILY DICKINSON'S DOG

A NEWFOUNDLAND PUPPY WAS GIVEN TO EMILY Dickinson when she was nineteen; she named him "Carlo" after the dog in *Jane Eyre*. "You ask of my Companions," Dickinson wrote years later to a friend. "Hills—Sir—and the Sundown—and a Dog—large as myself, that my Father bought me—They are better than Beings—because they know—but do not tell." Carlo was discreet, like all of dogkind, but probably larger than Dickinson. Male Newfoundlands weigh about 150 pounds; Dickinson was five foot three and "small, like the wren."

The legend of Dickinson as recluse is hard to sustain in light of the time she spent with this boisterous animal. (One poem begins, "I started Early—Took my Dog—" Elsewhere, "Emily with her dog, & Lantern!" a friend recalled, suggesting that Dickinson walked with Carlo at night.) When Dickinson explored Pelham Woods and the surrounding meadows, Carlo tramped along, offering her physical confidence and mental freedom. She praised him for being "brave and dumb."

Carlo was either black or brown and, like all Newfoundlands, a heavy shedder. Though a legend sprang up that Dickinson dressed "wholly in white," she described herself liking "calicoes," and wearing "a brown dress with a cape if possible browner"—a more practical color for a woman

covered in dog hair. She never complained about keeping a large dog—in one poem she sings of muddy dog paws—but we know that she loathed housework. "They are cleaning house today, Susie, and I've made a flying retreat to my own little chamber." Perhaps the creature she called her "Shaggy Ally" slept at Dickinson's feet as she wrote; perhaps he slobbered on her dress and writing paper.

The word "perhaps" plays a star role in all the Dickinson biographies, given how closely she guarded her secrets. One enduring mystery concerns three love letters Dickinson wrote but never posted. We don't know if the man addressed in the letters was real or imaginary, but when Dickinson asks him, "Could Carlo, and you and I / walk in the meadows an hour," there is no doubt whom she imagined tagging along on their date.

Carlo lived more than sixteen years, and Dickinson wrote some of her greatest poetry during his lifetime. When the Newfoundland died, this forger of a new poetic language found few words for the event. She wrote to her friend Thomas Higginson, "Carlo died. Will you instruct me now?" Later she noted, "I explore little since my mute Confederate" died. She never had another dog.

WRITTEN BY **SARA LEVINE** / ILLUSTRATED BY **SARAH JACOBY**
www.sara-levine.com / www.thesarahjacoby.com

JACK SENDAK

MAURICE SENDAK'S BROTHER

I'm working on a new book now, about noses. It's a long poem. I love noses. I have a passion for them. It must have begun early in life, because my brother and I shared a bed. There was no privacy. And we had bed bugs. And to protect me, my brother said, "Lie on top of me." And I said, "I'll fall." And he said, "No, you won't, not if you clamp your teeth on my nose." I didn't fall to the left, I didn't fall to the right. The bed bugs didn't get me. They got him. Maybe that's where the love of noses began. He had a great nose.

AUTHOR MAURICE SENDAK AND HIS OLDER brother Jack shared a closeness that formed within an often unsettling and anxious household. His parents, Philip and Sadie Sendak, were immigrants from Jewish shtetls outside Warsaw. Maurice was born on a dining room table in Bensonhurst, Brooklyn, the youngest of three children. At home, young Maurice felt claustrophobic with parents who often told him they could not afford him. Their traditional ideas of success (a doctor, a lawyer) were in stark contrast to the identities of their children. As Maurice later told interviewer Terry Gross, it was his brother Jack who rescued him from the loneliness and grief at home.

"I had a brother who was my savior, made my childhood bearable. He was older by five years, Jack Sendak. . . . He was very, very, very gifted. More importantly to my life, he saved my life. He drew me away from the lack of comprehension that existed between me and my parents, and he took his time with me to draw pictures and read stories and live a kind of fantastical life."

Jack took Maurice out to the movies, and Maurice cultivated a following among the neighborhood kids, retelling the weekly features, often with his own embellishments. When Maurice was only six, he and Jack collaborated on an illustrated book called *They Were Inseparable* "about a brother and sister who had a hankering for each other—it was a very naive and funny book."

Encouraged by his brother, Maurice continued making small homemade books. When Maurice was sixteen, Jack joined the army and disappeared in the Philippines for a year, before returning home to work in the new industry of color television. In 1948, still living at home, the brothers collaborated on making wooden toys. Their father eventually kicked them out of the house. When asked about the eviction, Maurice recalls, "Two sons who made toys, I mean really?" Maurice took a job illustrating backgrounds for the comic strip *Mutt & Jeff* and started creating props for the windows of the FAO Schwarz toy store. Maurice's career as an illustrator began to take off, and in 1956 the two brothers collaborated on an illustrated book, *The Happy Rain*.

Over the years, their careers diverged and the two brothers grew apart. Maurice went on to write and illustrate *Where the Wild Things Are* and *In the Night Kitchen* but in interviews maintained that he wasn't much of a writer—that in his family, Jack had the real talent. Jack published several children's books that were critically praised for their surreal storytelling, and he worked for the US Postal Service before he passed away in 1995.

For many years after, Maurice struggled with his brother's death; he dreamed of writing a book about the brother who was his inspiration. Sendak's final book, *My Brother's Book*, tells the story of two brothers, Jack and Guy, who are separated when a falling star crashes to earth. In the story, Jack is sent to a continent of ice where he lies buried until Guy discovers his nose protruding from the ground:

Guy saw Jack's nose and rooted toes deep buried in veiled blossoms. And he bit that nose to be sure. Just lost or I am saved, Jack sighed, and his arms as branches will wound round his noble-hearted brother who he loved more than his own self. And Jack slept safe and folded in his brother's arms and Guy whispered, good night and you will dream of me.

WRITTEN BY **ABIGAIL COHEN** / ILLUSTRATED BY **PHOEBE WAHL**
www.phoebewahl.com

1873 FRANK WILD 1939

ERNEST SHACKLETON'S RIGHT-HAND MAN

FAILURE WAS ALL BUT ASSURED, A HORRIBLE death far from home likely. Yet thousands volunteered to sail for Antarctica—for glory, for science, for the chance to plant one's flag in a land that had been, for all time, off-limits to humankind. Many suffered and died there, the beautiful indifference of the universe neatly distilled in the cold and gorgeous shapes all around them. "We had seen God in his splendors, heard the text that Nature renders," wrote legendary polar explorer Ernest Shackleton when he and his men were rescued after nearly two years adrift. "We had reached the naked soul of man."

On December 5, 1914, Shackleton had set sail on the *Endurance*, bound for Antarctica. Beside him, as always, was Frank Wild, his second-in-command, the man Shackleton called his "other self." Fearless, energetic, and endowed—like Shackleton—with an indefatigable optimism, Wild recalled reading a book on Arctic adventure when he was eight that had set the course of his life. "Even now after five Antarctic Expeditions and one to the Arctic," he confessed years later, "that longing is not extinguished."

Just shy of Antarctica, the *Endurance* was captured and crushed by the ice, forcing the crew to abandon ship. Shackleton, Wild, and twenty-seven men drifted for months on unstable floes, stalked by killer whales and on the brink of starvation. Eventually, they reached land by rowing—for a week straight—in three battered lifeboats. But the joy of landfall didn't last: Elephant Island was cosmic in its desolation, as far-flung as a meteor, with sheer black cliffs plunging hundreds of feet into violent seas that flooded the rocky beaches at high tide. "No one had ever landed on it before us," noted Wild. No one else ever would. Shackleton took five men and sailed for the whaling station on South Georgia Island—some eight hundred miles away. He left Wild an equally daunting task: Keep twenty-two starving, frost bitten, demoralized men alive and well until he could return with help.

The weather on Elephant Island that winter was, as Wild put it, "simply appalling." Gales alternated with blizzards; ninety-mile-an-hour gusts shredded their tents; rogue waves threatened to wash them out to sea. The men took refuge under two overturned lifeboats, stacked like bunks, the gaps sealed with the ruined tents. They survived on penguin, limpets, seal, and seaweed. There was little they could do

but hunker down, essentially blind, in their pitch-black hut and listen to the wind howl—until Wild sewed the glass lid of their maritime clock into the tent siding. Thanks to "Wild's window," the men could see each other again and mend their clothes—and read. Each night, they recited one recipe from the penny cookery, debating it talmudically as they fell asleep, so that they dreamed of feasts. The weeks rolled into months. Meager rations dwindled. No ship appeared. But Wild's "cheery optimism" (in Shackleton's words) never faltered. Mornings, he roused the men from their sleeping bags and ordered them to "Lash up and stow! The boss may come today."

In fact, Shackleton had been trying to return to Elephant Island for more than four months, only to be repelled again and again by the ice. Finally, on August 30, 1916, he reached the marooned men, calling out to Wild, "Are you all well?" Wild, who in Shackleton's estimation, "always rose superior to fortune, bad and good," answered coolly, "We are all well, boss."

The men of the *Endurance*—all of whom had survived—returned to "a world gone mad." World War I was raging, with millions dead. Most of the men enlisted immediately upon returning to England. Wild was sent to the Russian Front and, after the war, emigrated to South Africa to try his hand at farming. But he couldn't resist when, in 1921, Shackleton cobbled together a hazy expeditionary return to Antarctica.

Their first night on South Georgia, Shackleton died of heart failure and was buried. Wild and the crew sailed on, revisiting the dread silhouette of Elephant Island, for which, despite themselves, some of the men experienced an almost intolerable nostalgia.

Wild spent the rest of his life, somewhat adrift, in South Africa, where he died in 1939. His ashes, long lost, were rediscovered in 2010 and carried by his family, accompanied by Shackleton's, back to South Georgia. Wild was laid to rest beside the old boss under a simple epitaph: "Shackleton's Right-Hand Man." Not a memorial to individual glory but a monument to an absolute and mutual trust, a friendship forged at the very limit of human endurance. Anyway, there they are—reunited at last, facing together, for all time, the Great Ice Barrier.

WRITTEN BY **JULIA HOLMES** / ILLUSTRATED BY **JONATHAN BURTON**
www.juliaholmes.net / www.jonathanburton.net

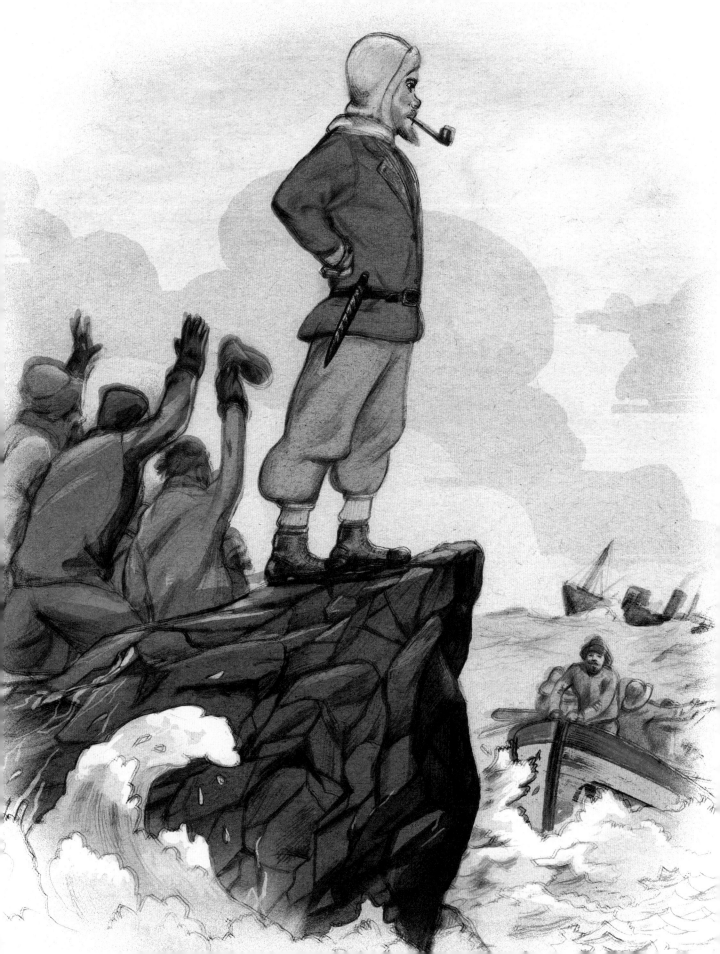

WASHINGTON ROEBLING'S WIFE

T A TIME WHEN WOMEN WERE NOT EXPECTED to go to college or even to learn math, Emily Roebling ended up supervising one of the greatest achievements in civil engineering of her day: the construction of the Brooklyn Bridge.

Her husband, civil engineer Washington Roebling, whom she met and married during the Civil War, had become chief engineer of the project in 1869, when his father, civil engineer John A. Roebling, suddenly died: Three days into construction, Roebling Sr.'s foot was crushed in an accident, and, two weeks later, he died of tetanus. Then, in 1872, Emily's husband became bedridden from caisson disease, the acute, debilitating decompression sickness also known as "the bends," due to working in the caissons (watertight chambers) deep under the river to construct the bridge's piers. Washington also suffered residual headaches, nervous exhaustion, and increasingly poor eyesight. Emily, age twenty-nine and mother of a four-year-old (who would be her only child), stepped in to oversee the project for the next eleven years, completing what was then the longest bridge ever built.

Washington Roebling would see only his wife, giving her instructions to relay daily to the engineers and laborers onsite. Emily, the second-youngest of twelve children born to New York State Assemblyman Sylvanus Warren and his wife, Phebe, had studied mathematics and science as a teen at the Georgetown Visitation Convent in Washington, DC. Now she was quickly learning stress analysis, the strength of materials, cable construction, and the like. In addition to being project manager and daily supervisor of the bridgework, she kept records, answered her husband's mail, and represented him at social events. Emily was her husband's point person as he lay in bed, unable to work and afraid he'd die before seeing his father's dream realized. "I thought I would succumb," he said after contracting the bends, "but I had a strong tower to lean upon, my wife, a woman of infinite tact and wisest counsel."

When, in 1882, there was a move to oust Washington Roebling as chief engineer, Emily successfully defended his title, even addressing the American Society of Civil Engineers in an era when women rarely spoke in public without being derided and dismissed. She was not just the woman behind the man. She was his stand-in on a monumental project he could not have completed without her.

When the bridge opened on May 24, 1883, Emily was given the honor of being the first to cross it, riding in a carriage from Brooklyn to Manhattan, carrying a rooster as a sign of victory.

She went on to earn a law degree from New York University, but her health declined and she died on February 28, 1903. Her husband outlived her; he died in 1926.

At the dedication ceremony before the Brooklyn Bridge opening, Congressman Abram S. Hewitt called the bridge "an everlasting monument to the self-sacrificing devotion of a woman and of her capacity for that higher education from which she has been too long disbarred." He added, "The name of Mrs. Emily Warren Roebling will thus be inseparably associated with all that is admirable in human nature."

WRITTEN BY **REGAN MCMAHON**
www.commonsensemedia.org

ILLUSTRATED BY **ELIZABETH BADDELEY**
www.ebaddeley.com

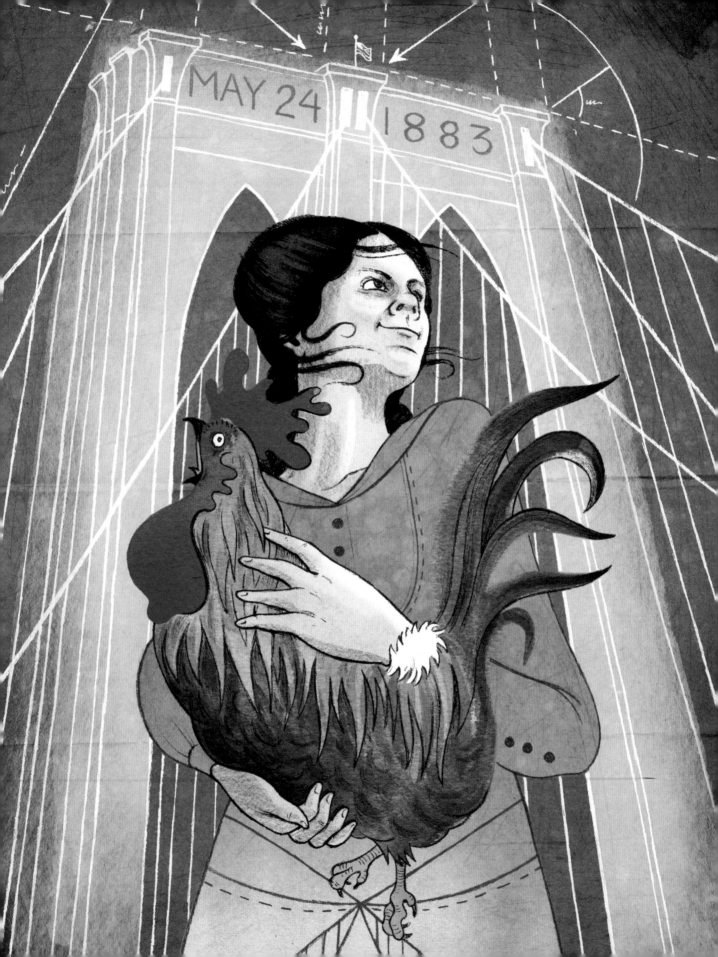

1876 MAX DEUTSCHBEIN 1949

MARTIN HEIDEGGER'S COLLEAGUE

WHEN MARTIN HEIDEGGER'S *Being and Time* was published in 1927, it struck the intellectual world like lightning. Guided by the question, "What is the meaning of being?" the book provides an analysis of everyday existence and develops this into a radical rethinking of Western metaphysics. Its publication made Heidegger an instant celebrity, and it has had a lasting impact as a foundational text of twentieth-century philosophy. However, the book wouldn't have come into print if not for a man named Max Deutschbein.

Deutschbein was a consummate academic. His father wrote English grammar books, and Deutschbein set out to follow in his father's footsteps. He went to the finest schools and produced a steady stream of publications on both English literature and linguistics, earning special renown for his own English grammar books. On the basis of this work, Deutschbein successfully worked his way up the academic ladder. In 1919, he joined the faculty of the prestigious University of Marburg, where he conducted his scholarly life in the warm company of valued colleagues and students until his death in 1949.

While Deutschbein was born for academia, Heidegger had trouble fitting in. When he arrived at Marburg as an untenured professor in 1922, Heidegger already felt alienated from the profession and university life. He preferred the solitude of his mountain hut in the Black Forest and would retreat there at every opportunity. When on campus, Heidegger shunned his colleagues and seemed like he'd rather be elsewhere: He often lectured in his ski outfit in the winter and his hiking clothes in the summer. Most significantly, Heidegger let ten years go by without publishing anything. But his eccentric posturing and inspiring lectures won Heidegger a loyal student following. On the basis of Heidegger's reputation as an outstanding teacher, Deutschbein, now dean of the philosophy faculty, recommended that he be granted tenure. However, the German Ministry of Education (which had to approve such things) rejected the promotion, citing Heidegger's lack of publications. Heidegger shrugged this off as "a matter of indifference," but Deutschbein wouldn't let Heidegger be undone by academia's publish-or-perish culture. Deutschbein approached Heidegger and insisted that he publish something immediately. Heidegger retreated to his mountain hut to work on a manuscript; one month later, he had completed a draft of *Being and Time*.

Without Deutschbein's intervention, it's doubtful that Heidegger would have published this work. The published text is actually only the first half of a much larger project that Heidegger planned, but it was enough to win approval for Heidegger's tenure. With the pressure off of him, Heidegger delayed the rest of the project, eventually abandoning it altogether. Writing to a friend, Heidegger lamented this failure, but noted: "I have at least proved that I can get something into print." Helping Heidegger prove himself changed the history of thought like nothing else Deutschbein accomplished in his prolific career. And Heidegger needed the help. Sometimes it takes a by-the-books professional to rein in an eccentric genius.

WRITTEN BY **ADAM RING** / ILLUSTRATED BY **MATT LAMOTHE**
www.also-online.com

RALPH WALDO EMERSON'S AUNT

WHEN RALPH WALDO EMERSON WAS A small boy, his father, William, tried to teach him to swim. More than forty years later, with a fright that felt fresh, Ralph recalled that he "put me in mortal terror by forcing me into the salt water." Not quite eight when William died in 1811, Ralph would always remember his Unitarian minister father as withholding and severe.

In contrast to that memory was his Aunt Mary, or "Tnamurya," as Emerson would later anagram her name in the journals that formed the basis of his transcendentalist literature and philosophy. She "spun faster than all other tops," Emerson said of his father's younger sister's unpredictable vitality. Especially by nineteenth-century standards, she was brilliant and boisterous, though of course there was no possibility of following the men in her family to Harvard. A self-educated, original thinker, she offered visionary encouragement that would prove to be the strongest force in Emerson's life.

"Her correspondence with him," writes Robert D. Richardson Jr. in *Emerson: The Mind on Fire,* "is the single best indicator of his inner growth and development until he was well over thirty. Emerson said that in her prime his aunt was 'the best writer in Massachusetts.' He noted that she set an 'immeasurably high standard' and that she fulfilled a function 'which nothing else in his education could supply.'"

Following her brother's death, Mary Moody Emerson moved to Boston, where she helped his widow, Ruth, care for their five living sons (Ralph was the third, and the silliest, according to Richardson). Within the family, Aunt Mary fulfilled a role her biographer Phyllis Cole likens to that of a surrogate father. She guided the spiritual and intellectual lives of the children and advised them, without any forcing, "Always

do what you are afraid to do." In Victorian New England, her bypassing of marriage and motherhood (she denied the one suitor who proposed) was radical.

Despite Aunt Mary's dismissal of standard English in what she herself wrote—she had her own way with the language, substituting "imajanation" for "imagination"—she read broadly. Her range included Plato, Coleridge, Wollstonecraft, Rousseau, and Goethe, in addition to pillars of New England Puritanism. She introduced Emerson to the writings of Eastern mystics that would underlie the transcendentalist philosophy first captured in his 1836 essay "Nature." At four foot, three inches tall, she towered over his expanding mind more than his instructors at Harvard ever would.

An avid diarist—chronicling her own faith, doubt, reading, and daily tasks in her "Almanack," or spiritual diary, over fifty years—she urged a teenage Ralph to begin his own journals. Those would, in turn, inspire the classic *Walden, Or Life in the Woods* by his protégé Henry David Thoreau. Even Thoreau's emphasis on intuition in seeking a personal and direct relationship with God through nature can be traced to Emerson's aunt. Over 1804 and 1805, when her brother was editing *The Monthly Anthology,* Mary contributed "a piece on the importance of imagination in religious life and one on natural history and its connection to natural theology," Richardson reports. Ralph was so moved by her writing that he hand-copied and indexed nearly nine hundred of her unpublished pages.

Although the two drifted apart over matters of theology in the years leading up to her death in 1863, Mary's impact on Ralph was permanent. Slowly, steadily, she formed his thinking as water shapes stone. These two—with their commitments to individualism, risk, and self-reliance—they belong to one another.

WRITTEN BY **CARA CANNELLA** / ILLUSTRATED BY **NATHAN GELGUD**
www.caracannella.com / www.nathangelgud.com

1912 GLADYS LOVE PRESLEY 1958

ELVIS PRESLEY'S MOTHER

ANY GROWN MAN WHO CALLS HIS MOTHER "baby" and speaks baby talk with her must love her tenderly. But Elvis Presley didn't just love his mother—he worshipped her. In return, she inspired him to create a sound that would change popular music forever.

It was Gladys who gave her son his first guitar for his eleventh birthday, even though Elvis had preferred a bicycle. And it was his love for Gladys that prompted him to record his first song. In 1953, Elvis walked into the Sun Records studio in Memphis to cut a version of "My Happiness" as a special birthday gift for his baby. A year later, "That's Alright, Mama" propelled him onto the national stage.

The special bond between mother and son had existed from the very minute Elvis was born. On January 8, 1935, then-twenty-two-year-old Gladys suffered a hemorrhage and barely survived giving birth to a set of twins. The first one, Jesse Garon, was stillborn, which led Gladys to believe that the surviving twin, Elvis Aaron, had inherited Jesse's soul. Elvis, she believed, was "the One." Throughout his childhood, she instilled in him how special he was. So when the studio receptionist at Sun Records asked Elvis what kind of singer he was, the eighteen-year-old answered: "I don't sound like nobody."

The belief in her only son's special calling, whatever that would turn out to be, plus having lost her father to pneumonia and her mother to tuberculosis at a young age, made Gladys very protective of Elvis. Over the objections of her husband, Vernon, she slept in the same bed as Elvis until he was thirteen and made sure he never spent a night away from home until he was seventeen. Gladys and Elvis were sleepwalkers and both suffered from recurring nightmares of impending doom.

Once Elvis's musical career took off, things went south for his muse. When Elvis was touring, she worried about the fans mobbing and tearing at him. After his chartered prop lost an engine and crash-landed, she begged him to stop flying. But even when he drove to his gigs, she still feared he'd have a fatal accident.

Gladys started drinking and became depressed. She would pop pills to sleep, use speed to wake up, and need ever greater quantities of vodka to cope. In 1958, when Elvis was drafted into the army and transferred to Germany, Gladys's gloom and despondency increased even further—as did her drinking. She put on a lot of weight, which prompted her to take diet pills. On August 14, 1958, she succumbed to a heart attack. Later, Elvis would say of that day, "I lost the only person I ever loved."

After Gladys's death, Elvis remained an incredibly successful artist, but his music would never regain the intensity of the early days, let alone create the same excitement. In his thirties he started to gain weight, the result of a lifestyle that closely resembled that of his mother—the main difference being that Elvis replaced Gladys's vodka with an enormous intake of food. In 1977, only forty-two years old, he died from an overdose of medications while on the toilet in his Graceland mansion. The date was August 16—the very same day he had buried his beloved mother nineteen years earlier and inconsolably wept, "Oh, God, everything I have is gone."

WRITTEN BY **MARS VAN GRUNSVEN** / ILLUSTRATED BY **RACHAEL COLE**
www.marsvangrunsven.com / www.rachaelcole.net

GERTRUDE STEIN'S LOVER

OCCUPYING THAT SPECIAL, INVISIBLE AREA historically reserved for homosexual partnerships, Gertrude Stein's relationship with her "companion," Alice Babette Toklas, was never entirely out in the open, but neither was it hidden from view. Between Gertrude and Alice, however, the nature of the relationship was unshakably clear. On the occasion of an early trip to Florence, Gertrude professed her love to Alice with the intention of entreating Toklas into marriage: "Pet me tenderly and save me from alarm. . . . A wife hangs on her husband that is what Shakespeare says a loving wife hangs on her husband that is what she does." Toklas wept and wept, and accepted: "She came and saw and seeing cried I am your bride."

Alice B. Toklas grew up in San Francisco to a middle-class Jewish family. Her father had come to California as a prospective miner but soon found more luck as a merchant. With hopes of one day becoming a classical pianist, Alice studied music for a couple of years at the University of Washington before her mother died in 1897, leaving her responsible for the men of the house. With no desire to marry a man, she found herself trapped. She eventually managed to secure a loan to get herself to Paris on September 8, 1907. On that same day she met Gertrude Stein.

The nurturing of Stein's brilliance was Toklas's primary occupation for most of her life. At 27, rue de Fleurus, the house in Paris where they lived together for forty years, hosting salons to some of the twentieth century's most influential artists and writers, Toklas was in charge of the household. In one famous anecdote, a photographer arrives to take pictures of Stein for a magazine spread. He asks her to engage in any everyday activity, such as unpacking her airplane bag, to which she replies, "Miss Toklas always does that." Talking on the telephone then? "Miss Toklas always does that." Stein drolly suggests he take pictures of her drinking some water, or taking her hat on and off.

Everyone at 27, rue de Fleurus had an opinion on Toklas and Stein's relationship, and Toklas, often seen as dark and self-effacing in the presence of the charismatic Stein, was under particular scrutiny. (To poet James Merrill her raspy voice was "like a viola at dusk"; Picasso's mistress Françoise Gilot likened it to a "sharpening of the scythe.") Draping herself in dramatic robes and ghostly colors, Toklas often found herself charged with entertaining the other "wives of geniuses."

"I always wanted to be historical," Stein said before she died. "From almost a baby on, I felt that way about it." But if Stein hadn't met Toklas, it seems likely she would have given up on the whole genius-of-modernism endeavor. Not only did Toklas provide a constant flow of encouragement and praise that Stein needed to keep going, but she also typed up her notebooks and prepared them for publishers. It was Alice who helped popularize Stein's trademark modernist phrase "Rose is a rose is a rose is a rose"; she came across it while typing up *Geography and Plays* and insisted that Stein employ it as a device.

But not all of Toklas's influence on Stein's work was so generative. For years, Stein scholars puzzled over Toklas's typed version of *Stanzas in Meditation*. In the manuscript, every mention of the word "may" is crossed out violently and changed to "can" with no regard for context or sound. Eventually, Stein scholars solved the mystery: Alice had suspected that the word "may" referred to one of Gertrude's former lovers, May Bookstaver, and demanded Stein remove its every mention.

After Stein died, Toklas published a cookbook that would achieve cult-like status for its eccentric recipes (particularly notable was its recipe for Hashish Fudge, which included figs, almonds, and cannabis). But her focus continued to be tending to Stein's literary estate and reputation. And, though Stein's will granted her "friend Alice B. Toklas" full rights to her estate and painting collection, the provision was not enough to save Toklas from poverty. Without official recognition of their union, Toklas was left very vulnerable. One day she came home to empty spaces in their apartment at 5, rue Christine, where paintings that she had lived with for more than half a century (works by Matisse, Picasso, Gauguin, Renoir, Manet, and others) had once hung; in Toklas's absence, Stein's niece had pillaged the apartment. Soon thereafter, Alice B. Toklas was evicted. She died penniless a few years later.

WRITTEN BY **SVETLANA KITTO**
www.svetlanakitto.com

ILLUSTRATED BY **KATTY MAUREY**
www.kattymaurey.tumblr.com

ANTOINE LAVOISIER'S WIFE

WHEN JACQUES-LOUIS DAVID WAS COMMIS-sioned to paint the portrait of the great eighteenth-century French chemist Antoine Lavoisier and his wife Marie Anne, he had evidently figured out who was really in charge of the relationship. Madame Lavoisier dominates the scene, gazing confidently at the viewer while Antoine, looking adoringly and a trifle nervously at his wife, seems to be writing under her instruction. A black-stockinged leg, pinned between her flowing skirts and the scarlet table drape, rightly suggests that this relationship doesn't lack for passion.

But it began as a marriage of convenience. In 1771, Marie's father, Jacques Paulze, a senior partner in the firm of tax collectors that the aristocratic Lavoisier joined, needed to marry her off to escape the insistence of a baroness that she be wed to the baroness's middle-aged brother. Marie, aged just thirteen, insisted she'd have nothing to do with that old "fool and ogre," and so she agreed to marry the dashing young scientist instead.

Antoine Lavoisier had already made a name for himself for his chemical studies and in 1768, aged twenty-five, had been elected to the French Academy of Sciences. In the 1770s he conducted his most brilliant work, deducing that substances burn not because they release an inflammable vapor called phlogiston (as just about all chemists then believed) but because they combine with a component of the air, which he called oxygen. Lavoisier's oxygen theory of combustion revolutionized chemistry, making sense of a whole range of phenomena, from respiration to the formation of acids.

In the 1780s Lavoisier used his oxygen theory to construct a whole new framework for chemistry. He clarified what a chemical element is (a substance that can't be reduced to anything simpler), compiled a list of no fewer than thirty-three of them, and developed methods for "analyzing" chemical compounds: splitting them into their elements and figuring out the relative proportions of each. Lavoisier's 1789 book *Elementary Treatise on Chemistry* laid the basis for the future of chemistry.

But Marie didn't stand back demurely while her brilliant husband worked away in the lab. She became his indispensable assistant. From the beginning, the young woman took a keen interest in his studies, and his friends were soon calling her his "philosophical wife." She learned chemistry, kept notes of his results, made sketches of his lab and equipment, and drew the illustrations for his 1789 book—she was an excellent artist, studying under Jacques-Louis David himself. She organized and hosted the philosophical soirées at which Lavoisier discussed science with his peers.

Most usefully of all, she translated chemical works for Antoine from English, which he never mastered. Without Marie, he would have struggled to read and then demolish the Irish chemist Richard Kirwan's "Essay on Phlogiston"—a task central to his formulation of the oxygen theory.

Lavoisier's involvement with tax collectors, and his work for Louis XVI's government, were his undoing. In the French Revolution's Reign of Terror he was accused of misconduct, and in 1794 he was sent to the guillotine. Marie was jailed and humiliated, but her spirit was undiminished. She organized her husband's notes and memoirs, ensuring his legacy. She eventually left for England, where she married Benjamin Thompson, Count Rumford, the adventurer and physicist who cofounded the Royal Institution in London in 1799. The marriage didn't last—the fact that she kept her first husband's name shows where her affections lay. She died back in Paris, aged seventy-eight.

WRITTEN BY **PHILIP BALL**
www.philipball.co.uk

ILLUSTRATED BY **ELENA BULAY**
www.behance.net/grafimale

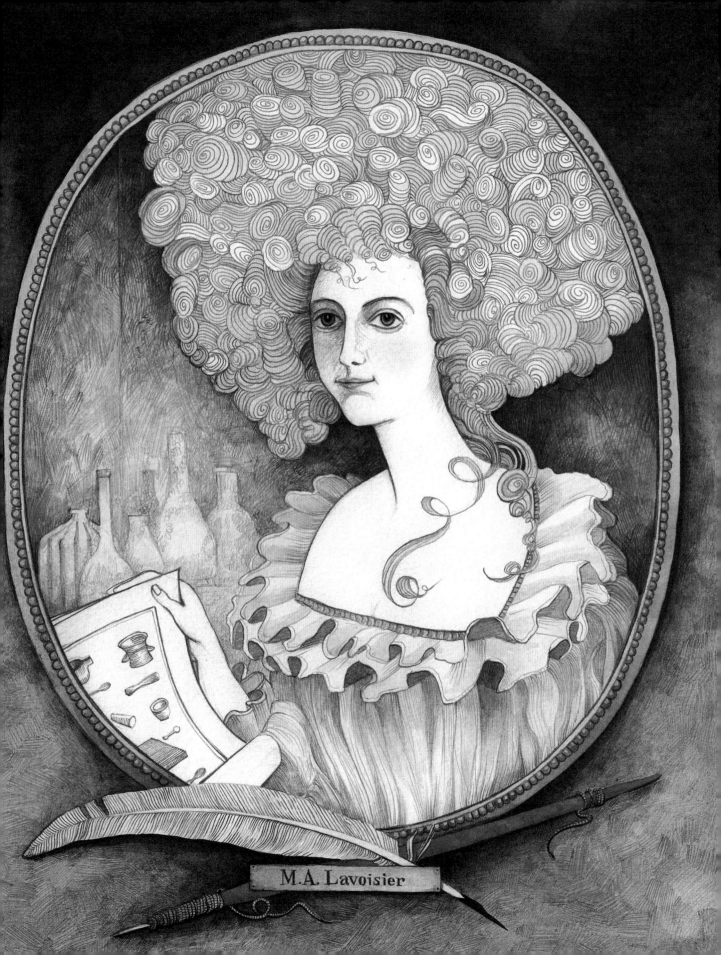

M.A. Lavoisier

CHARLES DARWIN'S COLLEAGUE

ALTHOUGH JOSEPH DALTON HOOKER IS A MINOR background character in Charles Darwin's story, he was instrumental in securing Darwin's place in history. Were it not for Hooker, Alfred Russel Wallace might today be recognized as the father of evolution.

Hooker and Darwin became acquainted just before Hooker left for his first overseas botanical studies in 1839, eight years after Darwin began his studies on the *Beagle*. During his four-year voyage, Hooker read proofs of *Voyage of the Beagle,* gaining great admiration for Darwin's work. After Hooker returned to England, Darwin wrote him for help in classifying plants from the Galápagos Islands, to which Hooker happily agreed. Thus began a decades-long correspondence.

Charles Darwin and J. D. Hooker exchanged 1,400 letters. Some were strictly professional, while others were playful, showing their friendship growing alongside their work. Some letters were deeply personal. "I think of you more in my grief than of any other friend," Hooker wrote to Darwin in 1863 after losing his six-year-old daughter. "Trust to me that time will do wonders, & without causing forgetfulness of your darling," Darwin wrote back. The two men became so close that Darwin might even have confessed committing a murder to Hooker. In essence, Darwin did just that.

On January 11, 1844, Darwin wrote one of the first references to his theories of evolution in a letter to Hooker, adding that sharing the idea of species changing over time was "like confessing a murder." The very idea of species evolving went against contemporary science that was rooted in biblical interpretation. In Victorian England, science and religious faith existed harmoniously, for science was seen as a means to discover the machinations of a designing God. However, Darwin's claims went directly against the literal interpretation of the book of Genesis. Darwin knew that some would see his ideas as extremist or even dangerous.

Darwin's letter is full of anxiety and self-deprecation, calling his work "foolish" and "very presumptuous" and telling his friend Hooker, "You will now groan & think to yourself, 'on what a man have I been wasting my time in writing to.'"

Though flippantly expressed, Darwin had his doubts. He trusted J. D. Hooker to help navigate them. The depth of this trust would become painfully evident in the coming years.

Darwin wrote two letters to Hooker on June 29, 1858. The first was Darwin's grief-stricken revelation of his eighteen-month-old son's death. "You will & so will Mrs. Hooker be most sorry for us when you hear that poor Baby died yesterday evening. . . . It was the most blessed relief to see his poor little innocent face resume its sweet expression in the sleep of death. Thank God he will never suffer more in this world." The second letter to Hooker became critical to Darwin's receiving credit for originating the theory of evolution.

Hooker was anxious to publish Darwin's work because another naturalist, Alfred Russel Wallace, was near to publishing his own findings on evolution. Two weeks before the death of Darwin's son, Wallace had written Darwin himself for help in publishing his ideas. Darwin acknowledged to Hooker the need to move forward in his second letter on June 29. Despite feeling that his work imperfectly explored the means of change and did not touch on reasons why species changed, Darwin sent the pages along, remarking, "I daresay all is too late. I hardly care about it."

Hooker cared deeply for Darwin's work on evolution, having seen it as far back as 1839 and contributing to it for more than fifteen years. With the help of geologist Charles Lyell, Hooker ensured that when Wallace's work on evolution was presented on July 1, 1858, Darwin received credit for originating the theories.

Charles Darwin passed into history with his fame secured. J. D. Hooker's legacy drifted into more modest annals. When Hooker died on December 10, 1911, his widow was offered a burial for him alongside Darwin in Westminster Abbey. But Hooker was buried in the churchyard of St. Anne's on Kew Green beside his father, having succeeded him as director of Kew Gardens in 1865 and working there for twenty years. Although Hooker's place of rest and place in history are more modest than Darwin's, their stories remain intimately entwined.

WRITTEN BY **COLIN MILROY**
www.thefactorytheater.com

ILLUSTRATED BY **MASHA MANAPOV**
www.mashkaman.com

1866 ALEXANDER ULYANOV 1887

VLADIMIR LENIN'S BROTHER

THE WORLD TODAY WOULD BE QUITE A DIFFERent place if not for one very determined man—Vladimir Ulyanov, known to the world under his nickname, Lenin. In 1917, he organized a disjointed mass of rebelling workers into an efficient army that overthrew the centuries-old Russian monarchy and founded the world's first socialist state: the Soviet Union.

The Soviet revolution gained momentum by giving a voice to the poor and the uneducated. "Land to the peasants! Factories to the workers!"—that slogan led Russia's underprivileged to battle and on through a bloody civil war. The revolution intended to destroy the old society completely and build a new one on its ruins, and it succeeded in doing that. All the institutions were to be closed down and reinvented; all possessions taken away and reassigned. The massively ambitious plan was to start from ground zero, to erect a new civilization on a land cleansed of its past.

But people are attached to their past and rarely ready to erase it without a trace, even if offered something better. Who was this Lenin who believed in destruction so much that he managed to infect others? He must have suffered terribly in that old life that he yearned to annihilate. His life in the old regime must have been so unbearable that he preferred anything—pools of blood, cities in flames—to the old Russia he knew. What happened to him?

What happened was, he grew up in a privileged, well-off, loving family. His father—a nobleman, professor, and high-ranking education administration official—invested in his children's education and received well-connected guests in his comfortable house. His mother, a wealthy bourgeoise by birth, organized their home life around staging plays, reading books, and practicing foreign languages over meals. Vladimir received an excellent education at a private school, where he learned Latin, Greek, German, French, and English. His teachers remember him as a diligent, straight-A student who showed no signs of rebellion or dissatisfaction. He looked up to his elder brother, Alexander, who went off to St. Petersburg to study math and physics. The family gathered by the fireplace to read Alexander's letters out loud. In his third year at the university, Alexander received a gold medal for independent scientific research in zoology. Vladimir and his younger siblings adored their talented brother and hoped to follow in his steps. When their father died unexpectedly at age fifty-four, Alexander became the de facto head of the family, the main center of gravity for his mother and five younger siblings.

And then, in Vladimir's last year of high school, the terrifying news comes: Alexander is arrested for participation in a terrorist plot to assassinate the czar and is sentenced to be hanged. Horrified, all friends and neighbors turn away from the family. Even an old teacher friend, who, for decades, had spent his evenings at the Ulyanovs' playing chess, stops coming. The mother, in fever from shock and fear, travels to St. Petersburg to ask the czar for mercy. Alexander refuses to sign the petition to spare his life. His mother begs; Alexander finally agrees, citing his family's well-being as the reason. The czar refuses the petition. Alexander is executed.

The same year, Vladimir enters the university to study law. Right away, he joins a revolutionary circle, thus kicking off his long, dizzying career as the ideologist, mastermind, and leader of the twentieth century's biggest revolution. Now, he is often dubbed "a bloody genius." One of his most controversial decrees was the order to assassinate the czar's family, including five children.

WRITTEN BY **NINA WIEDA**
www.middlebury.edu/academics/
cmlt/faculty/node/434576

ILLUSTRATED BY **RICCARDO VECCHIO**
www.riccardovecchio.com

103 B.C.E. MARCUS TULLIUS TIRO 4 B.C.E.

MARCUS TULLIUS CICERO'S SECRETARY

Cicero's soaring rhetoric has reached across the ages, inspiring the philosophers of the Enlightenment and the US Founding Fathers' vision of constitutional democracy, but the influence of Rome's greatest statesman might have ended with the empire had it not been for Tiro, the learned slave who faithfully recorded his master's every word—and invented a form of shorthand that enabled him do so.

Scholars believe Tiro was born in 103 B.C.E. in the home of Cicero's family, a well-to-do but by no means aristocratic clan from a provincial town outside Rome. Marcus Tullius Cicero's talent and ambition enabled him to rise to the highest echelons of Roman power, first as a feared courtroom lawyer and later as a senator, consul, and master political operative who advised Pompey and went toe-to-toe with Julius Caesar.

As archivist and scribe, Tiro recorded his master's voluminous thoughts on governance and philosophy. Tiro's work also preserved Cicero's ideas about how political power could be shared and kept in balance, a template for the Founding Fathers as they struggled to create the US Constitution.

As Cicero turned his rhetorical weapons against the tyranny and corruption of the crumbling empire, Tiro dedicated himself to guarding and disseminating the master's words. Cicero spoke so seamlessly that Tiro developed a four-thousand-character symbolic script to transcribe the master's orations as quickly as he delivered them. He used an iron stylus to take notes on a wax tablet and later made permanent copies on papyrus.

Although he was a few years younger than Cicero and lived well into his nineties, Tiro suffered ill health for much of his life. Cicero's concern for Tiro's well-being reveals a deep affection for Tiro as a treasured friend and not merely his secretary. "Even though, when well, he is tremendously helpful to me in all kinds of business or literary pursuits, I want to see him healthy because he is civilized and modest, not because it is convenient for me," Cicero wrote to his friend Atticus.

Cicero eventually gave Tiro his freedom and supported Tiro's decision to exercise his right as a freed man to buy property. He seemed to view Tiro more as a family member and confidant, and the flirtatious tone of their personal correspondence hints at something more. Cicero even penned a romantic ode to Tiro, though scholars believe he intended it to be a playful send-up of romantic Greek poetry.

In any case, Tiro was as much Cicero's collaborator as stenographer. Cicero: "My (or our) literary brainchildren have been dropping their heads missing you. . . . Pompey is staying with me as I write, enjoying himself in a cheerful mood. He wants to hear my compositions, but I told him that in your absence my tongue of authorship is tied completely."

Tiro was also an author in his own right, writing a biography of Cicero that would be referenced by the ancient historian Plutarch. Although Tiro's own writings have been lost to history, a version of Tiro's shorthand, "Tironian notes," continued to be used in European monasteries until the seventeenth century.

WRITTEN BY **JANE H. FURSE**
www.JaneHFurse.com

ILLUSTRATED BY **CACHETEJACK**
www.cachetejack.com

GWEN JOHN

AUGUSTE RODIN'S MUSE

GWEN JOHN WAS A YOUNG FEMALE ARTIST. SHE was originally from Wales but decided to walk across France with another woman, painting people's portraits as she went, so they would have enough money to buy food. This would be quite unusual even nowadays, but it happened in 1904, more than a hundred years ago, when well-bred women wore ankle-length skirts and were supposed to stay in their homes.

This wasn't the only unusual thing about Gwen. When she got to Paris, she rented a tiny attic apartment near the train station in Montparnasse and she began to model for a sculptor by the name of Auguste Rodin. Rodin loved Gwen John, even though she was twenty-eight years old and he was sixty-four and had a long white beard. Gwen loved Rodin, too, eventually sending the old man more than two thousand handwritten and illustrated letters. Every day before she modeled for him, they would climb into an old cupboard where he stored his paints and kiss.

They had to be careful not to be seen, as Rodin was already famous in France, and his reputation was spreading throughout the world. He would go on to become one of the most famous of all sculptors, defying convention again and again. He had just finished a statue called *The Thinker* when he met Gwen.

After the sculpture of *The Thinker* was exhibited, people in England asked Rodin to make a statue of the painter James McNeill Whistler, who had recently died. Rodin wanted to make a massive sculpture that could be exhibited together with *The Thinker*, like bookends, but while *The Thinker* was bent over and compressed, he wanted his new sculpture to show an upward thrusting release of energy.

Rodin knew that Gwen had been a student of Whistler and that she was a strong and powerful woman. He also loved her and wanted to have a permanent record of what she looked like, so he made an unusual decision. Instead of portraying Whistler for the commission, he made a sculpture of Gwen, climbing a steep mountain. At the time, taking this approach rather than creating a simple bust of Whistler was very innovative and shocking.

The public complained; but people also noticed Rodin's work because it was radically different from everyone else's. His decision, because of his love of Gwen, to portray Whistler as a woman climbing a steep mountain was a turning point in his career. He called the new sculpture *Muse Climbing the Mountain of Fame*.

A muse is someone or something that inspires an artist to create her or his best work. Even though Gwen wasn't Whistler's muse (she was Rodin's!), she is still immortalized, in plaster, and marble and bronze, in Rodin's extraordinary and powerful *Monument to Whistler*.

WRITTEN BY **GOLDIE GOLDBLOOM**
www.goldiegoldbloom.com

ILLUSTRATED BY **KATRIN COETZER**
www.katrin.co.za

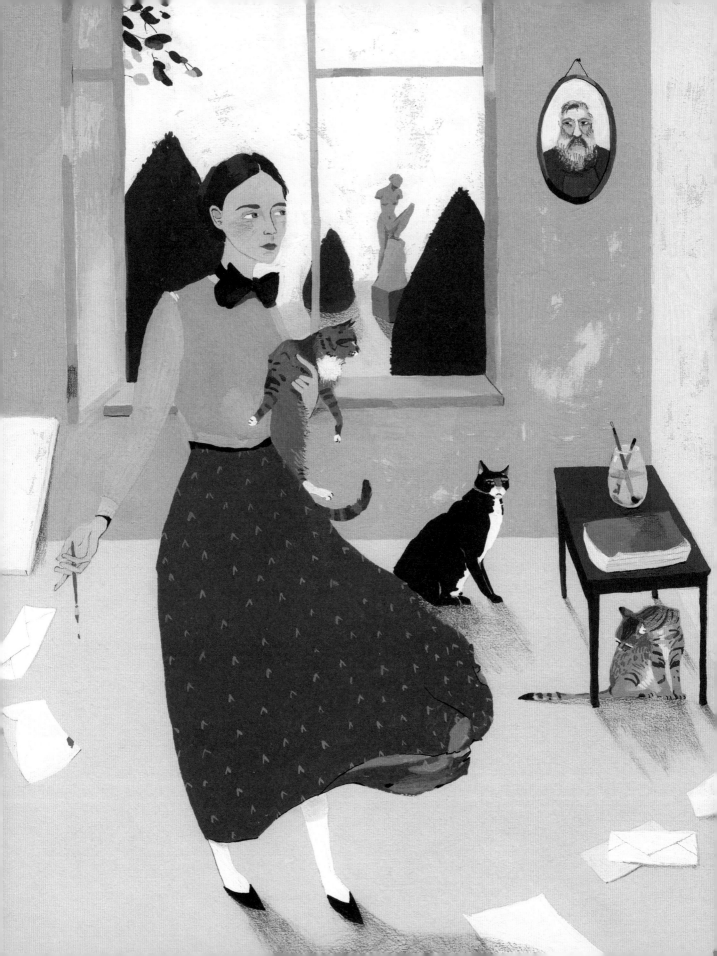

1882 JOHNNY TORRIO 1957

AL CAPONE'S MENTOR

JOHN "LITTLE JOHNNY" TORRIO, LATER KNOWN AS "Johnny Terrible," "Johnny the Brain," and "Johnny the Immune," was born in Italy in 1882 and raised on New York City's Lower East Side. A bouncer, bruiser, and gang leader from a young age, Torrio was recruited to rid his uncle "Big Jim" Colosimo of some extortionists in Chicago in 1909. Through murder and persuasion, Torrio was able to free his uncle's chain of brothels from outside financial pressures and soon took over all management responsibilities.

Torrio used his business acumen to bring class and horizontal integration to the Chicago prostitution trade, dressing call girls as wholesome young virgins, threatening the competition, and introducing stricter accounting practices. While bringing order and organization to the Windy City sex trade, Torrio saw a new business opportunity in bootlegging. Colosimo, fearing the attentions of rival gangs and the police, forbade his nephew from getting involved in liquor distribution. His refusal to expand operations in light of the newly amended Constitution in 1920 led to a dispute, his death, Torrio at the top of the family business, and illegal alcohol in every bordello in Chicago. Big Jim's murder took place on the steps of his most popular nightclub, Colosimo's Cafe, at 4:25 on a Tuesday afternoon. No one was ever prosecuted.

As Torrio's power and influence expanded, he organized the city into different sections of turf controlled by different gangs, bringing to Chicago crime the same level of organization that he brought to sex-for-pay earlier in his career. The most important thing Torrio brought to Chicago was his former New York errand boy and gang associate, Alphonse Gabriel "Al" Capone. The two met shortly after Alphonse was expelled from a Brooklyn middle school for punching a teacher. Capone worked under Torrio in various New York gangs including the Forty Thieves Junior and the Brooklyn Rippers. After attempting to live the straight life as a legitimate bookkeeper and family man for six years in Baltimore, Capone jumped at the opportunity to move to Chicago and manage a brothel for Torrio. Capone, with business experience and street smarts, became a trusted ally to Torrio and soon became his partner in crime. Together, they controlled the Chicago Syndicate and reaped immense profits from the city's liquor, prostitution, and gambling industries.

Although Torrio had organized the city's criminal outfits and brokered peace between them, he was not without enemies. With Prohibition profiteering in full swing, Johnny the Immune survived one assassination attempt with only a few bullet holes in his hat and survived a second only because his would-be assassin, with a gun pressed against Torrio's temple, ran out of ammunition and ran out of the room. But after surviving being shot in the jaw, lungs, groin, legs, and abdomen while returning from dinner one night with his wife, Torrio began to think about retirement. Surrounded by thirty bodyguards and recovering from surgery in a Chicago hospital in 1925, Torrio decided that he did not want to test the limits of his nickname. He cashed out, gifted his $100-million-a-year empire to Capone, and got out of town. Capone continued a life of crime, immortalized in innumerable films, publications, and Public Enemy No. 1 T-shirts.

Capone, who famously said, "You can get much farther with a kind word and a gun than you can with a kind word alone," and who is believed to be responsible directly and indirectly for at least four hundred murders, was finally brought down by charges of income tax evasion in 1931. After running Chicago, drinking heavily, making millions, killing hundreds, and going to jail, Capone suffered from the physical scars of a life hard lived and the psychiatric manifestations of tertiary syphilis. Shortly before his forty-eighth birthday, with deteriorated mental health, angrily denouncing communists and imagined enemies, Capone was released from an Ohio prison to die at home in 1947. Ten years later, Torrio, long retired and extremely wealthy, died of a heart attack on a barber's chair near his home in Brooklyn at the age of seventy-five.

WRITTEN BY **DAVE ZACKIN**
www.davezackin.com

ILLUSTRATED BY **KYLE PLATTS**
www.kyleplatts.com

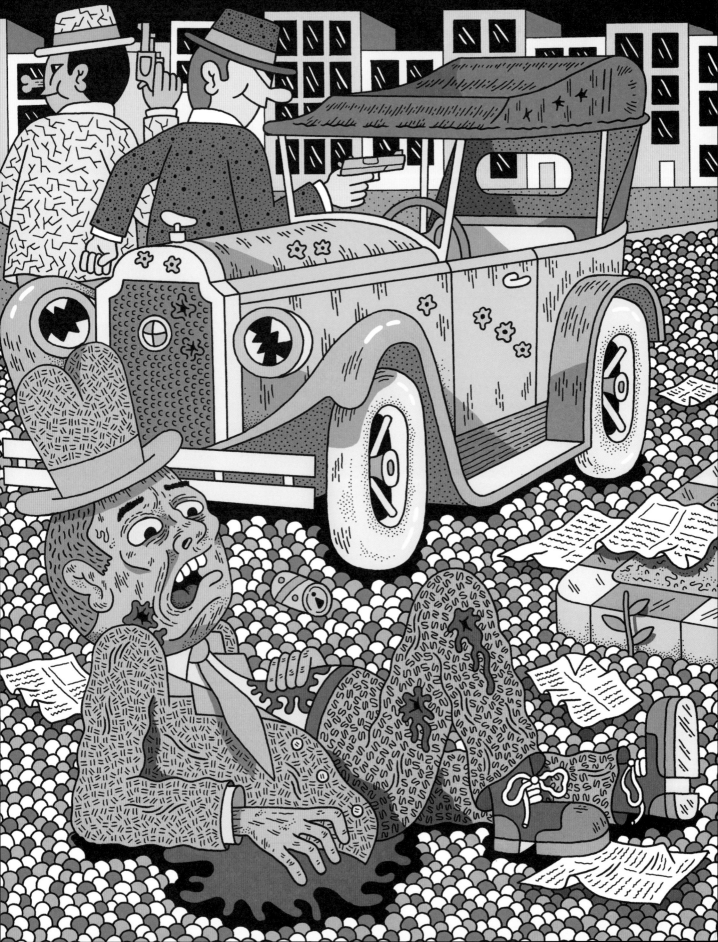

HELEN KELLER'S TEACHER

ANNE SULLIVAN ARRIVED AT THE TUSCUMBIA, Alabama, home of six-year-old Helen Keller on March 3, 1887. She found the blind, deaf, mute girl she'd come to tutor roaming the home like a wild animal, grabbing food off others' plates and throwing tantrums to get what she wanted. Sullivan, just twenty-one years old, couldn't have imagined that her first teaching position would last a lifetime, or that her seemingly incorrigible pupil would become an influential writer and activist, as well as her friend and companion until the day she died, forty-nine years later.

Sullivan had graduated from Boston's Perkins Institution for the Blind as valedictorian in 1886. She went to Perkins after a brutal childhood. Born Johanna Mansfield Sullivan in Agawam, Massachusetts, to poor Irish immigrant parents on April 14, 1866, Annie, as she was known, was nearly blind by age seven due to an untreated case of trachoma. Her mother died when Annie was eight, and just before she turned ten, her abusive father abandoned the surviving three of his five children: Annie; her brother, Jimmie, five, who had a tubercular hip; and sister, Mary, three. Mary was reportedly sent to live with an aunt, and Annie and Jimmie were sent to the state poorhouse in Tewksbury, where Jimmie soon died and Annie underwent two unsuccessful eye operations.

At fourteen, bright, strong-willed Annie begged to be sent to Perkins; there she learned to read and write and had several eye operations that greatly improved her sight. She also learned the manual alphabet—"finger spelling," she called

it—to communicate with a friend who was deaf and blind. She would use it to teach Helen, achieving a breakthrough a month after her arrival, when she flushed water from a pump onto Helen's hand and spelled W-A-T-E-R into her other hand—the climactic scene of the 1959 play and 1962 movie *The Miracle Worker*, which chronicle the beginning of Annie and Helen's relationship.

"The word coming so close upon the sensation of cold water rushing over her hand seemed to startle her," Annie wrote to a former teacher at Perkins, on April 5, 1887. "She dropped the mug and stood as if transfixed. A new light came into her face."

Helen thrived under Annie's tutelage and gained admission to Radcliffe College in 1900. Annie attended every class with her, spelling each lecture and textbook into her hand. Helen graduated with honors in 1904—the first deaf and blind person in the United States to earn a bachelor of arts degree.

At Radcliffe, Helen wrote her autobiography, *The Story of My Life*, published in 1903. Annie and Helen's friend John A. Macy, a Harvard instructor, helped edit it. He and Annie fell in love and married in 1905, and the three lived together. The marriage crumbled within a few years, and the couple separated in 1914 but never divorced. Annie and Helen traveled, lectured, advocated for the disabled and other causes, and raised funds for the American Foundation for the Blind.

Annie died of a heart attack at seventy, blind and in a coma, at home in Forest Hills, New York, on October 20, 1936, with Helen holding her hand.

WRITTEN BY REGAN MCMAHON / ILLUSTRATED BY HYE JIN CHUNG
www.commonsensemedia.org / www.hyejinchung.com

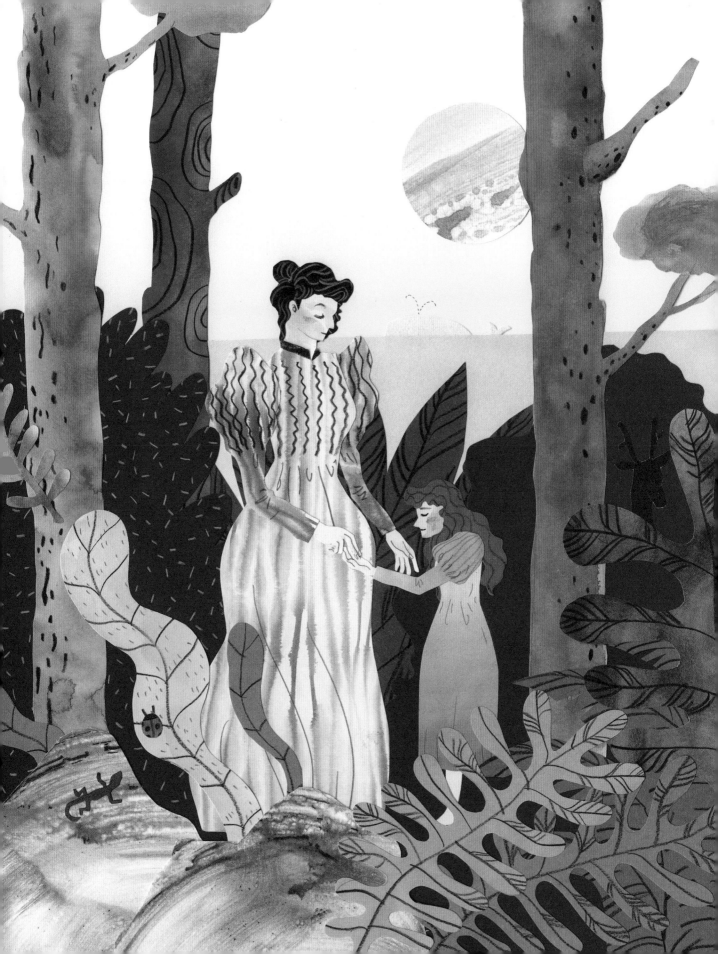

WOODY GUTHRIE'S WIFE

FOLKSINGER WOODROW WILSON "WOODY" Guthrie (1912–1967) occupies a mythic status in the United States, the godhead for socially engaged songwriters. Schoolchildren across the country diligently learn Guthrie's "This Land Is Your Land," and his lyrical refrains waft nightly from coffeehouses.

Few know about Marjorie Greenblatt Mazia, Guthrie's second wife, social guide dog, critic, editor, helpmate, lover, nurse, and artistic peer during much of his most productive and creative period.

Marjorie Mazia (her stage name) was born Marjorie Greenblatt in Atlantic City in 1917, the year the Russian Revolution began. Her parents were Russian Jewish immigrants whose fortunes waxed and waned in the clothing industry, but who remained passionate about intellectual activity and the arts. Her mother, Aliza Waitzman, was a Yiddish lyric poet who emerged as a key figure in the mid century Yiddish revival and was herself a major influence on Guthrie's religious writings.

When Mazia met Guthrie in New York in 1942, she was a longtime member of the revolutionary Martha Graham Dance Company. Graham held Mazia in such high regard that she anointed her instructor #1 for fifteen years. Mazia was among the very few people from whom Graham took criticism. As part of another dancer's production, Mazia was drafted to teach Guthrie to perform songs in systematic time and rhythm. Guthrie was undisciplined with "time," as he was with most everything, but Mazia set him straight. In the process they fell in love.

Both Guthrie and Mazia were married at the time. Never bound by social conventions, Mazia became pregnant by Woody but continued living with her husband until the child was born. After her divorce and subsequent marriage in 1945 to Guthrie, their first child, Cathy Ann, died in a tragic fire. They had three more children—Arlo, Joady, and Nora.

A domesticated and more disciplined Guthrie churned out scores of songs, recorded 125 tracks for Moe Asch's iconic Folkways Records, and performed steadily with the likes of Pete Seeger and Leadbelly. He and Marjorie combined forces for a series of songs that Guthrie recorded for Folkways as *Songs to Grow On*, a classic work and the foundation for the children's music genre.

When the publisher E. P. Dutton expressed interest in Guthrie's writing, Mazia kept him on a strict schedule and organized his work. This is evident from one of the letters she wrote during that time, "Put a wet towel around your neck (on a hot day) and it'll work miracles. Eat lightly but well. . . . And please, honey, take your shower!!!" That book became *Bound for Glory*, a semiautobiographical account of the Dust Bowl, which Bruce Springsteen counts as a major influence.

Even after they divorced in 1953, Marjorie Mazia remained central to Guthrie's life. In 1967, Woody succumbed to his fifteen-year struggle with Huntington's disease (HD), a rare neurological degenerative disease that was largely unknown at the time. Marjorie soldiered on and established her own dance school, helped create the organization that became the Woody Guthrie Foundation, maintained his archives, established the Committee to Combat Huntington's Disease, and helped create the World Federation of Neurology Research Commission on HD. A formidable lobbyist, she persuaded President Jimmy Carter to form a presidential commission on neurological diseases. By the time of her death, she had created a worldwide movement against HD that brought better treatment and hope to victims and families.

She also alternately nurtured and cajoled writers to turn their attention on Woody, including Joe Klein, author of the first real biography of Guthrie. She even wrote letters to young musicians, including this author, encouraging them to perform and record Woody's material and to carry on as "Woody's Children."

WRITTEN BY **BUCKY HALKER**
www.buckyhalker.com

ILLUSTRATED BY **RACHEL LEVIT**
www.rachellevit.com

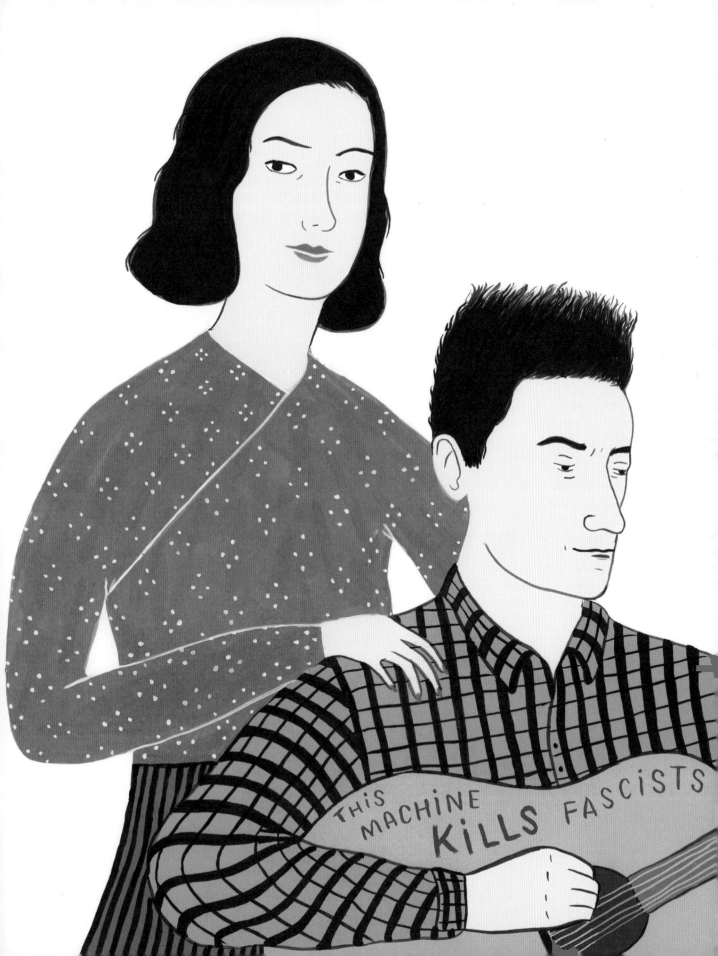

EDGAR ALLAN POE'S FOSTER FATHER

JOHN AND FRANCES ALLAN OF RICHMOND, VIRGINIA, brought Edgar Poe to live with them in 1811, when he was two years old. Edgar was an orphan. His father, David Poe, had died sometime during the preceding year; his mother, Eliza, early that December. At first, the informal adoption by an affluent businessman without children of his own seemed like a happy one: Frances Allan and her maiden sister, who resided with the Allans, doted on the boy. Household accounts show that Edgar was well provided with books and toys, and in his correspondence John mentions Edgar often and with pride. In surviving early letters, Edgar addresses Allan as "My dear Pa."

But by the time that Edgar Allan Poe was a student at the new University of Virginia in 1826, something in this relationship had gone wrong. The evidence is incomplete and conflicting, so it is hard to tell exactly what transpired. Poe claimed that Allan, having agreed to support him in his studies, left him without sufficient funds to pay his tuition, room, and board. He was forced to turn to gambling, he said, as a last resort to pay his bills, and he ended up in debt. For his part, Allan seems to have formed a bad opinion of Poe's character during the boy's adolescence, calling him miserable, sulky, ill-tempered, and without gratitude. He claimed that he had come to Charlottesville to pay all of Poe's debts, apart from those incurred through gambling. It's not clear whether he indeed did this, or whether he did or did not help Poe find employment later on that year.

What caused the rift? There is no satisfying answer to this question, though Allan's own biography offers some clues. During Poe's childhood, Allan suffered financial losses when his attempt to establish his trading business, Ellis & Allan, in London failed. Could this have made him feel less generous, or act less patiently toward his foster son? After the Allan family returned to Richmond, Allan was unfaithful to his wife. Poe, who was devoted to Frances, may have known about this, disapproved, and treated Allan coldly. Whatever the reasons, the fact remains that what started as a warm, supportive relationship devolved into fractiousness and mutual dislike, such that Allan in his "recommendation" for Poe to West Point wrote: "Frankly, sir, do I declare he is no relation to me whatever." When Poe's foster father was dying, he went to visit him. (John Allan was remarried by then and had a legitimate heir). Edgar had to physically push aside John's second wife to get to him. As he approached, Allan raised his cane to strike Poe if he came closer and ordered him out of the room. This was the last time that they met.

Allan's influence on Poe, then, is complicated, to say the least. He was the reason that Poe gained an education. He took Poe abroad, his first and only journey outside the United States. This encounter with the Old World, with the long-settled, storied landscapes of England and Scotland, fed the settings of Poe's fiction. But what about Allan's rejection of Poe, whether justifiable or not? Allan was one of a list of parental figures to abandon Poe during his young life. So many of Poe's stories center on houses and families that have turned from noble and grand to unfamiliar, decadent, and broken, and on people who at first appear to be one thing but are actually something else entirely. The uncanny, the *unheimlich,* is most fundamentally a feeling that the skin may slip off the world at any moment, that what is familiar, homey, and welcoming may turn strange and hostile without warning. Clearly, Poe's early experiences could have engendered such a sense of things. This cannot be attributed entirely to John Allan. But Allan's apparent inconsistency, his inexplicably altered affections for his foster son, can't have done anything to dispel this frightening outlook that so permeates Poe's fiction.

WRITTEN BY **EMILY MITCHELL**
sites.google.com/site/lastsummeroftheworldbook

ILLUSTRATED BY **BYRON EGGENSCHWILER**
www.byronegg.com

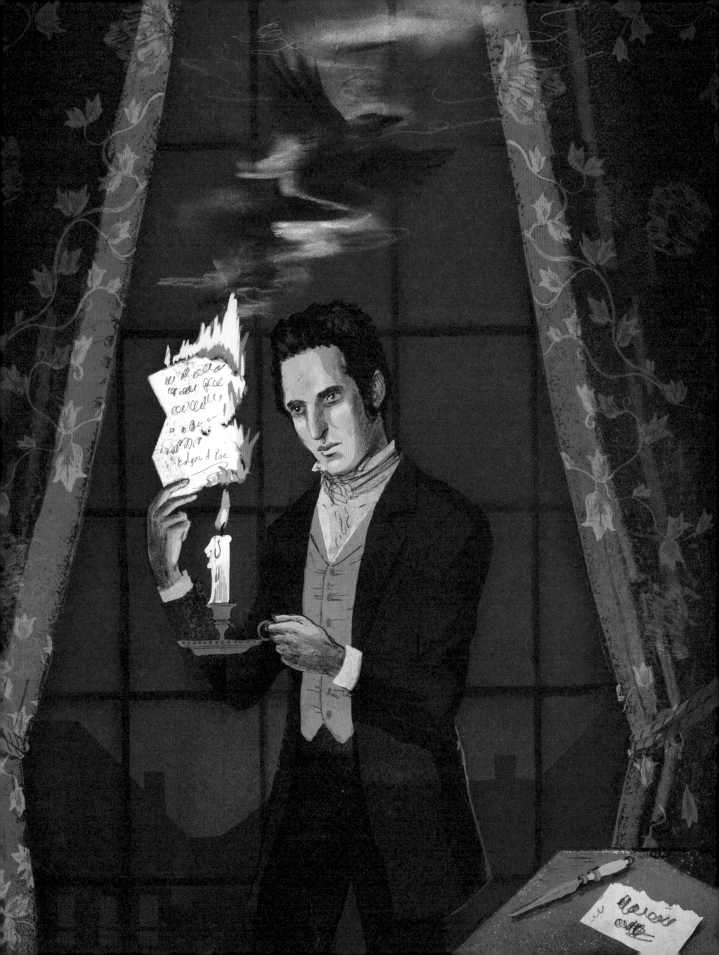

RICHARD NIXON'S SECRETARY

WHILE RICHARD NIXON MAY NOW BE remembered as one of the United States' least loved presidents, the man knew the way to a secretary's heart. In 1947, Nixon wowed Rose Mary Woods, then working as a secretary on a select House foreign affairs committee, with his skill at completing expense reports. When Nixon was elected to the Senate, Woods went with him as a staff member. She served Nixon for decades, through his election as vice president and his campaigns successful and otherwise, even leaving Washington with him to work at his New York law practice in the 1960s. Nixon's return to Washington upon his presidential election in 1968 was, of course, a return for the devoted Rose Mary Woods, too.

Born in 1917 into a tightly knit Irish Catholic family in Sebring, Ohio, Woods began her professional career working at Royal China, Inc., a pottery company, at the age of seventeen. Although she was once engaged to marry, her fiancé died in World War II. In an effort to shake her grief, Woods pulled up stakes and moved to Washington, DC, in 1943, performing secretarial work at a series of federal offices before accepting a position with Nixon in 1951. Over the years, Rose Mary Woods became almost part of the Nixon family—so close that she traded clothes with first lady Pat Nixon and went by "Aunt Rose" to the Nixon daughters.

Woods's more than twenty years of devoted service are remarkable and earned her unprecedented attention. She logged hundreds of thousands of miles traveling with Nixon, whom she called "the Boss," and was well known for her loyalty. In 1961, the *Los Angeles Times* named her one of its nine "Women of the Year," marking the first time the title was bestowed on a secretary, and ten years later, *Ladies' Home Journal* listed her as one of its "75 Most Important Women in the United States." Despite these accolades, Woods's legacy is largely tied to the Watergate scandal. Woods claimed responsibility for accidentally erasing up to five minutes of tape. According to Woods, the gap, part of a larger gap of eighteen-and-a-half minutes, might have been made when she reached to answer the phone while accidentally pressing the erase key of a transcriber and stepping on the machine's pedal. Skeptics dubbed the seemingly unlikely maneuver "The Rose Mary Stretch."

Woods remained loyal to Nixon even as his political career ended, maintaining his office in the Executive Office Building until the Ford administration forced her to vacate it. Under Woods's care, the office, kept exactly as Nixon had left it, was a kind of shrine, complete with a half-smoked cigar in the ashtray. Although Woods never married, she claimed to have been happy to have dedicated her life to serving Nixon, a professional relationship that had given her a "stimulating and interesting life."

WRITTEN BY CARLY A. KOCUREK / ILLUSTRATED BY ELLA COHEN / ELLAKOOKOO
www.sparklebliss.com/blog / www.ellakookoo.com

1841 LAVINIA WARREN THUMB 1919

TOM THUMB'S WIFE

GENERAL TOM THUMB NEEDED A WIFE. THE diminutive performer, whose given name was Charles Stratton, had been the most famous exhibition of the showman P. T. Barnum since he was presented to Queen Victoria at the age of five. For the next twenty years, the "little general" charmed European and American audiences with his singing, dancing, and—most of all—his doll-like proportions.

But by 1863, Stratton was officially retired from performing—there was little demand for a twenty-six-year-old living doll. A miniature marriage—and a miniature spouse—was the logical next step for Barnum's protégé, and Mercy Lavinia Warren Bump, a wasp-waisted, delicate brunette, the logical choice. She was as tiny as Stratton, but not as practiced at show business: her middle-class, *Mayflower*-descended family in Massachusetts was a far cry from Barnum's stage, from which Stratton first saw her and reportedly fell in love.

Whether the wedding of Lavinia Warren (her theatrical name) and General Thumb was only a public relations stunt is impossible to say with any certainty. If just a stunt, it was one for the ages: Hundreds of guests witnessed the couple's nuptials inside New York's fashionable Grace Church. Thousands more paid to attend their reception, orchestrated by Barnum, at the Metropolitan Hotel. The "Loving Lilliputians," as *The New York Times* dubbed them, greeted their guests from atop a grand piano. President and Mrs. Lincoln sent a wedding present and subsequently hosted the couple at a White House reception. That, too, was show business: a bit of bread and circus to take the Union States' mind off the ongoing Civil War.

The Thumb nuptials did more than that: They made the cover of *Harper's Weekly* in February 1863 and revived the general's fame, as Barnum (and Thumb himself) had intended. More important, the event thrust Lavinia into a complicated spotlight: She was at once a freak of nature and a "queen of beauty." The press managed this juxtaposition by infantilizing her: "We . . . make a pet out of her in spite of ourselves," one reporter confessed. Pet or no, the public was happy to pay to meet Tom Thumb's bride: The couple made their honeymoon into a three-year, 1,471-appearance tour of the United States and Europe. In order to hold their audience's interest, the couple also began to be serially photographed holding normal-size infants the better to suggest (but never confirm) that Lavinia had borne a child. For late-nineteenth-century America, it was a ticklish suggestion, particularly since the Thumbs' publicity broadsides trumpeted the fact that the couple themselves were "no larger than so many babies." The idea of two "Lilliputs," as *The New York Sun* called them, reproducing was as fascinating as it was taboo.

General and Mrs. Thumb capitalized on their joint celebrity for the next twenty years, making appearances as far away as Bangladesh. And Lavinia remained a national favorite even after Thumb's 1883 death. Her remarriage, to fellow performer and little person Count Primo Magri, was produced by Barnum, Bailey, and Hutchinson and once again warranted a headline in *The New York Times*. With Magri she formed the traveling Lilliputian Opera Company and performed in several early silent films. For a time, the couple made their home in "Lilliputia," the half-scale "Midget Village" at Coney Island's Dreamland amusement park. In this shrunken universe, Countess Magri was once again queen, lending her Victorian gentility to the thoroughly modern sideshow of twentieth-century Coney Island. It is tempting to see her installation at Dreamland as the apogee of her independent fame, but Lavinia Bump Warren Thumb Magri might not have agreed: At her death, she was buried in Tom Thumb's plot at Mountain Grove Cemetery in Bridgeport, Connecticut—a stone's throw from the grave of P. T. Barnum.

WRITTEN BY **ELIZABETH L. BRADLEY**
www.knickerbockerny.com

ILLUSTRATED BY **ROBERT BRINKERHOFF**
www.robertbrinkerhoff.com

DANTE GABRIEL ROSSETTI

WILLIAM MORRIS'S COLLABORATOR

WILLIAM "TOPSY" MORRIS (1834–1896) WAS a true Renaissance man; he designed furniture, stained glass, tapestries, and wallpaper; he wrote poetry and fiction; he was an active socialist; and he even opened his own press, Kelmscott Press. His expansive body of work—from intricate floral and animal textile designs to illustrated books that established the modern fantasy genre—has made a lasting impact on artistic practices worldwide. Morris's friends and contemporaries helped influence his ambitious career path, but none as much as Dante Gabriel Rossetti.

Rossetti and Morris met in 1856 when they both contributed to the *Oxford and Cambridge Magazine*, a publication dedicated to art, poetry, and reviews; from this point forward, their artistic, intellectual, and personal lives became inexplicably intertwined. Dante Gabriel Rossetti had studied poetry and then painting at the Royal Academy of Arts in London. Rebellious by nature, Rossetti challenged the conservative values he was taught; his paintings featuring colorful, detailed compositions and beautiful women in classical poses evinced his interest in the medieval and an aesthetic driven by libido. Rossetti, like Morris, appreciated community and routinely gathered with artists to explore like-minded aesthetic endeavors.

Rossetti's influence on Morris was immediate and multifaceted. First, Rossetti persuaded Morris to abandon a career in architecture for other artistic pursuits. Morris recounts, "Rossetti says I ought to paint, he says I shall be able; now as he is a very great man, and speaks with authority and not as scribes, I must try. I don't hope much, I must say, yet will try my best—he gave me practical advice on the subject." Then, in 1857, Rossetti introduced Morris to the future Mrs. William Morris, Jane Burden. Jane, whom Rossetti had met at the theater, was persuaded to model for the Oxford Union Society murals, a commission to paint the interior of the society's new debate chamber (today known as the old library) obtained by Rossetti, Morris, and other artists in their circle. Morris was captivated by Jane's beauty, and Rossetti, obsessed with her but already committed to another woman, encouraged their union. Further, by 1861, Morris and Rossetti were founding members of Morris, Marshall, Faulkner & Co., a decorative arts firm for designing furniture, stained glass, and textiles for church and home interiors.

The 1860s were a time of intense creativity for both Morris and Rossetti. Morris dedicated his energy to the firm and the design of his home, Red House; gradually, his focus shifted from painting to textile design. Rossetti, in addition to his work for the firm, continued to write poetry and paint, though the decade also brought him intense heartbreak. Rossetti finally married his love and muse of ten years, Elizabeth Siddal, but their happiness was short-lived; just two years later, in 1862, after the stillbirth of their child, Elizabeth overdosed on laudanum, a drug she took for depression and to which she was addicted. Distraught and depressed, Rossetti sacrificed his poetry and buried the bulk of his unpublished works in her grave.

Rossetti quickly found other women to replace his beloved Elizabeth as model and inspiration for his works—Jane Morris topping his list of beauties. Rossetti painted many works of his friend's wife and he wrote numerous poems—some with subtle hints of admiration, others with racy expressions of sexuality—inspired by his desire for Jane. In many ways, the years following Elizabeth's death were Rossetti's most productive, his output punctuated by poems and paintings inspired by his loves, both alive and deceased. In 1869, Rossetti had his wife's grave exhumed to retrieve his earlier poems. Rossetti published these along with newer prose and some translations in a collection that would become his greatest literary achievement, though they were not well received at the time.

This same year, Rossetti and Morris rented Kelmscott Manor, in Kelmscott, Oxfordshire. Morris would largely remain absent from the home, leaving Rossetti and Jane to share each other's company, their affair lasting many years. Perhaps as a form of escape, Morris again shifted gears, devoting more and more time to social activities and fiction writing, launching what we now call the fantasy genre. By the mid-1870s, Rossetti and Morris had drifted apart (likely a result of Rossetti and Jane's affair) and Morris cut Rossetti out of the decorative art firm.

Alone, Rossetti increasingly turned to drink and chloral, a sedative drug; he died in 1882. Tragic as his life was, Rossetti created works of profound beauty and freedom while inspiring a new generation of British artists and, notably, William Morris.

WRITTEN BY **EMILIE SIMS** / ILLUSTRATED BY **MORGAN SCHWEITZER**
www.morganschweitzer.com

WILLIAM MORTON'S TEACHER AND PARTNER

EVERY YEAR, ON OCTOBER 16, MEDICAL STU-
dents celebrate "World Ether Day," to honor the
late William Morton as the founder of modern
anesthesia. In truth, Morton stole the glory from
Horace Wells, in a tale of medical rivalry that ended tragically
in a New York City prison.

Horace Wells first observed the effects of nitrous oxide,
or "laughing gas" in December 1844, at an evening exhibi-
tion (a then-popular form of entertainment). While subjects
under the influence stumbled about the stage, encouraged
by audience laughter, Wells observed that one man who cut
his leg failed to notice his injury. He wondered, *Could the
nitrous oxide block pain on a surgical stage, as well?* A popular
dentist in Hartford, Connecticut, Wells inhaled the gas and
painlessly removed his own wisdom tooth as his contribution
to scientific research. He followed up with fifteen successful
procedures on dental clients and a few staff members. Wish-
ing to share his discovery, he scheduled a demonstration of
nitrous oxide for the Boston medical community.

Wells presented the gas's new use in front of a live audi-
ence in Boston in January 1845. Unfortunately, the dental
patient cried out mid procedure, and Wells left Boston in
disgrace. He continued to use nitrous oxide successfully in
his Connecticut practice but failed to recover from the
public shame.

William Morton benefited from Wells's misfortune. A
student of Wells's and later his partner in the Connecticut
practice, Morton stole books, money, plates, equipment, and
teeth that belonged to Wells before the two men finally dis-
solved their partnership after less than a year. Now Morton
prepared to steal Wells's idea.

Morton shifted his attention from nitrous oxide to ether.
Obsessed with patenting his formula, he mixed the ether
with oil of orange to disguise its composition and named it
"Letheon." He tested it on several of his farm animals, his
dog, Nig, and himself. On October 16, 1846, Morton success-
fully demonstrated the efficacy of ether at Massachusetts
General Hospital. He was twenty-seven years old. The
surgery on display: the removal of a tumor on the neck of
housepainter Edward Gilbert Abbott. That day, Morton
coined the procedural cue that is still used today: "Your
patient is ready, Doctor."[1]

If Wells had been the virtuous one and Morton the villain,
that soon changed. Wells, now obsessed with the attention
Morton received and which eluded him, moved to New York,
abandoning his wife and daughter. He posted a notice for his
dental services, and he continued to experiment with nitrous
oxide and chloroform, eventually forming an addiction to the
latter. Under its influence, Wells threw "sulfuric acid" at pros-
titutes on Broadway, burning their clothes and, in one case,
a woman's skin. For his crimes, he was put in the New York
City Tombs. When he realized what he had done, he soaked a
silk handkerchief in chloroform, stuffed it in his mouth, and
killed himself by cutting his femoral artery with a razor. This
was three days after his thirty-third birthday and twelve days
before the Académie Royale de Médicine recognized him
as the person "who first discovered and performed surgical
procedures without pain." High on chloroform, Wells wrote
in his suicide note, "My brain is on fire."

In 1870, the AMA recognized Wells. He is memorialized
with a sculpture in Hartford's Bushnell Park and honored
by members of the Horace Wells Club. Three thousand
international signatures were collected to petition his place-
ment on the 1994 postage stamp (Elvis Presley usurped him).
He received an honorary doctorate from Baltimore College
of Dentistry in 1990. But it is "Ether Day" that is celebrated
every year, and Morton's story that is recapitulated on
this holiday.

[1] Dr. Charles Jackson offered a different version of the story: He says
he asked Morton to run a trial of ether, as his assistant, and Morton
ran away with the work.

WRITTEN BY **SUZANNE SNIDER** / ILLUSTRATED BY **CLARA BESSIJELLE JOHANSSON**
www.suzannesnider.com / Bessijelle.tumblr.com

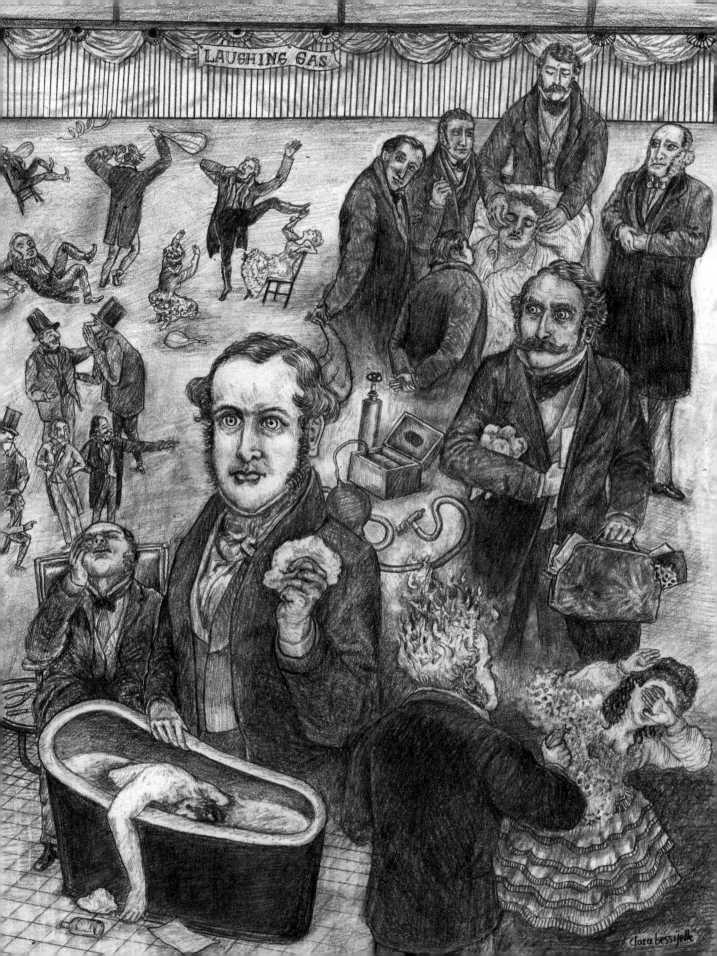

1895 NAT ELIAS 1964

MARGARET SANGER'S CHEMIST

ACTIVIST EXTRAORDINAIRE MARGARET SANGER is credited with bringing contraceptives into the American medical mainstream and out of back-alley black markets. In the early decades of the twentieth century, she launched a rebellion against the Comstock Laws, which since 1873 had classified contraceptives as obscene and forbidden their discussion and distribution. But even as her movement untied these laws, a material problem persisted. As Sanger pointed out: "We were quickly confronted with the situation that even willing doctors had little to recommend. . . . The acceptance of the theory was ahead of the means of practicing it."

Pessaries and condoms manufactured in Europe could not be imported. Chemical spermicides were too expensive, too irritating, too ineffective. As large as the market for medically sanctioned contraceptives promised to be, big American companies shied away from the controversial limelight, anxious about powerful lobbies such as the Roman Catholic Church. So Sanger turned to smaller, independent companies that could work in the shadows.

In these shadows, one modest and good-humored chemist named Nathaniel Elias supported Sanger for decades, supplying the material products and technical knowledge that she herself stumbled over. Raised among New York's Polish immigrant community, Elias had been involved as a youth in the city's flurry of socialist activity. Graduating from Columbia University in 1915, he committed to making products that served the welfare of the worker. In the laboratory of Thomas Edison he sought synthetic substitutes for "natural" rubber. In the research department of E. I. du Pont de Nemours & Co. he worked on dyes when the German dye industry was cut off in World War I.

After the war, a widower with two small children, Elias ran a small laboratory and directed research at Durex Products Inc., a small company tucked into 684 Broadway in New York City. The company set up in India as a manufacturer of pessaries, condoms, and other contraceptives. And, as it drew Sanger's attention, its "synthetic rubber and pharmaceutical products" found their way into clinics and homes across New York City and also became standard-issue to the British and Allied forces serving in the Far East campaigns of WWII.

The war was a busy time for Elias. He met his second wife, Leona Baumgartner, the eventual health commissioner of New York City, while singing along at a piano in a friend's apartment. He evidently forgave her her tone deafness. He shipped off on a government mission to assess the capacity of Axis powers to pay war reparations, hamming for photos from Manchuria to Tunisia. And in 1947 at the Nuremberg Trials he gave a critical testimony in the conviction of the I.G. Farben chemical company for their cooperation in Nazi projects, through provision of fuel, rubber, explosives, pharmaceuticals, and poison gases.

Elias brought new insights to his postwar collaborations with Sanger. She became president of International Planned Parenthood Federation at a time when most world reformers sought one-size-fits-all technical solutions to problems of health and welfare. Elias tried to convince her of the importance of matching contraceptive technologies to particular contexts. In the spring of 1952 Sanger wrote Elias from Bombay, asking for samples of a powder-foam spermicide. Elias pitched instead a new product, a liquid spermicide applied by rubber sponge. Durekol, he said, was a more appropriate "answer for the underprivileged countries." He included detailed analyses of the manufacturing capabilities and per capita costs and urged her to rely on governments for appropriate production, distribution, and education. Sanger showed little acknowledgment of the nuances he laid out.

More than once, as Sanger practiced her contraceptive diplomacy, Elias quietly covered for her gaps in technical knowledge. In private letters he corrected her when she thought chemical dyes, and not molding dies, were crucial components of pessary production, or when she wanted to test products on groups too small to have any statistical significance. It was only privately that Sanger acknowledged her debt to Elias. Reflecting on her successes, she wrote to him that "it could not have happened had not all in the movement made their contribution throughout the years. And that includes the manufacturer of good products and the scientists who spend endless time in research." But Nat's pleasures seemed to come less from celebrity than from the Martha's Vineyard seashore, where he had a house with his family, or from a life's worth of detailed discussions about science and computation with his son, preserved in the letters sent and received during his work in so many corners of the world.

WRITTEN BY **EMILY A. HARRISON** / ILLUSTRATED BY **JENNY VOLVOVSKI** www.also-online.com

SEARS, ROEBUCK BUSINESS PARTNER

I N 1895, A YOUNG CLOTHING MERCHANT IN CHICAGO borrowed $37,500 from his family and invested it in a mail-order retailer. Through this investment, Julius Rosenwald became part of the mail-order firm Sears, Roebuck & Co. Each determined the destiny of the other. "An opportunity opened before me," Rosenwald said years later. "I didn't create it."

The firm had been established a few years prior by Richard W. Sears and Alvah C. Roebuck. Both had gotten into the business by accident. While working as a railroad agent at a small depot in Minnesota, Sears came into possession of some watches that had been shipped on consignment to a local jeweler who refused them. Sears sent letters to other railroad agents, offering to sell them the watches, which, in turn, they could sell to local residents, keeping any profits. The watch business, conducted largely through the mail, soon took up more of Sears's time than the railroad work and proved more lucrative. In 1887, Roebuck, an amateur watchmaker from Indiana, joined the company, which by then had moved from Minnesota to Chicago. Sears and Roebuck began to sell more than watches, expanding into furniture, farm tools, patent medicines, and clothing. They used innovative and illustrated advertisements, appearing first in rural newspapers and later in their famous catalogue, to become a household name among countless Americans. For people living on remote farms, ranches, and mining camps, the Sears, Roebuck & Co. catalogue connected them to the larger world.

As the company grew, its organizational weaknesses became apparent. Demand for products outmatched the stock on hand; shipping proved costly and inefficient; and customer requests went unanswered. "Here I've got the most wonderful business in the world," Sears reputedly told Rosenwald, "and it is running away with me." Diligent and detail-oriented, Rosenwald streamlined purchasing and distribution upon becoming vice president in 1897. He purged the catalogue of hyperbolic descriptions of products and stopped selling quack medicines in order to build trust with the consumer. When a customer received a suit heavier than desired because it was the only one in stock that fit him, Rosenwald asked the clerk who fulfilled the order, "Why didn't you send him a watch?" He recognized that it was better to make a gesture of goodwill than to provide a faulty product. In Rosenwald's first year as vice president, annual sales went from just over $1 million to over $3 million. By the time he became president in 1908, the company had become one of the largest and most successful in the nation.

Rosenwald's commitment to people living in rural parts of the country who ordered from the Sears catalogue went beyond the relationship of a merchant to his customers. Born in Springfield, Illinois, a year prior to a fellow resident Abraham Lincoln's issuing of the Emancipation Proclamation, Rosenwald would in adulthood work to lessen the economic inequality and racial prejudice endured by a large number of African Americans, particularly those living in the South. A victim of anti-Semitism who'd risen from a modest start to financial success, Rosenwald believed that education was the strongest tool for solving these problems. He gave substantially to Booker T. Washington's Tuskegee Institute before establishing the Rosenwald Fund, which would support the creation of five thousand schools and four thousand libraries for use by African American youth.

He also used his wealth to give Chicago, then the industrial center of America, a much-needed hands-on museum— the largest of its kind in the world. As benefactor to a civic institution, Rosenwald would join the company of other Chicago elites, including Marshall Field with his Field Museum of Natural History, John G. Shedd with his Shedd Aquarium, and just about everyone of taste and means with a gallery or two in the Art Institute. But what separated Rosenwald's museum from these other institutions was its name. It was called, upon his insistence, the Museum of Science and Industry—just that. It was a move characteristic of a man who'd led a publicly engaged life with little public recognition.

WRITTEN BY **PAUL DURICA**
www.pocketguidetohell.com

ILLUSTRATED BY **SIYU CHEN**
www.siyuart.com

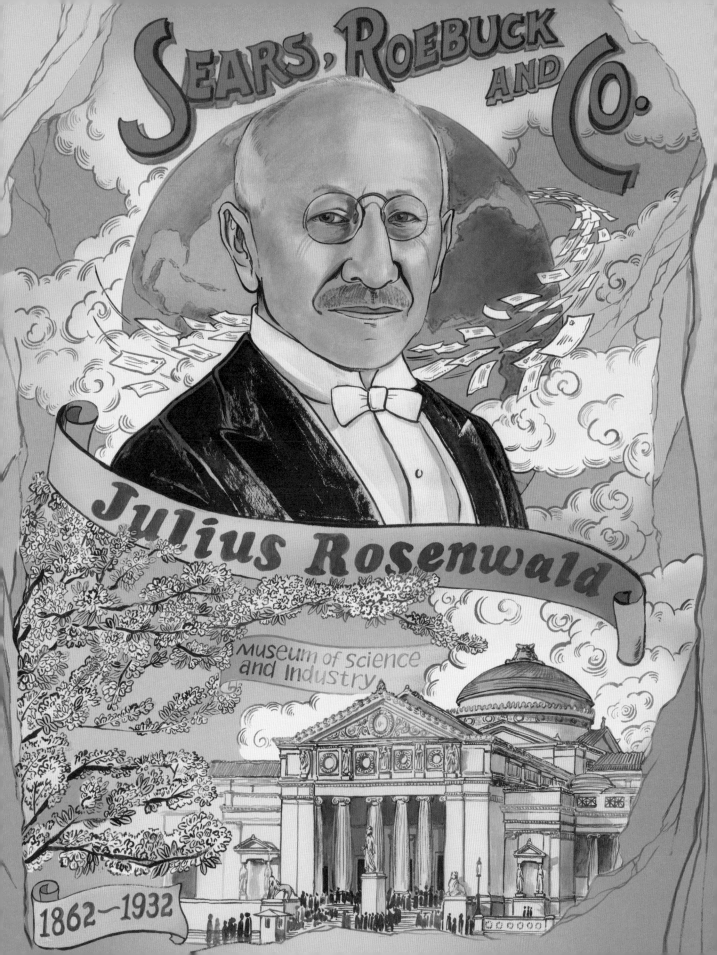

1832 OCTAVE CHANUTE 1910

WRIGHT BROTHERS' MENTOR

"FOR SOME YEARS," WILBUR WRIGHT DECLARED on May 13, 1900, "I have been afflicted with the belief that flight is possible to man. My disease has increased in severity and I feel that it will soon cost me an increased amount of money if not my life." This dramatic profession opened a five-page letter handwritten by Wright, who at the time ran a bicycle shop in Dayton, Ohio, with his younger brother, Orville. The recipient was Octave Chanute, a respected engineer and businessman thirty-five years Wright's elder. So began a ten-year exchange comprising hundreds of letters, equally rich in precision and passion—an invaluable resource and testament to collaborative innovation.

Octave Chanute was born in Paris in 1832. He came to the United States at the age of six and, drawn to railroads at a young age, began a career in civil engineering at seventeen. Eventually he would become chief engineer of eight different railroads. Deeply engaged in multiple areas of modern life, he chaired committees that influenced both urban planning and environmental conservation. In 1873, the city of Chanute, Kansas, was chartered in his honor.

By 1889, Chanute might have retired a widely respected man. Instead, he moved his office to Chicago and shifted his attention to aviation. Though it was late in his career, this "problem of the ages" invigorated Chanute, who pursued extensive international correspondence with anyone involved in the flight of heavier-than-air machines. He organized all the information he could find on the subject, covering hundreds of years. Uninterested in further renown and commercial gain, Chanute was deeply committed to the free and open distribution of knowledge in this vital area of innovation. He published numerous articles, culminating in the three-hundred-page book *Progress in Flying Machines* (1894), an exhaustive landmark resource.

Chanute's most famous developments in aviation began in the summer of 1896. In a well-documented series of experiments on the windswept sand dunes south of Lake Michigan, Chanute and his team designed and tested man-carrying gliders in more than two thousand flights—with zero injuries (save a tear in his son's pants). Beginning with a design developed by the ill-fated Otto Lilienthal, they ultimately produced the "Chanute-type" biplane, a glider constructed on a bridge-building principle called the Pratt truss. Stable, strong, and efficient, this was the most successful flying machine in the world to date. It was adopted by the Wright Brothers for their historic flights at Kitty Hawk and Kill Devil Hills in North Carolina, which led to their development of the legendary, powered *Flyer* of 1903.

Chanute supported the Wrights by putting his research at their disposal, visiting their experiments, and hailing their successes—all in the belief that modern flight was not one man's work but many. But while this progressive stance undoubtedly benefitted the brothers, it also led to friction. Chanute publicly denounced their lawsuits against competing experimenters, abstention from competitions, and "desire for great wealth." Nonetheless, the friendship was steadfast; both Wrights attended Chanute's funeral, and Wilbur delivered the eulogy. After all, as *Science* magazine then attested, "His valuable experience, information and advice were liberally and gladly furnished to them at the time when it was the most needed, when they were at the foot of the unblazed trail . . . to emerge at last at the summit, triumphant." Though his own accomplishments are largely forgotten, Chanute's generosity secured his legacy; as an exemplary mentor, he truly helped launch the Wright brothers.

WRITTEN BY **AIDAN O'CONNOR** / ILLUSTRATED BY **DAWID RYSKI**
www.talkseek.com

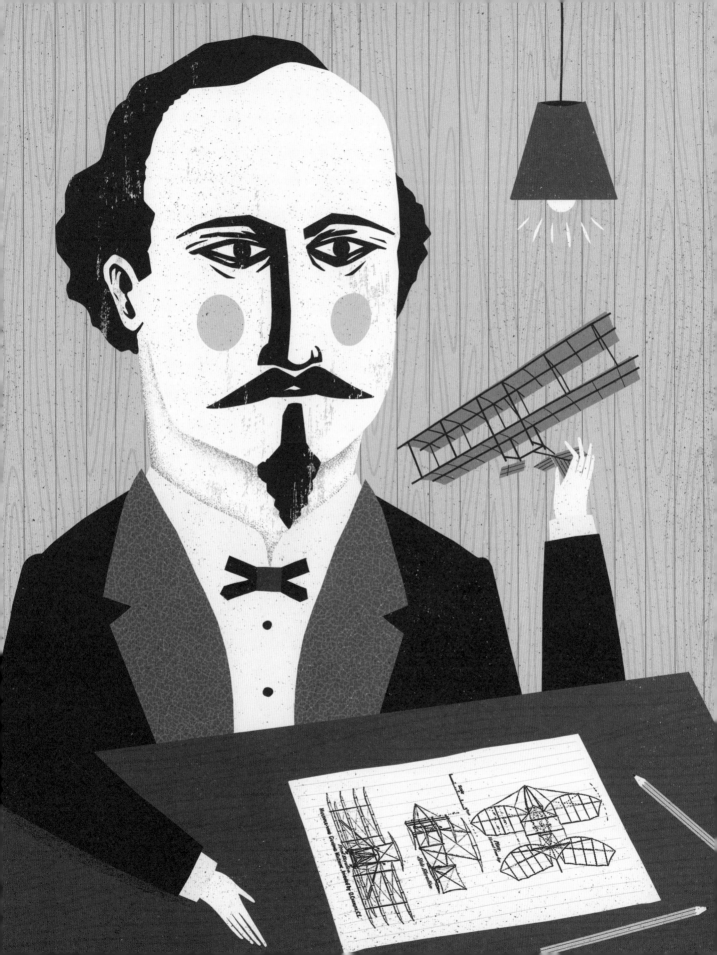

ALICE WATERS'S MENTOR

ALICE WATERS TRANSFORMED OUR RELATIONship to food in the United States. Before Alice, you could not find a salad made from mixed mesclun lettuce leaves with a little goat cheese on top. Think iceberg. But her legacy goes much deeper than that. With her restaurant, Chez Panisse, she helped people see that good ingredients make good food, and that good ingredients come from good farming. Her food and her voice helped to spark a movement that continues to fight for local, sustainable agriculture, dignity for farmers and workers, and well-being for our children. Her Edible Schoolyard program brought cooking classes and gardens to public schools, and she is not done yet. She will not rest till every public school has a garden, and every child grows up learning how to grow, cook, and share real food that nourishes their health and the health of the land.

Many people know of Alice. What's not well known is how her path was shaped by an elderly woman on a small family farm near the port town of Bandol, in Southern France.

Before she met Lulu Peyraud, Alice had a reputation as a good cook. Alice could not help feeding people. As an activist in the Free Speech Movement in Berkeley, Alice fed people. As a young staff member on Robert Scheer's antiwar-focused congressional campaign, Alice fed people. Her love of food led her to spending a year traveling in France.

At first, her time was focused on Paris, where the food was delicious, though a bit fancy. She became friends with Richard Olney, an American authority on French cuisine. Olney introduced Alice to Lulu Peyraud. Lulu and her husband, Lucien, owned and managed Domaine Tempier,

a vineyard that had been in Lulu's family since 1834. Lulu and her siblings had inherited the estate from their parents.

Lulu, too, had a knack for feeding people, and she took Alice under her wing.

On the farm, Alice found food that was a far cry from the fancy restaurant cooking in Paris. Lulu cooked simple food grown on the farm or fished from the Mediterranean, where she swam each day. She cooked in the fireplace on old wrought-iron grills and trivets, over a fire built from dried grapevines pruned in past years. Over breakfasts made with eggs from the farm, mushrooms from the woods, and bread grilled in the fire, Alice soaked in how powerful simple food, connected to a place, can be. It changed her.

Alice wrote in her introduction to Richard Olney's book *Lulu's Provençal Table,* "Lucien and Lulu's warm-hearted enthusiasm for life, their love for the pleasures of the table, their deep connection to the beautiful earth of the South of France—these were things I had seen at the movies. But this was for real. I felt immediately as if I had come home to a second family."

From Lulu, Alice learned about hospitality, simplicity, and that there is always room at the table for one more.

Today Lulu is over ninety-five years old. She still swims in the Mediterranean. And she and Alice still share breakfast when Alice visits France. When I last spoke to Alice, she told me, "Now Lulu is guiding me into an old age practice. I'm learning from her smile, her ease of being with anyone. Children, grandchildren, and great-grandchildren are all around her, not because they feel obliged, but because they want to be close to her. I aspire to grow old that way."

WRITTEN BY **JOSH VIERTEL** / ILLUSTRATED BY **JULIANA SABINSON**
www.julianasabinson.com

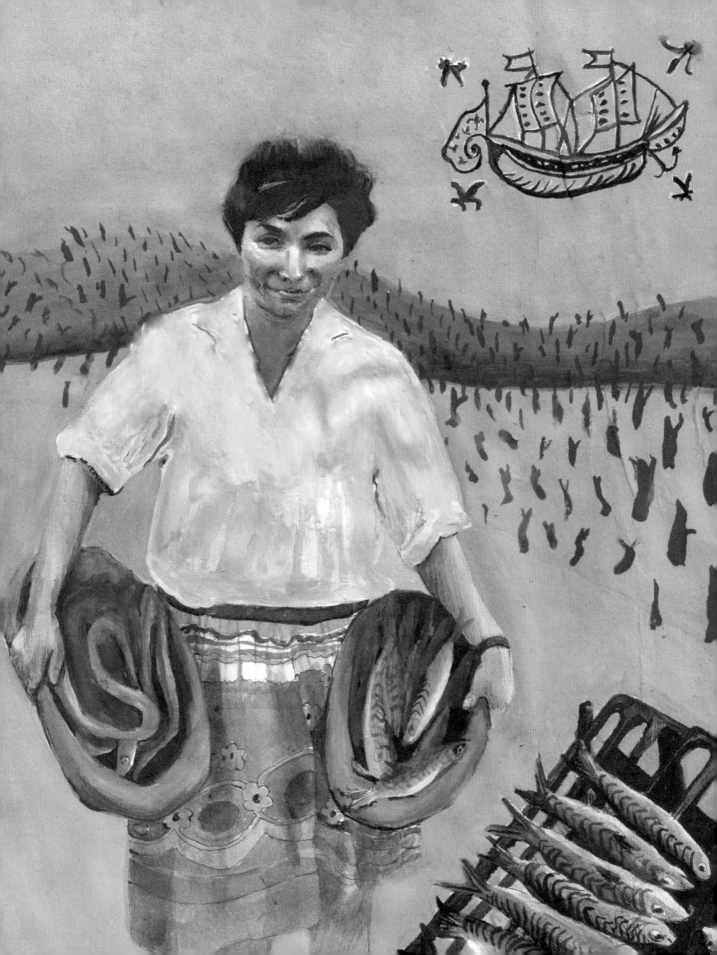

HOLGER GESCHWINDER –

DIRK NOWITZKI'S COACH

"**T**AKE DIFFERENTIAL AND INTEGRAL CALCULUS. Make some derivations and create a curve," Holger Geschwinder told *Time* magazine, when asked how he came to theorize the ideal arc for a basketball shot. "Everybody can do it." Of course, not everybody can do those derivations; few in high-level basketball have even tried. But Geschwinder has made the study of this fluid, beautiful, and strange game the subject of his life.

Geschwinder fell in love with basketball in postwar Germany, first sneaking in to watch US Army leagues as a child, and later dedicating himself to the game with the help of a sympathetic art teacher. He became a star as an amateur, was Germany's captain in the 1972 Munich Olympics, and played professionally in his country's top division until he was forty-one. Ten years after retiring from that league—a decade of "doing nothing," he says—Geschwinder joined a third division team more or less as a lark. In this shabby basketball afterlife, while waiting for a high school game to finish so his team's game could start—the third division, something notably more legitimate than a rec league but only barely a professional league, is like that—Geschwinder noticed a tall, skinny kid "doing pretty much everything a good player had to do." That was 1997, in Schweinfurt, Germany; the kid was Dirk Nowitzki. Geschwinder approached Nowitzki and demanded to know who was training him. Nowitzki was put off—"I thought he was crazy," Nowitzki told *Der Spiegel* in 2012. After Dirk's mother—a former player on Germany's women's national basketball team—told her son who Geschwinder was, the two embarked on Geschwinder's seven-phase plan for Nowitzki's career.

Two years after that first meeting, Nowitzki was chosen ninth overall in the NBA draft. In the intervening period, he worked with Geschwinder on not just perfecting the mechanics of his shot—and "perfecting" is the word, as Nowitzki is the best shooter at his size that the NBA has ever seen—but on a wide-ranging program of personal development.

This was something stranger than an apprenticeship — Geschwinder had ideas not just about how basketball should be played, but how basketball players should be. In the deceptively easygoing Nowitzki, Geschwinder found his student. This meant signing on to Geschwinder's eclectic and wholly self-taught vision of basketball as something grounded in theory and defined by improvisation.

"I studied metaphysics, I come from a different corner," he told *Slam* magazine in 2010. "I never studied physical education. I had to find my own way." And so Geschwinder gave Nowitzki books on physics and books of poetry; he made him learn various musical instruments and sent him to see Wagner's epic opera *Parsifal*. He called his fledgling basketball academy the Institute of Applied Nonsense, "since everything we were doing was called nonsense."

"Do you remember the expression on my face when your friend Ernie suddenly started playing the saxophone during training, and I was supposed to move in time to the music?" Nowitzki asked Geschwinder during that 2012 *Spiegel* interview. "I didn't want you to see basketball as just a schematic series of moves," Geschwinder responded.

At this point, Nowitzki is on his own, playing a stylistically unique version of basketball that's both precise and relentlessly idiosyncratic. He's outplayed LeBron James to lead his team to a NBA Championship, earned eleven straight All-Star Game selections and the league's Most Valuable Player Award.

Nowitzki's style was not so much created by Geschwinder as made possible by him. The game Geschwinder taught Nowitzki was a dance, and if it was grounded in equations and angles, it exists primarily as movement in time. Nowitzki is his own man and own player, but he has become the player his mentor imagined he could be. He's done so not by simply executing the moves that Geschwinder taught him, but by being able to move with the wild music playing under the game—the buried rhythms that Geschwinder fell in love with, and helped Nowitzki to hear.

WRITTEN BY **DAVID ROTH**
www.theclassical.org

ILLUSTRATED BY **MICHAEL BYERS**
www.michaelbyers.ca

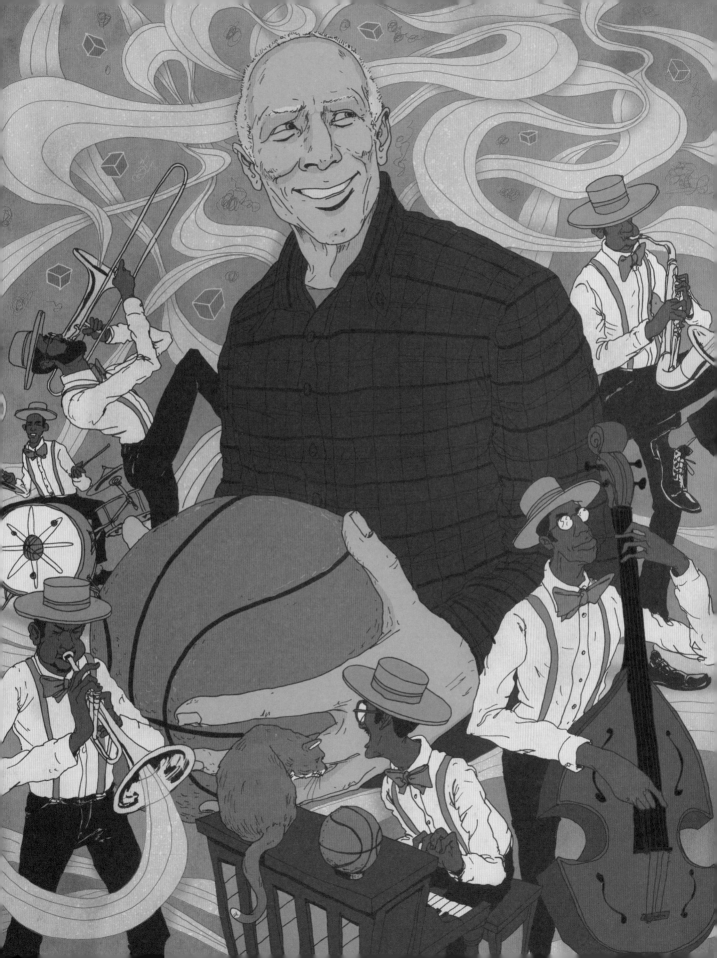

LOUIS ARMSTRONG'S BENEFACTOR

ALTHOUGH LOUIS ARMSTRONG PLAYED TRUMPET like he was born holding one, the jazz innovator might never have taken up the instrument at all without help from Louis Karnofsky, a New Orleans coal merchant who provided Armstrong with his first horn.

Details vary: Armstrong was six or he was eleven; the instrument was a trumpet or it was a cornet; the cost was $5 or it was $12. What's known for sure is that the Karnofskys were a surrogate family to Armstrong, who was born into poverty—his father left when Armstrong was an infant, and his mother turned him and his younger sister over to the care of their grandmother for a time. Karnofsky, a Lithuanian immigrant described variously as a coal merchant or junk dealer, is said to have employed Armstrong when he was a small child, taking the boy along with his sons on rounds and letting him blow a whistle to let customers know the Karnofsky wagon was coming through their neighborhood.

As the story goes, Armstrong was captivated by a horn he saw in a store window while making deliveries with Karnofsky, whose son Morris lent him the money to buy it. The future jazz icon learned to play the instrument, probably a cornet, later in his youth, thanks in large part to Peter Davis, a local music instructor who helped guide Armstrong while he was a ward of the New Orleans Home for Colored Waifs in his early teens. From there, Armstrong grew into

one of the towering figures in jazz. He altered the focus of the music from ensemble performances to solo improvisation and pioneered scat singing as he broadened his distinctive sound from Dixieland into swing and, later in his career, pop songs such as "What a Wonderful World."

As his career blossomed, Armstrong became one of the most beloved entertainers of the twentieth century, and was among the earliest African American artists to find crossover success with white audiences. Through it all, he never forgot the compassion or generosity of the Karnofskys. "They were always warm and kind to me, which was very noticeable to me—just a kid who could use a little word of kindness," Armstrong wrote in a memoir about his relationship with the family. Even as a boy, he recognized that the Karnofskys were subject to discrimination because they were Jewish. In their honor, the musician wore a Star of David around his neck for most of his life and credited the family for his fluency in Yiddish—critics have even identified in his own music the influence of the Yiddish folk melodies he heard Mrs. Karnofsky sing to her children. The Karnofskys also instilled in him a love for Jewish food: Armstrong was said to snack on a supply of matzo he kept around his house.

The family is still remembered in New Orleans, too: The Karnofsky Project is a nonprofit group that gathers donated band instruments and distributes them to children in need.

WRITTEN BY **ERIC R. DANTON** / ILLUSTRATED BY **KIM SIELBECK**
www.ericdanton.com / www.kimsielbeck.com

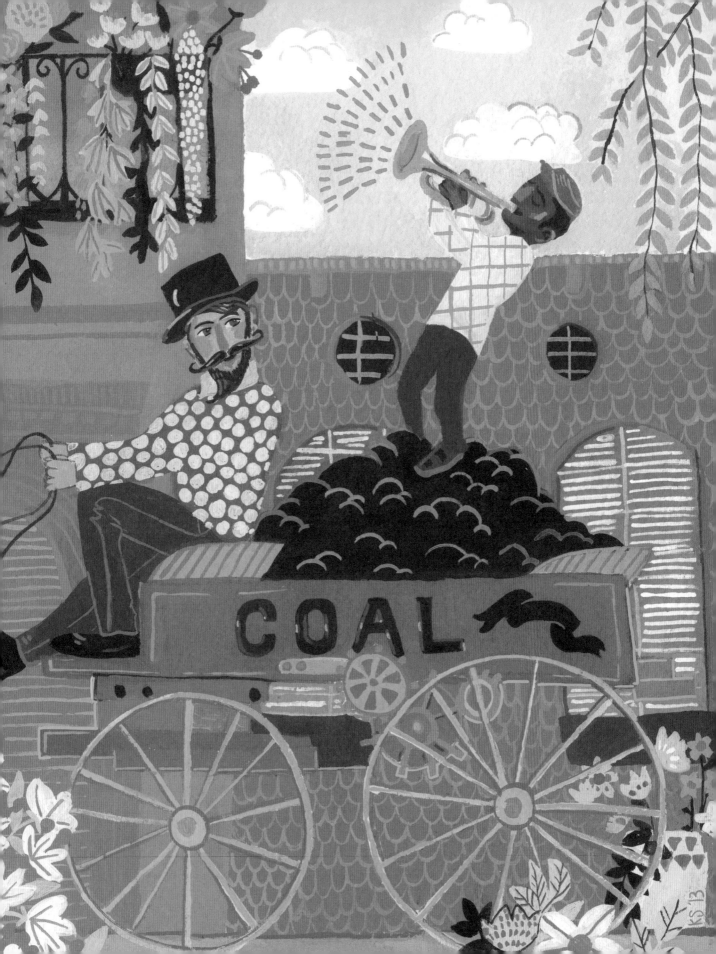

1792 JOHN INGERSOLL 1859

ROBERT INGERSOLL'S FATHER

ROBERT INGERSOLL WAS NINETEENTH-CENTURY America's most popular orator, the nation's leading proponent of Darwin's theory of evolution, and its most famous atheist. Known as "the Great Agnostic," he grew up on the frontier, the son of an itinerant hell-and-damnation fundamentalist preacher. John Ingersoll's fiery sermons advocating the abolition of slavery caused him to be rejected by congregation after congregation across the Midwest; so the family moved often, leaving Robert without sustained formal education until the age of fifteen.

Father and son, though, knew no rancor. Robert's prodigious intellect and powers of memory (later in life he would speak for hours from memory before throngs of enthralled spectators) allowed him to absorb the entire Bible from boyhood. Preparing his hellfire-and-brimstone sermons, John would consult his son for citations, and Robert would respond with long passages from the Old and New Testaments.

While John lamented Robert's heterodoxy, which was evident from an early age, he respected the power of his son's mind, and Robert returned his affections. "My father was a man of great natural tenderness," Robert wrote, "and loved his children almost to insanity. The little severity he had was produced by his religion."

That didn't keep Robert from observing with characteristic humor the contours of living in a rigidly orthodox household. In one of his later speeches, Robert spoke of the approach of the Sabbath, when "a darkness fell upon the house ten thousand times deeper than that of night."

"Nobody said a pleasant word; nobody laughed; nobody smiled," he continued, observing that "the child that looked the sickest was regarded as the most pious. That night you could not even crack hickory nuts. If you were caught chewing gum it was only another evidence of the total depravity of the human heart."

Come Sunday, he continued, "the solemnity had simply increased." After the excruciating sermon, Robert said, "The minister asked us if we knew that we all deserved to go to hell, and we all answered 'Yes.' Then we were asked if we would be willing to go to hell if it was god's will, and every little liar shouted 'Yes.'"

John Ingersoll decamped with his family to Illinois around 1850, still searching unsuccessfully for a permanent congregation. Robert and his brother were admitted to the Illinois bar in 1854 and launched their law practice, which quickly thrived.

Eventually arriving in Peoria, Illinois, Robert met his future wife, Eva Parker, a brilliantly intellectual daughter of a prominent freethinker. Robert was not yet officially labeled an atheist, but his denial of religion became complete when Eva introduced him to influential writers and thinkers such as Voltaire.

Father and son never did see eye to eye with respect to religion, but they proved to be closely connected by devotion to abolitionism. When the Civil War broke out, Robert recruited the Eleventh Regiment Illinois Volunteer Cavalry and became its commander, eventually attaining the rank of colonel.

Robert was discharged from the Union army after being captured by Confederates. Because "frontier" states like Illinois still had hotbeds of proslavery supporters, Robert began speaking publicly in support of abolition and continuing the Union's cause. His orations were so popular, he began to widen his subject matter to another matter close to his heart—deriding superstition and religion. These addresses became even more celebrated, and Robert was guaranteed a sellout crowd wherever he spoke.

He ranged across the country, speaking at big-city amphitheaters and tiny hamlets. Tens of thousands of spectators, almost all of them professed Christians, came to hear him speak, paying as much as $1—an enormous amount at the time—for the privilege of hearing "Robert Injuresoul" ridicule their beliefs.

Speaking of states' attempts to codify superstition into laws, Robert said, "An infinite god ought to be able to protect himself, without going into partnership of state legislatures." The audience roared.

It was said that if he had repudiated his atheism, Robert Ingersoll would have become president of the United States. "They knew that to put god in the Constitution was to put man out," he said of the Founding Fathers' intent in framing the Constitution. Like the Founding Fathers, he was a true child of the Enlightenment but, unlike these learned men, Robert Ingersoll came by his wisdom in an entirely different way—and, surprisingly, with a little help from his fundamentalist yet enlightened father, John.

WRITTEN BY **TOM BIEDERBECK** / ILLUSTRATED BY **JUSTIN GABBARD**
www.justingabbard.com

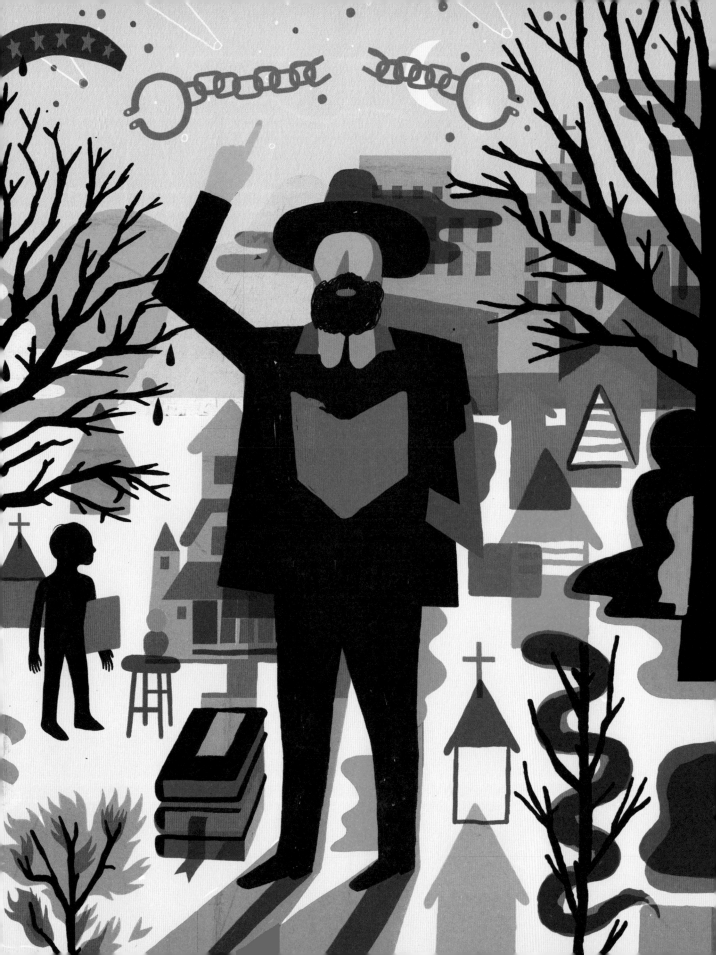

JOSHUA SPEED

<p style="text-align:center">1814 1882</p>

ABRAHAM LINCOLN'S FRIEND

JOSHUA SPEED WAS IN HIS SPRINGFIELD COUNTRY store in April 1837 when Abe Lincoln entered looking for a bed, mattress, sheets, and a pillow. Speed was twenty-two at the time. He had grown up on a Kentucky plantation with more than seventy slaves. He didn't have to work but he chose to move to Illinois, where he invested in real estate and then opened his own store. Speed described Lincoln, twenty-eight, as "ungainly . . . a little stooped in the shoulders. His eyes were gray. His face and forehead were wrinkled . . . Generally, he was a very sad man."

Lincoln said he could pay Speed the $17 for his bedroom items by the end of the year—but only if he was successful in his new endeavor as a lawyer. "If I fail in this," Lincoln said, "I do not know if I can ever repay you."

"You seem to be so much pained at contracting so small a debt," said Speed. He offered an alternative. Speed suggested that the "pained" man who was uncertain of his ability to pay bills become his roommate. Lincoln inspected Speed's single bedroom above the store and accepted. They shared the bed, which was common at that time.

By the winter, Lincoln was inviting groups of people to Speed's house every night for long conversations on any topic other than politics. Years later when Speed gave lectures sharing his anecdotes about Lincoln, he made a point of demonstrating that Lincoln would have conversations with anyone "without distinction of party"—but you can't help but hear in Speed's words a little irritation in the assembling of "eight or ten choice spirits" gathered "on every winter's night at my stove . . . no matter how inclement the weather." Still, the two men roomed together for years and remained lifelong friends.

In the winter of 1840–41, Lincoln decided to end his engagement with Mary Todd in order to focus on his law career. He wrote her a letter, which he asked Speed to deliver. Speed refused, telling Lincoln it needed to be handled face to face. Eventually, Lincoln worked up the nerve to do it himself. At this time, Speed considered returning home following his father's death, so he could help care for his mother. Lincoln became greatly depressed without Mary Todd and with the idea of losing his friend, and Speed chose to stay with Lincoln instead. He later said that Lincoln went crazy and he had to remove the razors and knives from Lincoln's room. Speed told his friend to pull himself together or else he would surely die. Lincoln replied, he wouldn't mind dying if he had done anything that he would be remembered for. Twenty years later, Lincoln reminded his friend of this conversation and said that he hoped the Emancipation Proclamation was the act he had lived for.

Speed remained an adviser to Lincoln in life and politics, even providing counsel as to the leanings of Speed's home state in the run-up to the Civil War. Speed turned down many offers of cabinet positions, but his brother James served as Lincoln's third attorney general.

The last time Speed saw Lincoln was in the White House. Speed observed Lincoln meeting with the mothers of two men from Western Pennsylvania who were in jail for avoiding the draft. The mothers were not kind to Lincoln, but at the end of the meeting, the president announced he would pardon all twenty-seven incarcerated draft dodgers from Western Pennsylvania despite Secretary of War Edwin Stanton's threat to resign. "Those poor fellows suffered enough," said Lincoln.

Afterward, the two friends sat together. Lincoln revealed that he believed one of the mothers was a fraud—actually the wife of a prisoner—and, he confided, he was worried about his health. Speed noted that Lincoln was cold and clammy. Two weeks later, Speed's old roommate and bedfellow was assassinated.

WRITTEN BY ADAM WEBB
everydayfootnotes.tumblr.com

ILLUSTRATED BY KYLE T. WEBSTER
www.kyletwebster.com

On every winter's night
at my stove no matt...
how inclement the...

Speed

DAVID THOMPSON'S WIFE

MARRIAGES OF CONVENIENCE WERE COMMON in the fur-trading industry in Canada, and Charlotte Small's family was full of them. Her mother, an indigenous Woods Cree woman whose name has been lost, married a North West Company trader named Patrick Small, who left the family to return to Scotland. Her older sister's marriage to a partner from the same company ended when he left her to marry a North West Company heiress. "Country wives," these native or Métis (mixed descent) women were called, and it was common practice for a trader to leave such a wife and family behind when he returned to Europe or the East. So when Charlotte was married according to native customs at the age of thirteen to another North West Company employee, an ambitious young surveyor named David Thompson, one might have expected a similar fate for her. Indeed, his journal entry from June 1799, simply read, "this day, married Charlotte Small."

But their life together would be a remarkable and enduring partnership. David Thompson became one of the most prolific geographers the world has ever seen, mapping nearly 1.5 million square miles (3.9 million square kilometers) of North America, with such accuracy that many of his maps were not improved on until the advent of airplane mapping. Small accompanied him on many of his travels. She was a person of two worlds, that of the fur-trading company life, as well as that of her mother's people. She seemed at home in the wild, happy to live off the land as her husband used his remarkable talents to put vast stretches of land to paper. She brought a perfect blend of skills to their partnership: She could hunt and trap and she could translate with the Cree people and other First Nations they encountered. David would later write about the advantage that his wife brought him; her language skills and fur-trading knowledge gave them immediate acceptance.

At the age of fifteen, Charlotte gave birth to a daughter named Fanny, the first of five children born during this period of western exploration, and the first of thirteen in total. The lives of these children unfolded at trading houses such as Rocky Mountain House, Kootanae House, and Boggy Hall and more often on the difficult roads between them and into the unexplored frontier of the Canadian Rockies. Ten days after Charlotte's second son was born, they began a 1,500-mile journey east. In all, Charlotte traveled more than 15,000 miles by her early twenties, more than three and a half times the distance traveled by Lewis and Clark on their famous expedition.

In 1812, David decided it was time to retire from the frontier and return to Montreal to complete his vision of a great map that combined all his surveys. Often, a moment like this would be the time in a trader's life where he left his country wife behind, but Charlotte traveled with him to Montreal, and soon after they were married legally in the church.

In the remaining years of their life together, they faced very different challenges. Though Thompson was able to complete his great map and an atlas of the West, the fortunes of the North West Company declined, and he was never fully compensated for his work, and company politics resulted in the work being largely ignored until nearly sixty years after his death. A Métis woman would likely have been an outsider in Montreal, though neither David nor Charlotte seemed interested in social circles. Two of their children died within the first few years in Montreal, and Charlotte would have eight more. David and Charlotte's last years were spent in poverty. After fifty-eight years of marriage—the longest in pre-Confederation Canada—the two died within three months of one another.

David rarely wrote about his wife or his family . . . except in exceptional instances, such as when one of his children was nearly crushed by a horse or wandered alone into the forested wilderness, and Charlotte's story remains largely unknown. Yet for every harrowing river crossing David describes, for every frugal winter, for every tense negotiation with rival First Nations, there's an unwritten narrative of her presence and involvement.

WRITTEN BY **GLEN DRESSER** / ILLUSTRATED BY **JESSICA FORTNER**
www.jessicafortner.com

1912 BAYARD RUSTIN 1987

MARTIN LUTHER KING JR.'S MENTOR

IF WE KNOW THE REVEREND MARTIN LUTHER KING Jr. to be a champion of nonviolence in the fight for civil rights, it is because of his openly gay, pacifist adviser Bayard Rustin.

Rustin's pacifism stemmed from his Quaker upbringing and remained a strong current throughout his life. Born in West Chester, Pennsylvania, in 1912, Rustin became motivated to fight discrimination after being refused service at a restaurant in Media, Pennsylvania, while traveling with his high school football team. A *New York Times* obituary in 1987 describes Rustin's response to the incident: "I sat there quite a long time and was eventually thrown out bodily. From that point on, I had the conviction that I would not accept segregation."

Rustin met King for the first time when he traveled to Alabama to help with the Montgomery Bus Boycott in 1956. King had armed guards protecting his home after it had been bombed that January, and Rustin persuaded him to give up his guns and take up nonviolence instead.

Rustin became a large figure in the civil rights movement—as writer, thinker, strategist. He had his biggest impact as an aide and mentor to King, and as the organizer of the March on Washington for Jobs and Freedom in 1963. But there's a good chance you've never heard of him, or heard much about him. That's because, as an openly gay man who had been active in the communist and socialist movements, he was thought to be too much of a liability to be a public leader at a time when homophobia was so rampant.

So he helped shape King's message from behind the scenes. Historian Peter Dreier describes this relationship as Rustin advising from a distance: in phone calls, memos, and drafts of articles and book chapters Rustin wrote for King. Rustin even ghost-wrote King's first publication—an article on the Montgomery Bus Boycott for the April 1956 edition of the magazine *Liberation*. He urged King to concentrate on the moral issues behind segregation and discrimination—rather than the political ones—believing that King could be the spiritual leader the civil rights movement needed. Rustin also pushed King toward a message of economic injustice, which was a main focus of the 1963 march on Washington. The NAACP feared that Rustin's 1953 arrest for homosexual acts would be a liability if he were to be the march's public organizer. A. Philip Randolph, Rustin's longtime mentor, insisted on keeping Rustin in charge. So Randolph held the title of director of the march and kept Rustin as the deputy director, a perch from which Rustin clearly ran the show. The weeks leading up to that hot August day "were the busiest in Rustin's life," writes biographer John D'Emilio, author of *Lost Prophet: The Life and Times of Bayard Rustin*. The march was a success, with more than two hundred thousand showing up at the National Mall and marching for jobs and equal rights.

Decades later, Rustin is finally getting more recognition for his role that day, by being posthumously awarded the 2013 Presidential Medal of Freedom by the country's first black president.

WRITTEN BY **LISA BONOS** / ILLUSTRATED BY **JUNGYEON ROH**
www.jungyeonroh.com

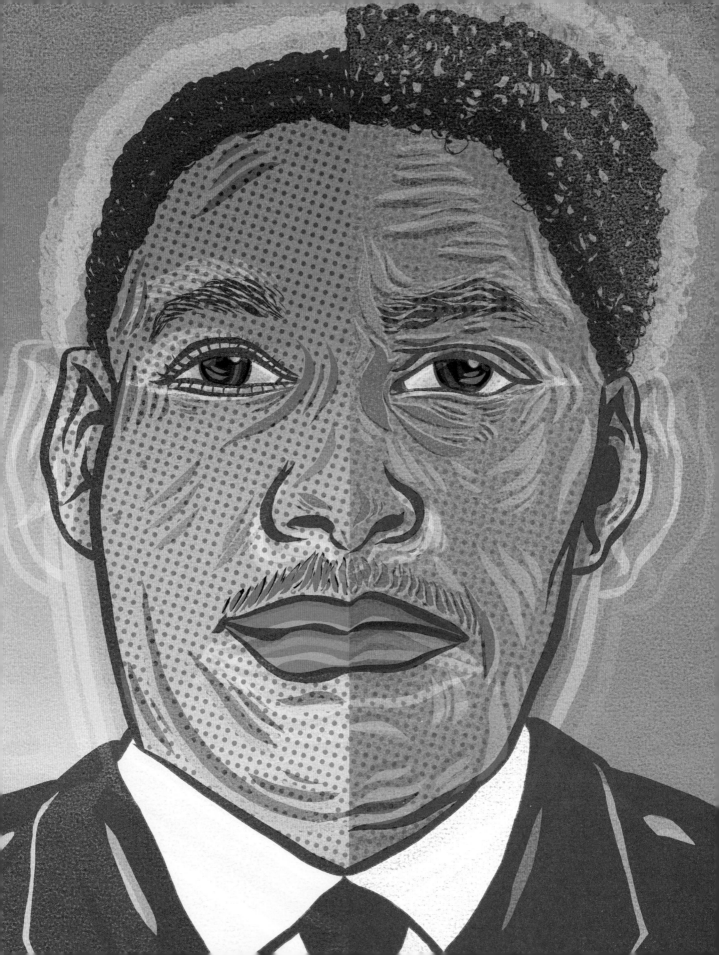

FRANCIS CRICK AND JAMES D. WATSON'S PEER

HER X-RAY PHOTOGRAPH OF DNA WAS THE critical piece of evidence that allowed James Watson and Francis Crick to accurately describe the structure of deoxyribonucleic acid in 1953, for which they were awarded the Nobel Prize in 1962. But, surprisingly, Rosalind Franklin did not share that X-ray photograph with them—another colleague showed it without her knowledge.

A brilliant and driven scientist from a wealthy British family, Rosalind excelled in school and developed a lifelong love of travel. After graduating from Cambridge, she worked in a government lab, then moved to Paris, where she learned how to use X-rays to study the structure of crystals. Though she adored Paris, Rosalind felt she should return home to England to be closer to her family.

In 1951, Rosalind brought her expertise in X-ray crystallography to King's College London. There she took one-hundred-hour-long exposures of DNA, producing X-ray photos of unparalleled clarity. Rosalind discovered that DNA had two forms: an A form and a B form. It was her photo of the B form that allowed Watson and Crick to prove that DNA is in the shape of a helix.

Rosalind doggedly pursued her research within a strained work environment at King's College. She endured ongoing friction with colleague Maurice Wilkins, who was also using X-rays to study DNA, and who would one day show Rosalind's DNA X-ray photo to Watson (and would share the Nobel Prize with him). Part of Rosalind's difficulty with Wilkins was seemingly caused by a misunderstanding about her role. With her superior expertise in X-ray crystallography, Rosalind believed that she had been hired as an independent researcher; Wilkins thought she was to be his assistant, and he likely felt cut out of her research. Rosalind clashed with Watson, too. Throughout *The Double Helix*, his book about his discovery of the structure of DNA, Watson refers to Rosalind as "Rosy," a nickname he says he and his peers "called her at a distance." In his book he also criticized the way she dressed and claimed that on one occasion he thought she might hit him. This book, by a Nobel winner who freely admits he needed Rosalind's DNA photo to make his discovery, was published *ten years* after her death. However, in the epilogue, he went on to call her X-ray work "superb," said he appreciated her "honesty and generosity," and said he realized "years too late the struggles that the intelligent woman faces to be accepted by a scientific world which often regards women as mere diversions from serious thinking."

Due to the tense environment at King's, Rosalind went to work at Birkbeck College (at the University of London) in 1953 and pursued a new line of research studying viruses. One of her collaborators, Aaron Klug, went on to win a Nobel Prize in 1982 and praised her in his Nobel lecture.

In 1956, Rosalind was diagnosed with cancer, perhaps brought on by her exposure to X-rays. She worked diligently up until shortly before her death at the age of thirty-seven. What more she could have accomplished will never be known, but today we do know that her work was intricately entwined, helix-like, in the discovery of the structure of DNA.

WRITTEN BY **KRISTI THOM**
www. kristithom.com

ILLUSTRATED BY **GISELLE POTTER**
www.gisellepotter.com

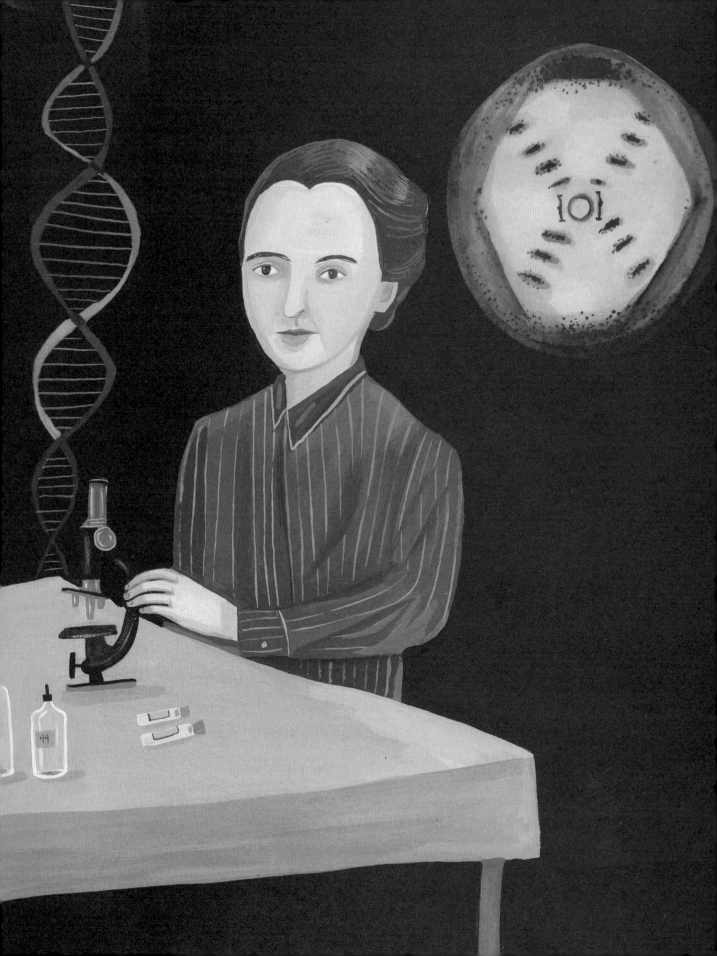

1981 JOHN MALOOF –

VIVIAN MAIER'S DISCOVERER

MY NAME IS JOHN MALOOF, AND I'M A FILM-maker and street photographer. In 2007, I was coauthoring a history book about my neighborhood, Portage Park in Chicago, and was having a difficult time finding old photos to cover my subject matter. I stopped by a nearby auction house that sells furniture antiques, etc., from local estates. My thinking was, maybe there is an old photo album here that I can use for my book.

At the auction house, among the furniture, appliances, and boxes of household junk, there were several boxes of old negatives from Chicago. I purchased the largest box, which contained thirty thousand to forty thousand negatives, hoping to find some useful images to illustrate my subject. Unfortunately, nothing worked for the book, so I stuffed the box of photos into my closet.

After writing the neighborhood book, I took out the box and tried to figure out what to do with the work. Would I sell it, donate it? I started scanning the negatives and saw beautiful images that depicted Chicago in the '50s and '60s. It inspired me to document the city I was living in now, the way this photographer had then: the John Hancock building under construction, State Street theaters bustling with people and classic cars. Over time, these negatives inspired me to become a photographer myself.

Looking back at the images, I realized that this work was better than I'd originally thought. Images of people, which I had at first overlooked, were classically great street photographs. Women with crying children, life on the streets as the photographer saw it, captured in black and white and on medium-format film. There is a street scene that captures a "decisive moment" shot of a group of people; there are women in mid stride, a man waiting for a bus, two little girls leaning out the window, a boy rolling a whitewall tire. It looks staged but it's not: It's a feat of perfect timing.

I started researching the photographer and discovered her name was Vivian Maier. She was born in New York City and spent her childhood in both France and New York. Maier had an Austrian father and a French mother. In 1956, Maier moved from New York to Chicago to work as a nanny; she would spend the rest of her life there, shuffling from family to family, caring for children and the elderly, while obsessively documenting the world around her with her camera—sometimes two or three—which she kept around her neck at all times. She never married, had no children, no close family, and no close friends. Many people who knew Maier have detailed her paranoia and secretiveness. She kept a massive deadbolt on her bedroom door, sometimes a padlock. She would use variations of her name from family to family and use aliases at shops and with people she hardly knew.

Maier was very much an enigma. She was a prolific and masterful photographer with no one to offer her feedback, and she apparently never showed her images to anyone. In fact, no one knew she was a *good* photographer during her lifetime. Vivian Maier died in 2009, two years after her storage lockers were auctioned off, and shortly before the world would be blown away by her art.

In May of 2009, I created a blog for Maier, posting about two hundred images online. No one visited. A few months later, I linked that blog to a discussion post on Flickr (Hardcore Street Photography), and immediately that thread and the linked blog went viral. Hundreds of emails and interest from around the world started to pour in. Around that same time, I found and purchased most of the other boxes that had been part of the original auction house sale and reconstructed about 90 percent of Maier's archive.

Over the years that followed, my research tracked down more than ninety people who knew Maier—relatives, employers, and acquaintances. In 2009, I embarked on directing a documentary film, *Finding Vivian Maier*, which took four years of research and travels around the world. By 2013, Maier's work had been seen in art galleries and books, and just about every major press outlet has published the story in some form, including *The New Yorker*, *The New York Times, Vanity Fair,* and *Time* magazine.

Currently, my collection of Maier's work (the Maloof Collection) is represented by one of the most prestigious photography galleries in the world, the Howard Greenberg Gallery. Her negatives have all been digitally archived and are stored safely in an art-storage facility in New York. What is to come of Maier's work and story in the future is still unknown, but the interest that has been shown around the world makes it certain history will remember her.

WRITTEN BY **JOHN MALOOF** / ILLUSTRATED BY **DANIEL FISHEL**
www.johnmaloof.com / www.o-fishel.com

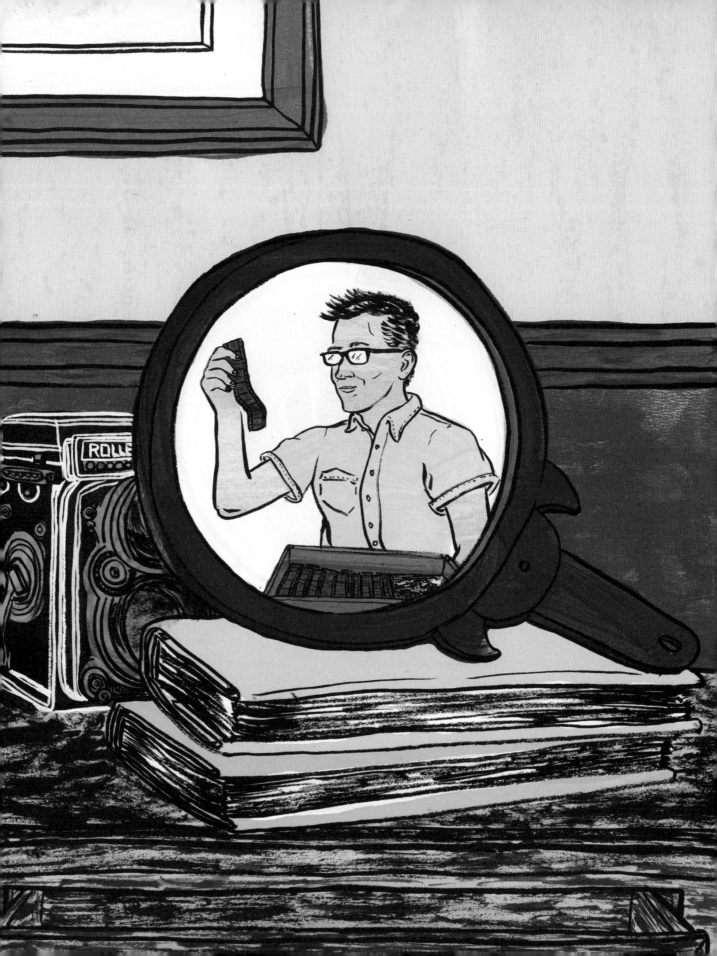

AUTHOR BIOS

LAUREN ACAMPORA is a fiction writer whose short stories have appeared in *The Paris Review*, *Prairie Schooner*, and *The Missouri Review*, among other publications. Her first collection of stories is forthcoming from Grove Atlantic. She lives outside of New York City with her husband, artist Thomas Doyle, and daughter.

AMID AMIDI is the authorized biographer of Ward Kimball. Aside from being editor-in-chief of the influential animation industry website CartoonBrew.com, he is the author of numerous books about contemporary and classic animated filmmaking, most notably *Cartoon Modern: Style and Design in Fifties Animation* (Chronicle Books), which was awarded the prestigious Theatre Library Association Award. He lives and works in New York City, and often lectures at studios, schools, and festivals.
www.amidamidi.com

PHILIP BALL is a freelance science writer and the author of many books on science and its interactions with the broader culture. He was previously, for many years, an editor at *Nature*.
www.philipball.co.uk

DAPHNE BEAL's writing has appeared in *New York Times Magazine*, *McSweeney's*, and the *London Review of Books*. Her novel, *In the Land of No Right Angles*, was published by Vintage Anchor Books in 2008. She divides her time between Brooklyn and Marfa, Texas.
www.daphnebeal.com

TOM BIEDERBECK is a writer, editor, and visual communicator. He is the former editor of *STEP Inside Design* magazine.

MARK BINELLI is the author of *Detroit City Is the Place to Be* and *Sacco and Vanzetti Must Die!* He is a contributing editor at *Rolling Stone* and *Men's Journal* and lives in New York.
www.markbinelli.com

LISA BONOS is an opinion editor and writer for *The Washington Post*.

ELIZABETH L. BRADLEY, PhD, is a Brooklyn-based historian whose interests include the intersections of literature, science, and American popular culture. Her books include *Knickerbocker: The Myth Behind New York* (Rutgers University Press) and *New York* (Reaktion Books, forthcoming) and she is the editor of the Penguin Classics edition of Washington Irving's *A History of New York*. She has contributed articles on New York's singular features to numerous anthologies, as well as to publications such as *Edible Brooklyn*, *Bookforum*, and *The New York Times*. Dr. Bradley is currently at work on a history of the eugenics movement in New York City.
www.knickerbockerny.com

CARA CANNELLA is a Key West–based freelance writer and editor covering books, boats, and culture. She graduated from the New School's MFA program in creative writing and founded the New York City live event series Speak Easy: Conversations with Artists & Entrepreneurs.
www.caracannella.com

ABIGAIL COHEN grew up in New York City, surrounded by the books of Maurice Sendak, and fondly recalls making a special trip to the Morgan Library to see his drawings in person. After majoring in art history as an undergraduate, she went on to study molecular neurobiology at the CUNY Graduate Center and medicine at Drexel University. In retrospect, she attributes a part of her interest in human behavior to Sendak's vivid depictions of resourceful kids navigating complex worlds. She is currently beginning a residency in psychiatry and loves a good nose.

ERIC R. DANTON writes for *The Wall Street Journal*, RollingStone.com, and *Salon*, and edits the blog listen dammit.com. He was rock critic at the *Hartford Courant* from 2002 to 2012.
www.ericdanton.com

GUINEVERE DE LA MARE is a writer based in San Francisco. Born and raised on the island of O'ahu, she was introduced to Hawaiian history by her grandmother, a minister's wife and educator who arrived in Honolulu by steamship in 1949, a decade before statehood. Guinevere graduated from Punahou School exactly fifteen years after Barack Obama, but she has yet to run into him at the annual alumni lu'au.
www.guineveredelamare.com

GLEN DRESSER is a Canadian writer and novelist whose first novel, *Correction Road*, came out in 2008 and was short-listed for the W. O. Mitchell Book Prize. He's an ongoing contributor for *UPPERCASE* magazine, where he's written everything from an article on dogs of the Soviet space program to an abecedary of geometric shapes. His ongoing projects include publishing a second novel, designing board games, tinkering with woodworking robots, and composing erotic palindromes.

PAUL DURICA is the editor, with Bill Savage, of *Chicago by Day and Night: The Pleasure Seeker's Guide to the Paris of America*, originally published in anticipation of the 1893 World's Fair. His writing has appeared in *Poetry, Tin House, Indiana Review, The Chicagoan*, and *Mid-American Review*, among other places. In Chicago, he runs a series of free walks, talks, and reenactments dealing with Chicago history called Pocket Guide to Hell. *www.pocketguidetohell.com*

JANE H. FURSE is a journalist who has covered murder, mayhem, money, museums, metro news, and many other subjects that don't begin with the letter *m*. She has been doing this for the last twenty-five years, primarily for the *New York Daily News*, as well as for *The New York Times*, the *New York Post*, Reuters, and numerous other publications. She lives in New York with her husband, John Friedman, and daughters, Meredith and ZZ. *www.JaneHFurse.com*

GOLDIE GOLDBLOOM's novel *The Paperbark Shoe* won the AWP Novel Award, as well as the Literary Novel of the Year from the Independent Publishers Association. Her short fiction has been published widely in anthologies, as well as in such journals as *Prairie Schooner, Story Quarterly*, and *Narrative* magazine. She is the winner of the *Jerusalem Post* Literary prize. Goldie is a professor at Northwestern University, a queer activist for religious Jews, and the mother of eight children. She lives in Chicago. *www.goldiegoldbloom.com*

MANUEL GONZALES is a writer living in Austin, Texas. He is the author of *The Miniature Wife and Other Stories* (Riverhead) and the forthcoming novel *The Regional Office is Under Attack!* (Riverhead).

MARNI GRAFF writes the award-winning Nora Tierney Mysteries, set in England: *The Blue Virgin* (Oxford); *The Green Remains* (Cumbria); *The Scarlet Wench* (Cumbria). Graff is also coauthor of *Writing in a Changing World* and writes weekly crime book reviews at www.auntiemwrites. com. The managing editor of Bridle Path Press, she is a member of Sisters in Crime and directs the NC Writers Read program. *www.auntiemwrites.com*

BUCKY HALKER, PhD, is a songwriter, performer, and historian with a dozen recordings to his credit, including *The Ghost of Woody Guthrie* (2012), an original tribute to Guthrie. He is the author of *For Democracy, Workers, and God: Labor Song-Poems and Labor Protest* (University of Illinois Press). Bucky produces the *Folksongs of Illinois* CD series and serves on the board of the Woody Guthrie Foundation and Archives. He received the Archie Green Fellowship from the American Folklife Center in 2011. *www.buckyhalker.com*

EMILY A. HARRISON is a doctoral candidate in the history of science at Harvard University. She holds a master's from the Harvard School of Public Health, where her research assessed a tool for monitoring and evaluation of community development programs in east Africa. In a previous life, she worked as a journalist at *Scientific American*. This year, she is traveling between research sites in Ecuador, India, Liberia, and the United States in hot pursuit of a completed dissertation.

NAS HEDRON is an author, editor, and artist who divides his time between Canada and Brazil. He is nonfiction editor at *International Speculative Fiction* and cofounder and principal editor at IndieBookLauncher.com, which provides editing, cover design, and e-book production services to independent authors. Nas is the author of *Luck and Death at the Edge of the World* (A Fallen World Book), *Los Angeles Honey*, and *The Virgin Birth of Sharks*, among other works. *www.nassauhedron.com*

JULIA HOLMES was born in Dhahran, Saudi Arabia, and grew up in the Middle East, Texas, and New York. Her first novel, *Meeks* (Small Beer Press), published in 2010, was a *New York Times Book Review* Editors' Choice and an Indie Next Notable Book. In 2013, she built a seventeen-foot rowboat in her Brooklyn apartment and began retracing an ancestor's 1813 river journey from New York to New Orleans. *www. juliaholmes.net*

SVETLANA KITTO is a writer, teacher, and oral historian in New York City. Her writing has been featured in the book *Occupy!: Scenes from Occupied America* (Verso Books), *The New York*

Times blog *The Local, Surface* magazine, *Kirkus Reviews, Mr. Beller's Neighborhood, Ducts, Plenitude* magazine, and the *Oral History Review*. She has contributed oral histories to the Brooklyn Historical Society, the Jewish Theological Seminary, the Columbia Center for Oral History, and the Museum of Arts and Design.
www.svetlanakitto.com

CARLY A. KOCUREK is a writer, researcher, and cultural historian. She holds a PhD in American studies from the University of Texas at Austin and lives and teaches in Chicago. Her current manuscript, a history of the video game arcade, is part of a larger project interrogating the cultural practices surrounding video gaming.
www.sparklebliss.com/blog

DANIEL KUGLER fits in with the famous singers no one can hear and the punks riding motorcycles no one can see. He is a writer, radio producer, interviewer, field organizer, folksinger, magazine delivery boy, event promoter, filmmaker, after-school tutor, journalist, poet, beer-booth volunteer, collage artist, sound recorder. He grew up in Chicago and its suburbs and went to a few of its colleges. He splits his time between Chicago and Vermont.
Torevealourbackstreets.tumblr.com

JORDAN KUSHINS is a writer based in beautiful San Francisco, California (by way of Hermosa Beach, Boston, and London). She is on staff at *Gizmodo*, has been a regular contributor at Co.Design and an editor at *Dwell*, and has an MA in creative writing. When she's not working with words, chances are good she's biking around the city or crocheting. Her favorite Black Sparrow Press book is *Ask the Dust* by

John Fante.
www. jordankushins.com

JESSICA LAMB-SHAPIRO is the author of *Promise Land: My Journey Through America's Self-Help Culture* (Simon & Schuster). She has received fellowships from the MacDowell Colony and the New York Foundation for the Arts and is a graduate of Brown University (BA) and Columbia University (MFA).
www.jessicalambshapiro.com

JACKIE LEAVITT is a creative nonfiction writer who lives in San Francisco, where she spends her free time writing, traveling, photographing, dancing, and rock climbing. She graduated from the University of New Hampshire with degrees in journalism and European culture studies.
www. jackie-leavitt.com

SARA LEVINE is the author of the novel *Treasure Island!!!* (Europa) and the short story collection *Short Dark Oracles* (Caketrain). She teaches at the School of the Art Institute of Chicago.
www.sara-levine.com

IGOR LEVSHIN was born in 1958 in Moscow, Russia. His publications in Russian underground magazines started as early as at the last years of the Soviet era. A book of short stories, *Zhir Igoria Levshina* ("The Fat of Igor Levshin") was published in 1995 in the *Classics of XXI* series. His poems and short stories were published in *Chernovik* (New York), *Muleta* (Paris-Moscow), *Vozdukh* (Moscow), and in other magazines. He lives in Moscow.
Igor.levshin.com

JOHN LIBRÉ is a former advertising copywriter. He lives in Brooklyn, New

York, with his wife and their two children. He'd like to thank his mother for driving him to the orthodontist biweekly for much of the mid-'90s.

JOHN MALOOF is a filmmaker, photographer, and artist. He is the chief curator of Vivian Maier's work and editor of the book *Vivian Maier: Street Photographer* (Random House). He is also director of the documentary *Finding Vivian Maier*.
www.johnmaloof.com

REGAN MCMAHON is senior editor, books, at Common Sense Media. A journalist, book critic, website editor, and author, she was a features editor and book editor at the *San Francisco Chronicle* and is copy editor for the literary journal *Zyzzyva*. Her book *Revolution in the Bleachers: How Parents Can Take Back Family Life in a World Gone Crazy Over Youth Sports* (Gotham/Penguin) was named a Chronicle Notable Book for 2007. She lives in Oakland, California.
www.commonsensemedia.org

COLIN MILROY is a freelance writer and ensemble member of the Factory Theater. Two of Colin's short plays debuted in 2010, and his first full-length play, *The Gray Girl*, was *TimeOut Chicago's* #1 Critic's Pick in November 2011. His second full-length play debuted in November 2013. Colin continues to experiment with fiction and essays while he writes more plays. Colin lives in Chicago with his wife and two children.
www.thefactorytheater.com

EMILY MITCHELL's first novel, *The Last Summer of the World* (W. W. Norton), was a finalist for the 2008 Young Lions Award. Her short fiction has

appeared in *Ploughshares*, *Alaska Quarterly Review*, *TriQuarterly*, and *New England Review*. She teaches creative writing at the University of Maryland. Her first collection of short stories is forthcoming. *Sites.google.com/site/lastsummeroftheworldbook*

JOHN NIEKRASZ is a writer, musician, and composer living in Chicago. He received his MFA from the Iowa Writers' Workshop in 2004 and has published in *Volt*, *Cutbank*, *Ancients*, and other periodicals. In his compositions, John seeks to bridge the musico-poetic divide through text-based arrangement and syllabic musical notation. John has studied history, art, and music in Latin America and India. Forthcoming books include *Nature Anatomy* (with Julia Rothman, Storey Publishing) and *Belacq* (KSG), a collection of poems. *JohnNiekrasz.wordpress.com*

AIDAN O'CONNOR is a design historian and curator based in Brooklyn and currently working at AIGA, the professional association for design. Previously, she has worked at the Museum of Modern Art; Cooper-Hewitt, National Design Museum; the Metropolitan Museum of Art; and the Peabody Museum of Archaeology and Ethnology. She holds an MA in design history from Parsons/Cooper-Hewitt and a BA in archaeology and social anthropology from Harvard.

AARON RAGAN-FORE writes about popular culture, history, folklore, and education from Oregon, where he lives with his wife and a pack of unruly dogs. He was recipient of a 2009 Oregon Literary Fellowship and a 2008

Society of Professional Journalists award. Aaron was lyricist and producer for the University of Oregon's *Call Me a Duck* viral video. In 2011, he enjoyed an offbeat freelance job: writing articles to fill *Daily Planet* newspaper props for the film *Man of Steel*.

ADAM RING is a PhD candidate in philosophy at Northwestern University. He lives in Brooklyn and teaches at St. John's University in Queens. When he is not philosophizing, he can usually be found hiking in Prospect Park with his toddler son, Ben, looking for squirrels.

JOSEPH RINGENBERG is a digital product designer and writes about architecture, education, and the Having of Wonderful Ideas. He likes bikes and brown bears, brutalist buildings, babies, and brewskis. Also regular skis. *www. jringenberg.com*

DAVID ROTH is a cofounder and editor of *The Classical* and a writer at *SB Nation*. He has written for *GQ*, *New York*, *Vice*, *Sports on Earth*, *Wall Street Journal*, *Outside*, and *The Awl*. *www.theclassical.org*

JAY SACHER is a writer, editor, and illustrator. His most recent books include *How to Hang a Picture: And Other Essential Lessons for the Stylish Home* (St. Martin's Press; coauthor, Suzanne LaGasa), and *Lincoln Memorial: The Story and Design of an American Monument* (Chronicle Books). He lives in Brooklyn, New York. *www.jaysacher.com*

Originally from Billings, Montana, **PATRICK SAUER** is a freelance writer/stay-at-home dad in Brooklyn. He writes for *ESPN*, *SB Nation*, *Airship*

Daily, *Deadspin*, *Biographile*, *Fast Company*, *The Classical*, *Narratively*, and other outlets. He likes presidents and gangsters in equal measure. *www.patricksauer.com*

JOSHUA WOLF SHENK is an essayist, curator, and author of *The New York Times* Notable Book *Lincoln's Melancholy*. His work has been published in *Harper's*, *The New Yorker*, *The Atlantic*, and in the national bestseller *Unholy Ghost: Writers on Depression* (Harper-Collins). His essay on Earl Tupper and Brownie Wise is adapted from his most recent book, *Powers of Two* (Houghton Mifflin Harcourt), on creativity and collaboration in innovative pairs. *www.shenk.net*

EMILIE SIMS lives and works in Chicago. She received her master's degree in art history from the School of the Art Institute of Chicago. Since 2006, she has been the editor and chief of research at Wright, an auction house specializing in twentieth-century design and postwar and contemporary art. Her days are filled with conversations with artists and artist foundations, discovering interesting facts in rare books, and eyeing the most beautiful things in the world.

BRYN SMITH is a writer, graphic designer, and critic. She studied journalism and new media at the University of Colorado and received her MFA in design criticism from the School of Visual Arts in New York. She lives in Brooklyn, with a dog and an architect. *www.brynsmith.com*

SUZANNE SNIDER is a writer and oral historian with a special interest in communes, religion, and medicine.

She is the founder of Oral History Summer School and is currently finishing a book about a divided commune in Middle America.
www.suzannesnider.com

RACHEL SOMERSTEIN's writing about literature and visual art has appeared in *ARTnews, Afterimage, Wired*, and the *Women's Review of Books*, among other publications. She is a PhD candidate in mass communications at Syracuse University, where she studies visual culture and history on the public screen. Rachel holds an MFA in creative writing from NYU.
www.rachelsomerstein.com

MELISSA STEVENS is the director of Shaw Family Archives, a family-owned company founded in 2002 that preserves and promotes the work of her grandfather, the photographer and filmmaker Sam Shaw. Before managing Sam Shaw's archive, Melissa worked in production and writing (HBO's *Rome*), visual effects (Wes Anderson's *The Life Aquatic*), location (HBO's *The Sopranos*), and accounting departments in the film industry. She is a graduate of Wesleyan University.
www.shawfamilyarchives.com

KRISTI THOM writes and illustrates books for children. She has been a girls' magazine editor, a toy designer, a craft developer, an advice columnist for girls, and a regular contributor to the *A.V. Club* of *The Onion*. She lives in Madison, WI.
www.kristithom.com

BONNIE TSUI is a writer in San Francisco. She is a frequent contributor to *The New York Times, The Atlantic,* and *Pacific Standard* and the author of *American Chinatown: A People's History of Five Neighborhoods* (Simon & Schuster). Her latest project, *Everybody in the Pool*, is a collection of essays on swimming.
www.bonnietsui.com

J. M. TYREE is the author of *BFI Film Classics: Salesman*, and the coauthor (with Ben Walters) of *BFI Film Classics: The Big Lebowski,* from British Film Institute publishing. He works as associate editor for nonfiction at *New England Review.*
www.nereview.com/j-m-tyree/

MARS VAN GRUNSVEN is a Dutch-American writer whose work appears in Holland's most respected magazines and newspapers. He is a true generalist: As a US correspondent, he writes about political thought, social issues, culture, and media, to name a few broad areas. Mars lives in Brooklyn with his wife, Rachael Cole, and their son, Alexander. He's an avid runner, with a lifelong passion for Elvis, cheese, and salami.
www.marsvangrunsven.com

LAUREN VIERA is a Chicago-based writer and journalist. She contributes stories on travel and leisure for the *Chicago Tribune, Forbes Travel Guide, Condé Nast Traveler, T Magazine,* and others and is currently working on her first book, which documents the twenty-first-century cocktail craze.
www.laurenviera.com

JOSH VIERTEL is a writer, farmer, and activist. He was named a Young Global Leader by the World Economic Forum and was listed as one of the seven most powerful voices in the food movement by *Forbes* and Michael Pollan. From 2008 to 2012, Josh was president of Slow Food USA. Before Slow Food, he helped found and direct the Yale Sustainable Food Project, which brought local sustainable food to Yale University and built an organic farm on campus.

TED WALKER has written about baseball for his own now-retired blog, *Pitchers & Poets*, and other online publications. He lives in Houston, Texas.
www.tedwalker.net

ADAM WEBB lives outside of Chicago with his wife and son.
www.everydayfootnotes.tumblr.com

NINA WIEDA is a poet, a journalist, and a professor of Russian literature at Middlebury College. Born in the south of Russia, Nina studied nationalism in Budapest and went to graduate school in Chicago. She has authored articles on Russian literature and culture, a book of poetry called *The Music of Blue Thunderstorms*, and coauthored *Russian for Dummies*. She enjoys traveling to sites of ancient civilizations and reading serious books to her eight-year-old daughter, Nadia.
www.middlebury.edu/academics/russian/faculty/node/434576

DAVE ZACKIN works for the city of New York as a writer and designer for the city's eleven public hospitals. He received a BFA in animation from the Rhode Island School of Design an MA in urban studies from Queens College and is currently earning a master's in public health at Hunter College. Zackin enjoys finding things in the garbage and using them to decorate the small studio apartment he shares with his wife and pet turtles in Brooklyn Heights.
www.davezackin.com

ILLUSTRATOR BIOS

WESLEY ALLSBROOK was born in North Carolina, studied illustration at the Rhode Island School of Design, and is currently a nomadic freelancer. *www.wesleyallsbrook.com*

The Tree House Press is the alias of illustrator **MARC ASPINALL**; with work gracing the pages of *The New Yorker, The New York Times, Monocle Magazine*, and more, there's little that Marc hasn't illustrated. From figurative, portraiture, and film, right through to social and current affairs. All with a clear nod to the warmth and charm of the mid century golden era of illustration. *www.thetreehousepress.co.uk*

ELIZABETH BADDELEY is an illustrator based out of Kansas City, Missouri, where she recently returned after obtaining her MFA in illustration from the School of Visual Arts in New York City. If she is not in her studio, Elizabeth may be found swimming laps at the pool, wandering around town with her sketchbook, or in her kitchen experimenting with the latest vegetarian cuisine. *www.ebaddeley.com*

ROBERT BRINKERHOFF is department head for illustration at Rhode Island School of Design, specializing in both editorial and corporate and institutional illustration. Since 2011, he has been the contributing illustrator for *Annenberg VUE*, published quarterly by the Annenberg Institute for School Reform. He was chief critic for RISD's

European Honors Program in Rome from 2007 to 2009 and is currently a faculty advisor to the Salama Bint Hamdan Al Nahyan Foundation Fellowship Program in Abu Dhabi, the United Arab Emirates. *www.robertbrinkerhoff.com*

JULIANNA BRION is an artist based in Baltimore, Maryland. She studied illustration at MICA and now spends her days in the studio with her cat, Ghostface. Some notable clients include *The New Yorker, The New York Times*, and *Nobrow Press*. *www.juliannabrion.com*

ELENA BULAY is a Russian artist. She graduated from the Moscow Print University where she developed a wide range of techniques, from oil on canvas to carving woodcuts and creating etchings. On top of that, Elena has experience working for an advertising agency as graphic designer. Currently she works freelance as both designer and illustrator. She loves making patterns, working on elaborate details, and making watercolor drawings. *www.behance.net/Grafimale*

JONATHAN BURTON is an English illustrator based in France. He recently won the Overall Professional Award 2013 from the Association of Illustrators in London and has also won a silver medal from the Society of Illustrators in New York. Other recognitions include Communication Arts and American Illustration. *www.jonathanburton.net*

MICHAEL BYERS was born and raised in a small city in Ontario, Canada. He is an image maker with a love of stories and characters. He tries to add whimsy and humor to his drawings when appropriate. Some of his clients include *The New York Times, Wall Street Journal, Variety Magazine, The Walrus*, and more. When he's not drawing, he loves drinking coffee, reading a book, and spending time with his beloved wife and two cats. *www.michaelbyers.ca*

CACHETEJACK are Nuria Bellver and Raquel Fanjul, a Spanish illustration duo based in London. Their illustration universe is full of colors, energy, humor, and irony. The hand-drawn work of Cachetejack takes a fresh and unique style in a variety of media, including— but not limited to—books, magazines, newspapers, clothing, drawing, painting, walls, and illustration. Cachetejack combines reality with a cool point of view to create situations and environments closer to the viewer. *www.cachetejack.com*

LAURA CALLAGHAN is an Irish illustrator living and working South East London. Her work is filled with pattern, fashion, and moody girls hand drawn in watercolor and pen. *www.lauracallaghanillustration.com*

SIYU CHEN was born and grew up in China. She went to New York to earn an MFA in illustration at the School of Visual Arts. After graduating from SVA, she moved to Germany. Since then, she

has been working as a freelance illustrator. She has had two books published in China, and her work has been selected to appear in the 2010 edition of *American Illustration*.
www.siyuart.com

HYE JIN CHUNG is a New York–based Korean illustrator. She was born in Singapore and has lived in several different countries before moving to New York City to attend the MFA Illustration as Visual Essay program at the School of Visual Arts. Her work has been recognized by the Society of Illustrators, American Illustration, Communication Arts, and 3x3 among others.
www.hyejinchung.com

KATRIN COETZER is an illustrator born and based in Cape Town, South Africa. She majored in illustration at Stellenbosch University and has worked on a variety of publications, products, and exhibitions in a freelance capacity since 2008. Her favored media are ink and gouache on paper.
www.katrin.co.za

ELLA COHEN, a.k.a **ELLAKOOKOO**, is an Israeli illustrator currently living and working in Berlin. Since graduating from Bezalel Academy for Art and Design (Jerusalem) in 2010, she has created illustrations for leading international newspapers and magazines. She's also a passionate printmaker and Turkish candies eater. Her inspiration comes from visiting crowded places, dreaming, reading, having strange coincidences, and just looking out the window.
www.ellakookoo.com

RACHAEL COLE solidified her love for all things inky and hand-drawn while earning her MFA in illustration at the School of Visual Arts. She is an art director, designer, illustrator and writer. She is currently the art director at Schwartz & Wade Books, an imprint of Random House Children's Books, where she works on picture books and novel jackets with illustrators such as Barry Blitt, Sophie Blackall, Chris Silas Neal, and Stephanie Graegin. Rachael lives in Fort Greene, Brooklyn, with her Elvis-loving husband and son.
www.rachaelcole.net

THOMAS DOYLE's small-scale sculptures and photographs have been shown in galleries and museums internationally. His work has appeared in *The New York Times Magazine, The New York Times Book Review, Newsweek*, and other publications. He lives in New York with his wife, writer Lauren Acampora, and their daughter.
www.thomasdoyle.net

JENSINE ECKWALL is a Brooklyn-based illustrator by way of Connecticut. She makes images about femininity, nature and emotional conflicts for clients such as *The New York Times, Town and Country, Nylon,* and Viacom. Her work has been recognized by the Society of Illustrators, American Illustration, and 3x3. She graduated from SVA in 2013.
www.jensineeckwall.com

BYRON EGGENSCHWILER is a graduate from the Alberta College of Art and Design. His work has been recognized by the Society of Illustrators, Communication Arts, and American Illustration. He currently lives and works in Calgary, Canada.
www.byronegg.com

DANIEL FISHEL = Keystone State Born 'n' Raised + Resides in Queens, NY + Illustrator + Hand Letterer + Boston Terrier Lover + Rootbeer Snob + Horoscope Junkie + I Keep Punk Rock Elite. Daniel has worked for *The New York Times, Washington Post, McSweeney's,* NPR, Landsend Canvas, Sundance Film Fest, and many others.
www.o-fishel.com

JESSICA FORTNER is a freelance illustrator from Toronto, Canada, focusing on editorial, advertising, and children's illustration. She works in both traditional and digital media. Jessica's illustrations have appeared in publications such as *Juxtapoz, Digital Arts, Harvard Business Review*, and *The New York Times*. Her website has been considered one of HOW's Top 10 Sites for Designers and featured on Communication Arts: Fresh.
www.jessicafortner.com

JUSTIN GABBARD is an illustrator and designer in San Francisco, California. Recently moved to the West Coast from Manhattan. He regrets nothing.
www.justingabbard.com

NATHAN GELGUD is an illustrator who lives in Brooklyn. Clients include BAM, *Paris Review,* Random House, and *The Believer.*
www.nathangelgud.com

LEAH REENA GOREN is an illustrator and surface pattern designer living in Brooklyn, New York. She graduated in 2012 from Parsons School of Design with a BFA in Illustration.
www.leahgoren.com

SAMANTHA HAHN is a Brooklyn-based illustrator and the author of *Well-Read Women: Portraits of Fictions Most Beloved Heroines.* Other clients include

Vogue Nippon, The Paris Review, and *Conde Nast Traveller.* She maintains a blog called Maquette and is represented by CWC-i in the United States and Asia. www.samanthahahn.com/blog

RYAN HAYWOOD is an illustrator living and working in Brooklyn, New York.
www.ryanhaywood.com

LESLIE HERMAN is an award-winning illustrator and image maker living in Chicago, Illinois, by way of Richmond, Virginia. He graduated from Virginia Commonwealth University in 2009, attended the Illustration Academy in 2008, and later followed up his education through the career mentorship program in a studio with the Art Department. Now he sings to his cat, makes music, and creates images all day for his dream job.
www.leslieherman.com

SARAH JACOBY is an illustrator, writer, and all-around creative thinker and maker. When making pictures she prefers to use brushes and inks and loves calling upon memories to bring her imagery to life. She studied literature and film at Haverford and Bryn Mawr colleges but has since traded in her pen for a brush and earned an MFA at MICA (Maryland Institute College of Art) in Baltimore.
www.thesarahjacoby.com

CLARA BESSIJELLE JOHANSSON is a cartoonist born in Stockholm, Sweden, now living in Brooklyn, New York. Her work is usually about odd characters who spend their time in richly illustrated environments. Clara has been anthologized in both European and American publications. Her latest comic, *Face Man,* was published by

Domino Books and got nominated for the Ignatz Awards as Promising New Talent 2012. She is currently working on a new comic.
www.bessijelle.tumblr.com

YINA KIM loves to go out on foggy nights to collect stars, moon tears, and pine needles. With these ingredients, she makes candles to light as she draws in the shadowy nights. She lives and works in San Francisco, which is an ideal place for her secret hobby.
www.yinakim.com

MATT LAMOTHE animates and illustrates for ALSO, a small design company he started with friends from RISD. When not staring into the lights of the internet, he finds comfort in pastries, coffee, and basic carpentry. He lives and works in a perpetually half-finished Chicago house.
www.also-online.com

JON LAU is an illustrator based in Los Angeles. He loves tiny brushes, patterns, and well-dressed animals.
www.jonlaustudio.com

RACHEL LEVIT was born in Mexico City and moved to New York in 2008 to study illustration. She currently lives and works in Brooklyn where she shares a studio with her illustrator friends.
www.rachellevit.com

BJORN RUNE LIE is a Norwegian illustrator/artist who now lives and works in Bristol, England. As well as doing commissions for a range of international clients, he finds time to do his own artwork and book projects. He has written and illustrated three children's books and exhibits his work around the world. Inspired by childhood memories,

folk art, and noir films, Bjorn's pictures often feature anatomically incorrect characters in strangely beautiful scenes.
www.bjornlie.com

PEDRO LOURENÇO started as a comic book artist in his mid teens, stored his brushes when the Internet was still a mirage, and by the following decade, dedicated himself exclusively to music. He has since returned as an illustrator and works for advertisement, press, books, music promoters, and bands. Pedro was born and raised in sunny Lisbon, the place he still lives today.
www.tigerbastard.com

HEATHER MACKENZIE is an artist, writer, and educator currently living in Chicago. She holds a BA from Brown University and an MFA in fiber and material studies from the School of the Art Institute of Chicago. She has studied textiles in Ecuador, Ghana, India, and Zimbabwe and has exhibited work and performed internationally at such venues as the TBA Festival in Portland, Oregon, and the National Museum of Ghana.
www.heather-mackenzie.com

WENDY MACNAUGHTON is a *New York Times* bestselling illustrator whose books include *Meanwhile in San Francisco: The City in Its Own Words, Lost Cat: A True Story of Love, Desperation, and GPS Technology,* and *The Essential Scratch and Sniff Guide to Becoming A Wine Expert.* Her work has appeared in places like *The New York Times, The Wall Street Journal,* and *Print Magazine.* Follow her @wendymac.
www.wendymacnaughton.com

MASHA MANAPOV is a designer and illustrator currently based in Tel

Aviv. She graduated from the Bazalel Academy of Art and Design with a major in illustration. Her work focuses mainly on print and press media. Masha's work has been exhibited both locally and internationally and published in various printed and online worldwide publications. Formerly, she participated in a few artistic collaborative projects and attended Casa de Velázquez in Madrid as an artist resident.
www.mashkaman.com

AVITAL MANOR was born in Jerusalem, Israel. She's been drawing ever since she can remember, but the path to becoming an illustrator had a few detours. She graduated in mathematics and computer science and worked as a software developer for few years, then studied literature editing and translation and, finally, visual communication (majoring in illustration) at the Bezalel Academy of Arts and Design, Jerusalem. She works with advertising agencies, musicians, magazines, newspapers, and more. Currently she lives and works in Tel Aviv, Israel.
www.avitalmanor.com

KATTY MAUREY is a freelance designer and illustrator based in Montreal. Her favorite things are making picture books, painting, and tending her plants in her spare time.
www.kattymaurey.tumblr.com

ROMAN MURADOV is an illustrator and cartoonist from Russia, currently living in San Francisco. His work has appeared in *The New Yorker, The New York Times,* and other nice places. He loves tea, books, and long aimless walks.
www.bluebed.net

KEITH NEGLEY is an illustrator raised in a Midwestern farm town now

living among the mountains of the Pacific Northwest. He has an MFA from the School of Visual Arts in New York and is a regular contributor to *The New York Times*. His illustrations have also been featured in numerous other publications including *Nobrow, Newsweek, The New Yorker*, and *Reader's Digest*. Awards include two silver medals from the Society of Illustrators and two bronze medals from the 3x3 Professional Show.
www.keithnegley.com

KYLE PLATTS grew up in Sheffield, England, and despite being told by a careers advisor to work in a steel mill rather than pursue a career as a cartoonist, he studied illustration at Camberwell College of Arts and graduated in 2011. Since graduating he has published two books with Nobrow Press, *Megaskull*, and *Festival Frenzy*. Kyle's comics aim to create a graphic reflection of the world we live in with playful irreverence towards contemporary society.
www.kyleplatts.com

GISELLE POTTER has illustrated more than twenty-five children's books including *The Year I Didn't Go to School*, which she wrote and illustrated about her experiences of traveling with her parents' puppet troupe in Italy when she was eight. One of her recent projects was illustrating a Gertrude Stein book entitled *TO DO: A Book of Alphabets and Birthdays* to accompany an exhibit of the Stein art collection. She lives in Rosendale, New York.
www.gisellepotter.com

JOSEPHIN RITSCHEL was born in Potsdam in 1986 and is currently living in Berlin. She studied illustration at the University of Arts Berlin. She is a

member of the collective the Treasure Fleets. She self-publishes her comics.
www.mevameva.de

CLAY RODERY lives and works in Houston, Texas, just down the road from NASA Mission Control (which accounts for a lot, as he was raised nearby, too). His pictures appear worldwide.
www.clayrodery.com

JUNGYEON ROH is a New York–based illustrator from Seoul, Korea. She likes drawing and eating pink grapefruit soaked in maple syrup.
www.jungyeonroh.com

MATT ROTA is an illustrator living and working in Brooklyn, New York. His work has appeared in publications such as *The New York Times, McSweeny's, The Washington Post, Foreign Policy Magazine*, and many others. His paintings have been exhibited in galleries in New York, Paris, and Los Angeles. He has taught illustration at the Maryland Institute College of Art and is currently part of the graduate illustration faculty at the School of Visual Arts in the Visual Narrative program.
www.mattrotasart.com

JULIA ROTHMAN has created illustrations and pattern designs for newspapers, magazines, dishes, wallpaper, bedding, books, and subway posters. She is part of the award-winning three-person design studio called ALSO and runs the blog Book By Its Cover. She also authored and coauthored four books and counting, most recently *Hello NY*, which is about living her whole life as a New Yorker.
www.juliarothman.com

RUBBER HOUSE is an award-winning Australian animation studio

run by directing-duo Greg Sharp and Ivan Dixon. The team have carved a niche for themselves in the animation industry for their irreverent character design work; it seems fresh but reeks of yesteryear. Rubber House is represented in Australia by the Jackie Winter Group.
www.rubberhousestudio.com

DAWID RYSKI was born in 1982. Landscape architect by profession. Lives and works in Pulawy, Poland. Author of numerous newspaper illustrations (*Computer World*, *Nature Magazine*, *Adweek*, *Health Leader's Media*) and many concert posters. Creator of album covers and graphic designs for apparel companies. Drummer of a Warsaw-based band the Black Tapes, cofounder of startup Pinata Unique Clothing.
www.talkseek.com

JULIANA SABINSON is an artist living in Wingdale, New York.
www.julianasabinson.com

MORGAN SCHWEITZER grew up in Arlington, Massachusetts. He graduated from Washington University in St. Louis in 2007 majoring in visual communication. A year later, he moved to New York City to continue his career as a freelance concept artist and illustrator. In 2012 he moved out west to Los Angeles, California, where he still resides and works as an illustrator. He has received recognitions from the Society of Illustrators, Communication Arts, and American Illustration.
www.morganschweitzer.com

CUN SHI (first name pronounced *shun*) was born in Beijing and grew up in the Pacific Northwest. At the

moment, Cun lives and works in Brooklyn, New York.
www.cunshiart.com

KIM SIELBECK was born in Alaska, shuffled around the United States in a coast guard family, and currently resides in Brooklyn. When not at her studio making art in Greenpoint, Kim can be found designing textiles, playing guitar in her band Puppies, dancing, biking around the city, finding the best beach this side of the Atlantic, or sailing around New York Harbor.
www.kimsielbeck.com

Bristol-based illustrator **JACOB STEAD** graduated from the University of the West of England in 2011. Since then he has created work for clients such as *The New York Times* and British Airways while working on personal projects often influenced by folklore, Hammer Horror, and mysticism.
www.jacobstead.com

ELLEN SURREY is a Los Angeles–based illustrator currently studying at Art Center College of Design in Pasadena, California. She loves to create things that people of all ages can enjoy. When she isn't making art Ellen enjoys watching old movies, finding treasures in thrift shops, and going to new places.
www.ellensurrey.com

ELEANOR TAYLOR is an artist and illustrator from the seaside city of Brighton, England. Some of the inspirations for her work include British folklore, medieval comics, botany, and science fiction. She graduated from the Royal College of Art in 2011 and was shortlisted for the Jerwood drawing Prize in 2012.
www.eleanortaylor.co.uk

Raised by his mother, comic books, and his bicycle, **PATRICK THEAKER** spent his youth bicoastal between Los Angeles and Philadelphia. After studying illustration at the Rhode Island School of Design, he settled back in Philadelphia. Having a varied expandable skill set and an ability to problem-solve, he proudly accepts the moniker of "art hack." If you have a problem, and you know how to find him, you, too, can hire the "art hack."
www.patricktheaker.com

PIETER VAN EENOGE studied graphic design and illustration at the Sint-Lucas School for Science and Art in Ghent, Belgium. His work combines witty concepts with elegant characters, nature with detailed geometry, and opposites like good/evil, light/dark, and ugliness/beauty. Pieter now lives in Bruges with his wife, two sons, and two cats.
www.pietervaneenoge.be

RICCARDO VECCHIO was born near Milan, Italy. In 1994, he was awarded a Fulbright Scholarship to enroll in the masters program at the School of Visual Arts in NYC, where he graduated in 1996. His work has been commissioned for a wide variety of magazines including *The New Yorker*, *The New York Times*, books, and other media in the United States and Europe. His last major solo exhibition was in Brooklyn in December of 2010. He lives and works in New York.
www.riccardovecchio.com

JENNY VOLVOVSKI was born in Russia, where the winters are long and chess is considered a sport. These and other factors helped her become who she is today—a designer for ALSO, a

three-person company with a flair for the unexpected. Aside from working, Jenny likes to spend time taking photos of bricked-up windows, redesigning book covers, and drinking fine coffee beverages.
www.also-online.com

PHOEBE WAHL is an artist whose work explores worlds imaginary and real, saturated with themes of comfort and connectivity to nature and one another. She works primarily in watercolor and collage, though she also creates three-dimensional fabric sculptures ranging from giant costumes to dollhouse-scale figures. A recent graduate of Rhode Island School of Design with a BFA in illustration, Phoebe has since returned to her roots and lives in the lush Pacific Northwest.
www.phoebewahl.com

KYLE T. WEBSTER is an illustrator, designer, digital product maker, and slightly better-than-average amateur card magician. Kyle's work has been published in every major magazine and newspaper in the country. He is also now officially dipping his toe into the world of writing and illustrating children's books, thanks to a contract with the literary agency DeFiore and Company in New York.
www.kyletwebster.com

PAUL WINDLE lives and works in Brooklyn, New York, and enjoys drawing things like tough guys, dinosaurs, and skateboarding dogs. He's looking for places to draw them, so if you'd like him to draw on your house, car, yacht, place of business, etc., contact him by going to his website.
www.paulwindle.com

Born and raised in Seoul, **JULEE YOO** was molded in New York City and graduated from Parsons the New School of Design in May 2012.
www.ju-leeyoo.com

MARIO ZUCCA hails from the rolling hills of Western Pennsylvania. Having earned his BFA from Tyler School of Art and his MFA from the University of Hartford, he's been illustrating for damn near a decade for a broad range of clients in the editorial, book, advertising, and institutional fields. Currently, Mario works out of his home studio in Philadelphia, Pennsylvania, and teaches illustration at Tyler School of Art and Philadelphia University.
www.mariozucca.com

BIBLIOGRAPHY

JOE MARTIN

Hauser, Thomas. *Muhammad Ali*. New York: Touchstone, 1991.

Remnick, David. *King of the World: Muhammad Ali and the Rise of an American Hero*. New York: Vintage, 1999.

JOHN GREENWOOD

Chernow, Ron. *Washington: A Life*. New York: Penguin, 2010.

Freeman, Douglas Southall. *Washington*. New York: Scribner, 1968.

Koch, Charles R. E. *History of Dental Surgery*. Chicago: The National Art Publishing Company, 1909.

VÉRA NABOKOV

Schiff, Stacey. *Véra (Mrs. Vladimir Nabokov)*. New York: Random House, 1999.

JOHN ORDWAY

Ambrose, Stephen E. *Undaunted Courage: Meriwether Lewis, Thomas Jefferson, and the Opening of the American West*. New York: Simon and Schuster, 1996.

Biddle, Nicholas, ed. *The Journals of the Expedition Under the Command of Capts. Lewis and Clark to the sources of the Missouri, thence across the Rocky Mountains and down the river Columbia to the Pacific Ocean, performed during the Years 1804–5–6 by order of the Government of the United States*. New York: Heritage, 1962.

Quaife, Milo M., ed. *The Journals of Meriwether Lewis and Sergeant John Ordway*. Madison, WI: State Historical Society of Wisconsin, 1916.

Slaughter, Thomas P. *Exploring Lewis and Clark: Reflections on Men and Wilderness*. New York: Vintage, 2003.

JULIA WARHOLA

Bockris, Victor. *Warhol: The Biography*. New York: Da Capo Press, 2003.

QUEEN KA`AHUMANU

Day, A. Grove, ed. *Mark Twain's Letters from Hawaii*. Honolulu: University of Hawaii Press, 1966.

Kamakau, Samuel. *Ruling Chiefs of Hawaii*. Revised edition. Honolulu: Kamehameha Schools Press, 1992.

IAN STEWART

Fornatale, Peter. *50 Licks: Myths and Stories from Half a Century of the Rolling Stones*. New York: Bloomsbury, 2013.

Fricke, David. "Ian Stewart: 1938–1985. 'The Sixth Stone' has died in London." *Rolling Stone*. January 30, 1986. www.rollingstone.com/music/news/ian-stewart-1938-1985-19860130.

Richards, Keith, with James Fox. *Life*. New York: Little, Brown, 2010.

Sandford, Christopher. *The Rolling Stones: Fifty Years*. London: Simon & Schuster UK, 2012.

Wyman, Bill, with Richard Havers. *Rolling with the Stones*. New York: DK Publishing, 2003.

THOMAS A. WATSON

Watson, Thomas A. *Exploring Life: The Autobiography of Thomas A. Watson*. New York: D. Appleton and Company, 1926.

SOFIE MAGDALENE (HESSELBERG) DAHL

Dahl, Roald. *More About Boy: Tales of Childhood*. London: Penguin, 2008.

Dahl, Roald. *The Witches*. New York: Penguin Young Readers Group, 2007.

CHRISTOPHER MORCOM

Hodges, Andrew. *Alan Turing: The Enigma*. New York: Vintage, 1992.

ALMA REVILLE

Diu, Nisha Lilia. "Mrs. Alfred Hitchcock: 'The Unsung Partner,'" *The Daily Telegraph*, February 8, 2013.

Spoto, Donald. *The Dark Side of Genius: The Life of Alfred Hitchcock*. New York: Da Capo Press, 1999.

BROWNIE WISE

American Experience: Tupperware! PBS: 2005.

Clarke, Alison J. *Tupperware: The Promise of Plastic in 1950s America*. Washington, DC, and London: Smithsonian Institution Press, 1999.

Kealing, Bob. *Tupperware Unsealed: Brownie Wise, Earl Tupper, and the Home Party Pioneers*. Gainesville, FL: University Press of Florida, 2008.

JOYCE MCLENNAN

James, P. D. *Death Comes to Pemberley*. New York: Knopf, 2011.

James, P. D. *Death in Holy Orders*. New York: Knopf, 2001.

James, P. D. *The Private Patient*. Canada: Knopf, 2008.

James, P. D. *Time to Be in Earnest: A Fragment of Autobiography*. London: Faber and Faber, 1999.

GIUSEPPINA STREPPONI

Dinnage, Rosemary. *Alone! Alone!: Lives of Some Outsider Women*. New York: New York Review of Books, 2004.

Rosselli, John. *The Life of Verdi*. Cambridge: Cambridge University Press, 2000.

HIROSHI ARAKAWA

Oh, Sadaharu, and David Falkner. Oh: *A Zen Way of Baseball*. New York: Times Books, 1984.

MICHEL SIEGEL

Jones, Gerard. *Men of Tomorrow: Geeks, Gangsters, and the Birth of the Comic Book*. New York: Basic Books, 2004.

Nobleman, Marc Tyler, and Ross Macdonald. *Boys of Steel: The Creators of Superman*. New York: Knopf, 2008.

Ricca, Brad. *Super Boys: The Amazing Adventures of Jerry Siegel and Joe Shuster—the Creators of Superman*. New York: St. Martin's Press, 2013.

Tye, Larry. *Superman: The High-Flying History of America's Most Enduring Hero*. New York: Random House, 2012.

Weldon, Glen. *Superman: The Unauthorized Biography*. Hoboken: Wiley, 2013.

SAM SHAW

Banner, Lois. "Photography Changes What and Who We Desire." In *Photography Changes Everything*. Edited by Marvin Heiferman. New York: Aperture Foundation and the Smithsonian Institution, 2012.

Karnath, Lorie. *Sam Shaw*. Ostfildern, Germany: Hatje Cantz, 2010.

Shaw, Sam. *The Joy of Marilyn: In the Camera Eye*. New York: Exeter Books, 1979.

Shaw, Sam, and Norman Rosten. *Marilyn Among Friends*. New York: Henry Holt, 1987.

EDITH BOLLING WILSON

Anthony, Carl Sferrazza. *First Ladies: The Saga of the Presidents' Wives and Their Power, 1789–1961*. New York: Harper Perennial, 1992.

Cooper, John Milton. *Woodrow Wilson: A Biography*. New York: Vintage, 2011.

Levin, Phyllis Lee. *Edith and Woodrow: The Wilson White House*. New York: Scribner, 2001.

G. P. PUTNAM

Butler, Susan. *East to the Dawn: The Life of Amelia Earhart*. New York: Da Capo Press, 2009.

Long, Elgen M., and Marie K. Long. *Amelia Earhart: The Mystery Solved*. New York: Simon & Schuster, 1999.

Rich, Doris L. *Amelia Earhart*. Smithsonian Press, 1996.

Thurman, Judith. "The Life of Amelia Earhart," *New Yorker*, Sept. 14, 2009.

LESLEY RIDDLE

O'Connell, Barry. Program notes, *Step by Step: Lesley Riddle Meets the Carter Family: Blues, County, and Sacred Songs*. Rounder Records, 1993.

Zwonitzer, Mark, and Charles Hirshberg. *Will You Miss Me When I'm Gone?: The Carter Family and Their Legacy in American Music*. New York: Simon & Schuster, 2002.

EILEEN GRAY

Adam, Peter. *Eileen Gray: Her Life and Work: The Biography*. London: Thames & Hudson, 2009.

Benton, Caroline Maniaque. *Le Corbusier and the Maisons Jaoul*. New York: Princeton Architectural Press, 2009.

Colomina, Beatriz. "Battle Lines: E.1027." In *The Architect: Reconstructing Her Practice*. Edited by Francesca Hughes. Cambridge, MA: MIT Press, 1996.

Huxtable, Ada Louise. *On Architecture: Collected Reflections on a Century of Change*. New York: Walker, 2010.

Weber, Nicholas Fox. *Le Corbusier: A Life*. New York: Knopf, 2008.

YAKIMA CANUTT

Davis, Ronald L. Duke: *The Life and Image of John Wayne*. Norman: University of Oklahoma Press, 2001.

CARLO

Howe, Susan. *My Emily Dickinson*. Berkeley: North Atlantic Books, 1985.

Johnson, Thomas, and Theodora V. Ward, eds. *The Letters of Emily Dickinson*. Cambridge, MA: Belknap Press of the Harvard University Press, 1958.

Wineapple, Brenda. *White Heat: The Friendship of Emily Dickinson and Thomas Wentworth Higginson*. New York: Alfred A. Knopf, 2008.

JACK SENDAK

Brockes, Emma. "Maurice Sendak." *The Believer*, November/December 2012. www.believermag.com/issues/201211/?read=interview_sendak.

Jonze, Spike, and Lance Bangs. *Tell Them Anything You Want: A Portrait of Maurice Sendak*. Documentary, 2009.

National Public Radio. "Fresh Air Remembers Author Maurice Sendak." May 8, 2012. NPR tribute compiling interviews with Maurice Sendak by Terry Gross.

Sendak, Maurice. *My Brother's Book*. New York: HarperCollins, 2013. As read by Tony Kushner in radio interview with Renee Montagne, 2013.

FRANK WILD

Shackleton, Ernest. *South: The Endurance Expedition*. London: Penguin Books, 1999.

MAX DEUTSCHBEIN

Heidegger, Martin. "My Way to Phenomenology." Translated by Joan Stambaugh. In *Philosophical and Political Writings*. Edited by Manfred Stassen. New York: Continuum, 2003.

Kisiel, Theodore J. *The Genesis of Heidegger's Being and Time*. Berkeley: University of California, 1995.

Macht, Konrad. "Karl and Max Deutschbein's English Grammar Manuals." In *English Traditional Grammars: An International Perspective*. Edited by Gerhard Leitner. Amsterdam: John Benjamins, 1991.

Safranski, Rudiger. *Martin Heidegger: Between Good and Evil*. Translated by Ewald Osers. Cambridge, MA: Harvard University Press, 1998.

MARY MOODY EMERSON

Cole, Phyllis. *Mary Moody Emerson and the Origins of Transcendentalism: A Family History*. New York: Oxford University Press, 1998.

Richardson, Robert D., Jr. *Emerson: The Mind on Fire*. Berkeley: University of California Press, 1996.

GLADYS LOVE PRESLEY

Dundy, Elaine. *Elvis and Gladys*. Jackson, MS: University Press of Mississippi, 1985.

ALICE B. TOKLAS

Malcolm, Janet. *Two Lives: Gertrude and Alice*. New Haven: Yale University Press, 2007.

Simon, Linda. *The Biography of Alice B. Toklas*. Garden City, NY: Doubleday, 1977.

MARIE ANNE LAVOISIER

Donovan, Arthur. *Antoine Lavoisier: Science, Administration and Revolution*. Cambridge, MA: Cambridge University Press, 1996.

JOSEPH DALTON (J. D.) HOOKER

Darwin Correspondence Project, www.darwinproject.ac.uk.

The Joseph Dalton Hooker Website, www.jdhooker.org.uk.

"The Victorians: Religion and Schinece," Gresham College website, www.gresham.ac.uk/lectures-and-events/the-victorians-religion-and-science

MARCUS TULLIUS TIRO

Bailey, Shackleton, ed. *Cicero: Select Letters*. Cambridge: Cambridge University Press, 1980.

Everitt, Anthony. Cicero: *The Life and Times of Rome's Greatest Politician*. New York: Random House, 2003.

GWEN JOHN

Lloyd-Morgan, Ceridwen. *Gwen John: Letters and Notebooks*. Aberystwyth: Tate, 2005.

Lloyd-Morgan, Ceridwen. *Gwen John papers at the National Library of Wales*. Aberystwyth: Tate, 1988.

Roe, Sue. *Gwen John: A Painter's Life*. New York: FSG, 2001.

ANNE SULLIVAN MACY

Keller, Helen. *The Story of My Life*. New York: Signet Classics, 2010.

Nielsen, Kim E. *Beyond the Miracle Worker: The Remarkable Life of Anne Sullivan Macy and Her Extraordinary Friendship with Helen Keller*. Boston: Beacon Press, 2009.

MARJORIE GREENBLATT MAZIA GUTHRIE

Cray, Ed. *Ramblin' Man: The Life and Times of Woody Guthrie*. New York: W. W. Norton, 2004.

Kaufman, Will. *Woody Guthrie, American Radical*. Urbana: University of Illinois Press, 2011.

Klein, Joe. *Woody Guthrie: A Life*. New York: Ballantine, 1980.

JOHN ALLAN

Fisher, Benjamin F., ed. *Poe in His Own Time*. Iowa City: University of Iowa Press, 2010.

Ingram, John. *Edgar Allan Poe:, His Life, Letters and Opinions*. New York: AMS Press, 1965.

Morton, Brian. *Edgar Allan Poe*. London: Haus, 2010

DANTE GABRIEL ROSSETTI

Harvey, Charles, and Jon Press. *William Morris: Design and Enterprise in Victorian Britain*. Manchester: Manchester University Press, 1991.

HORACE WELLS

Fenster, Julie M. *Ether Day: The Strange Tale of America's Greatest Medical Discovery and the Haunted Men Who Made It*. New York: HarperCollins, 2001.

Wolfe, Richard J. *Tarnished Idol: William T. G. Morton and the Introduction of Surgical Anesthesia*. Novato, CA: Jeremy Norman Co., 2001.

NAT ELIAS

Edwin W. Pauley Papers. Truman Library.

Frank, Julia Bess. *A Personal History of Dr. Leona Baumgartner, Covering the Years 1902-1962*. Yale University MD Thesis, 1 March 1977. Schlesinger Library, Radcliffe College.

Kennedy, David. *Birth Control in America: The Career of Margaret Sanger*. New Haven: Yale University Press, 1970.

Margaret Sanger Papers. Sophia Smith Collection, Smith College.

Sanger, Margaret. *An Autobiography*. New York: Dover Publications, Inc., 1971: 363.

U.S. National Archives. US Military Tribunals Nuremberg. USPTO Patent Full-Text and Image Database.

JULIUS ROSENWALD

Rosenwald, Julius. *Papers, 1905–1933*. University of Chicago Regenstein Library, Special Collections.

Wermer, M. R. *Julius Rosenwald: The Life of a Practical Humanitarian*. New York: Harper & Brothers, 1939.

OCTAVE CHANUTE

Chanute, Octave. *Progress in Flying Machines*. New York: The American Engineer and Railroad Journal, 1894.

Fowle, Frank F. "Octave Chanute: Pioneer Glider and Father of the Science of Aviation." *Indiana Magazine of History*: Vol. 32, No. 3 (September 1936): 226–230.

The Library of Congress. "Octave Chanute Papers: Special Correspondence." Wright Brothers 1900–1910. www.memory.loc.gov. Accessed August 2013.

Means, James. "Octave Chanute." *Science*, New Series, Vol. 33, No. 846 (March 17, 1911): 416–418.

Moore, Powell A. "Octave Chanute's Experiments with Gliders in the Indiana Dunes, 1896." *Indiana Magazine of History*. Vol. 54, No. 4 (December 1958): 381–390.

Short, Simine. *Locomotive to Aeromotive: Octave Chanute and the Transportation Revolution*. Champaign: University of Illinois Press, 2011.

Wendell, David V. "Getting Its Wings: Chicago as the Cradle of Aviation in America." *Journal of the Illinois State Historical Society*. Vol. 92, No. 4 (Winter 1999/2000): 339–372.

HOLGER GESCHWINDER

Geschwindner, Holger. "Q&A with Holger Geschwindner." NBA.com, August 6, 2006. www.nba.com/features/geschwindner_qa_060806.html.

Harrell, Eben. "Holger Geschwindner: What Do Physics and Jazz Have to Do with Basketball? Plenty, If You Really Want to Win." *Time,* March 20, 2008. http://content.time.com/time/magazine/article/0,9171,1724406,00.html.

Zarrabi, Nima. "A Boy from Wurzberg," *Slam*, February 23, 2010. www.slamonline.com/online/nba/all-star-2010/2010/02/a-boy-from-wurzburg/.

"Basketball Is a Dance: Dirk Nowitzki and the Man Who Discovered Him," *Spiegel Online*, October 9, 2012. www.spiegel.de/international/world/an-interview-with-dirk-nowitzki-and-his-mentor-holger-geschwindner-a-860109.html.

JOHN INGERSOLL

Jacoby, Susan. *The Great Agnostic: Robert Ingersoll and American Freethought*. New Haven and London: Yale University Press, 2013.

JOSHUA SPEED

Goodwin, Doris Kearns. *Team of Rivals*. New York: Simon & Schuster, 2005.

Speed, Joshua Fry. *Reminiscences of Abraham Lincoln and Notes of a Visit to California: Two Lectures*. Louisville, KY: John F. Morton, 1884.

BAYARD RUSTIN

D'Emilio, John. *Lost Prophet: The Life and Times of Bayard Rustin*. New York: Free Press, 2003.

Rustin, Bayard. *I Must Resist: Bayard Rustin's Life in Letters*. Edited by Michael G. Long. San Francisco: City Lights Books, 2012.

ROSALIND FRANKLIN

Glassman, Gary. *DNA: Secret of Photo 51*. A Nova Production by Providence Pictures, Inc., for WGBH/Boston in association with the BBC. 2003. DVD.

Maddox, Brenda. *Rosalind Franklin: The Dark Lady of DNA*. New York: Perennial, 2003.

Watson, James D. *The Annotated and Illustrated Double Helix*, Edited by Alexander Gann and Jan Witkowski. New York: Simon & Schuster, 2012.

Watson, James D. *The Double Helix: A Personal Account of the Discovery of the Structure of DNA*. New York: Touchstone, 2001.

AUTHORS

ILLUSTRATORS

INDEX

ACKNOWLEDGMENTS

This book wouldn't exist without the efforts of the many (not so) secret sidekicks who contributed their ideas, time, and effort to this very collaborative project. Without the help of these writers and illustrators, you would certainly not be holding this book in your hands. So, above all, we want to thank our 126 "accomplices," who deserve most of the credit for this book.

We also wouldn't be able to have put this book together without our editor Bridget Watson Payne and art director Brooke Johnson, who believe in our projects and push us to do our best work.

There were several people who went out of their way to come up with topics and round up more contributors for the book—Abi Cohen, Dan Kugler, Jessica Lamb-Shapiro, Gretta Keene, and Patrick Sauer.

And, of course our family and friends who tell us honestly if our ideas don't make sense, if our kerning is too tight, and to stop stressing out. We are happy to have them "behind the scenes" in all of our endeavors.